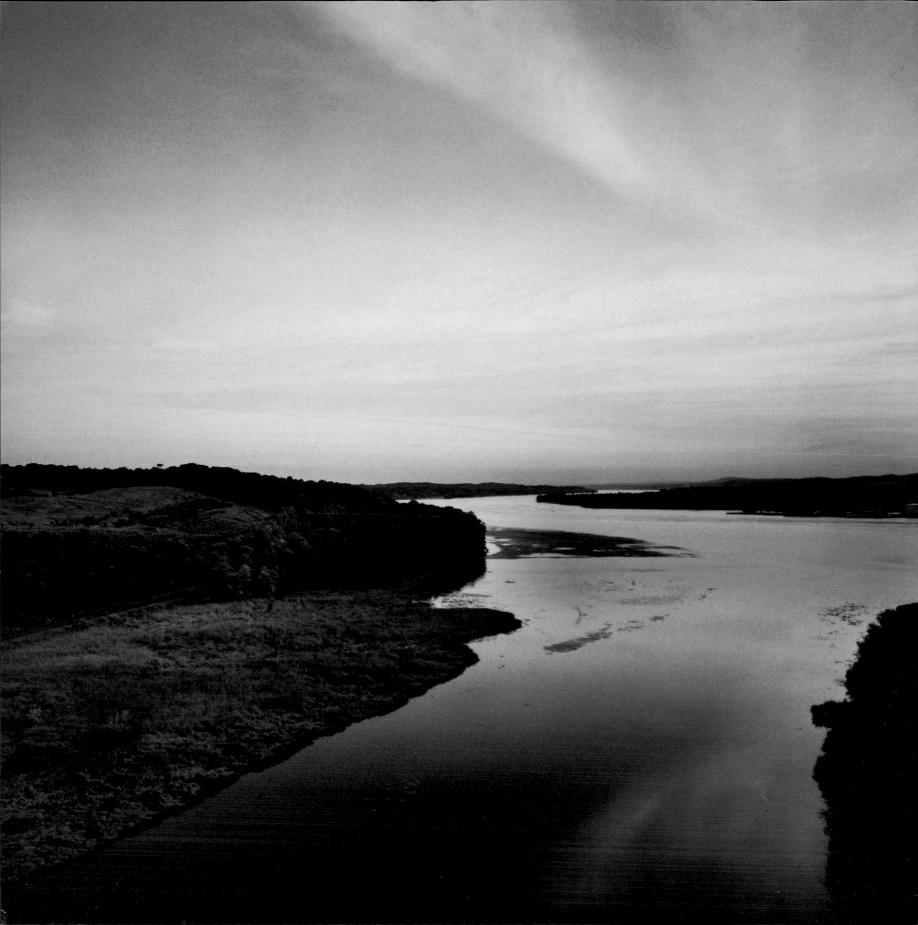

CONTENTS

Introduction 7

To Eric Engleman

ACKNOWLEDGMENTS

This book would not have been possible without the generous
help of many. I am especially grateful to Johnnie Moore,
Eric Lee, Leslie Kossoff, Johanna Grawunder, Kay Toll,
Jeremiah Rusconi, Robert and Sydney Knisel, Donna Agajanian,
and Barbel Meibach. I am hugely indebted to the people who
kindly allowed us to photograph their homes. Many thanks also
to the talented and ever–helpful Mikyla Bruder, Leslie Davisson,
and Brett MacFadden at Chronicle Books.

Library of Congress Cataloging-in-Publication Data available.
ISBN: 0-8118-4466-8

Design by Brett MacFadden
Typeset in Atma Serif, Benton Sans, and Egyptienne
Photographs printed by Hong Color, NYC
Map by Randy Stratton and Brett MacFadden
Manufactured in Hong Kong

Distributed in Canada by Raincoast Books
9050 Shaughnessy Street
Vancouver, British Columbia V6P 6E5

10 9 8 7 6 5 4 3 2 1

Chronicle Books LLC
85 Second Street
San Francisco, California 94105
www.chroniclebooks.com

PAGE 2: The Hudson River Valley is aglow in autumn.

AT HOME IN THE
HUDSON VALLEY

- by -

ALLISON SERRELL

- photographs by -

MEREDITH HEUER

CHRONICLE BOOKS

SAN FRANCISCO

AT HOME IN THE HUDSON VALLEY

INTRODUCTION

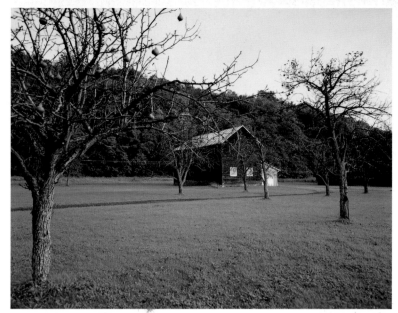

The Hudson River Valley has proven so pivotal in the history of our country it was declared a National Heritage Area by the United States Congress in 1996. They described it as "the landscape that defined America."

The majestic Hudson River runs 315 miles from the Adirondack Mountains to Manhattan; its wild and scenic valley comprises some 400 million acres. Marked by steep cliffs and craggy bluffs, the dramatic land-scape is bound by the Taconic and Berkshire Mountains to the east and the Catskill and Shawangunk Mountains to the west. The pastoral valley is defined in turns by rolling meadows and dense woodlands; sparkling streams run through a farmland rich with nature's bounty.

From New York City to Albany, small picturesque towns dot the river. Dairy farms, roadside produce stands, and dirt roads define the landscape. To visit the Hudson Valley—or, if you are lucky enough to live here—is to enjoy the valley's pick-your-own fruit stands, riding stables, and hiking trails, and to visit the area's numerous historical landmarks and cultural institutions.

The story of life on the Hudson is closely tied to the river itself and the fertile soil along its banks. British explorer Henry Hudson happened upon the river in 1609 when he was seeking a passage to China as he sailed along America's North Atlantic Coast. In his sea log, Hudson remarked on the local Algonquin tribes, who built canoes out of single large trees, planted fields of corn and pumpkin, and survived through hunting and fishing.

Drawn by the valley's lush farmlands, European colonists arrived from the Netherlands, England, France, and Germany throughout the seventeenth and eighteenth centuries. They built tidy houses of brick, stone, and wood and established thriving farm communities. With the coming of the railroad in the mid-1800s, small villages and towns sprang up along the river, bringing a new crop of inhabitants to the region.

This bucolic swath of countryside came to symbolize America's natural beauty, an ideal epitomized by the Hudson River's unspoiled land-scape. In the nineteenth century, the area drew artists such as Thomas Cole, who arrived on the scene in 1825 and eventually developed the Hudson River School of Painting, the country's first homegrown school of art. The valley's vast expanse of untouched wilderness seemed to symbolize America's potential for greatness, and the artists romanticized this ideal in their landscapes. Paintings of serene, open vistas illuminated by glowing sunlight gave the river—and America—an iconic status that resonated nationwide.

By the nineteenth century, the Hudson River Valley became an alluring refuge from city life. Weekenders from New York City and beyond sought—and continue to quest for—clean air and spectacular scenery. When the industrial revolu-tion saw the rise of the American millionaire, many so-called captains of industry—J. D. Rockefeller, Jay Gould, and Frederick Vanderbilt among them—craved an escape from New York City and built lavish country mansions along the Hudson. In fact, so many grand estates were constructed along the Hudson that the area became known as "Millionaires' Row."

Today, weekenders and full-time residents continue to find a peaceful, relaxed lifestyle in the Hudson Valley, one that is still tied to nature and the simple pleasures of domestic life. To live here is to breathe fresh air, to commune with the outdoors, and to be attuned with the seasons. Locals surround themselves in nature, be it in a creek-side cottage where the sound of water overtakes conversation, in a converted barn amidst a meadow blanketed in wildflowers, or nestled in a farmhouse near a wooded grove.

Along the banks of the Hudson, life is slower: those who live here shop at local farm stands rather than rush through supermarket aisles. They prepare

ABOVE: Throughout the Hudson Valley, old barns dot the pastoral landscape.

OPPOSITE: The sun sets over the Hudson River.

wonderful meals for friends to be enjoyed outdoors or by the hearth. They sip lemonade on the porch, watching birds frolic in the trees. They take long walks, spend time gardening, and watch the natural world unfold from their windows. Here, the senses are engaged: one can't help but notice the smell of summer rain, the rustle of autumn leaves, the pervasive quiet of a snowy winter night.

Recently a renewed appreciation for the valley's landscape and historic treasures has signaled a renaissance. Towns like Beacon and Hudson, where preservation efforts are transforming whole communities, are leading the way toward a cultural rebirth. Two years ago, the largest contemporary art museum in the world, Dia: Beacon, opened its doors, symbolizing a renewed creative spirit in the Hudson Valley.

The rebirth of the Hudson Valley is nowhere more evident than in the domestic life along the river. In recent years, prominent architects, designers, artists, and preservationists have been once again seduced by the breathtaking landscape and quieter way of life. Many have put down stakes, building—or reclaiming—houses of great significance and style. From farmhouses to townhouses, from old barns to modern masterpieces, houses in the Hudson Valley today are an enduring symbol of America's natural beauty and creative spirit—not to mention great style. This book is a tribute to a once forgotten but now recovered way of life, a celebration of a great American landscape and the singular existence enjoyed there.

The town of Hudson, New York, is among the most alluring along the river.

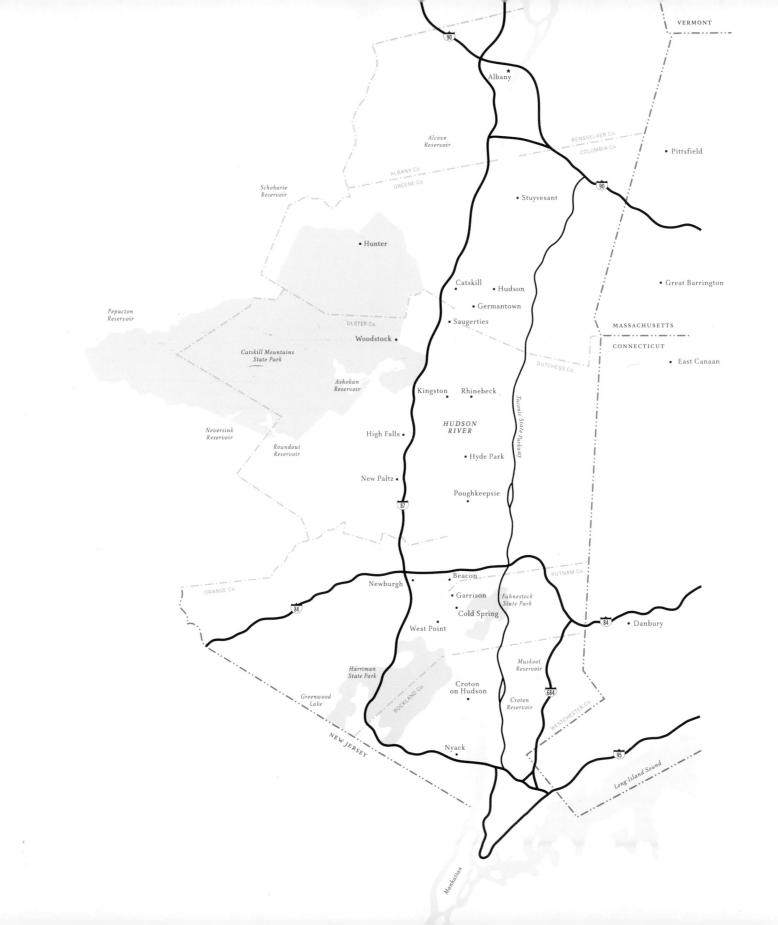

SHEDDING LIGHT

AMELIE RENNOLDS

Although she grew up in Virginia, the Hudson Valley has always been a home away from home for Amelie Rennolds. As a girl, she visited her grandmother's farm here every summer, spending two to three weeks at the one-hundred-acre site in Dutchess County.

When the opportunity arose to buy fifty acres across the road from where her grandmother once lived, Rennolds, an architect, and her two sisters jumped at the chance. "I have always had a real connection with the place," she says. The site, a secluded rocky knoll with a view of the Hudson River highlands, has long mesmerized Rennolds; she had been visiting the site, having picnics there, and showing it to friends for years.

When she finally bought the property five years ago, it was with an intimate knowledge of the place. Over time, she and her partner, Frits Drescher, began clearing the land, shaping views, and designing the house.

Rennolds wanted a simple structure that would mimic the rectangular layout of the site, take advantage of the views, and not overwhelm the plot with a boxy shape. For inspiration, she looked to structures she admired, from the garden pavilions she'd visited in Japan to the rustic, weathered barns that dot the Hudson Valley.

Primarily wood and glass, the home, Rennolds says, is a modern shed. "I liked the idea of doing a house that is very straightforward," she notes. Natural materials were a must in building her home. Clad in red cedar with teak doors and window frames, the structure radiates a warm, rich tone that in autumn matches the fiery glow of foliage outside. Inside, the natural palette is continued, with fir and concrete flooring. An open staircase of reconditioned pine joins the living area downstairs with the bedrooms above.

Privacy was also key. A gravel footpath places the house far off the road; the entrance to the house is reached via a wooden footbridge. Surrounded by cherry, oak, and locust trees, the house seems to nestle into the knoll.

With so many windows, Rennolds's home takes in a 180-degree view that reveals an ever-changing display of nature. "The mist in the valley is different each morning, as are the sunsets every evening," she says. "Each window offers a different visual experience: treetops, fields, faraway hills, and clouds."

Rennolds, who also maintains an apartment in Manhattan, now spends at least half her time at her house in the Hudson Valley. This life change has opened her world up to nature and to other things as well. "After living in a crowded noisy city, having so much space and light has a very positive effect on my sense of well-being," she notes. "I can spend all day here and never feel cooped up. Here I wake up with the sun and am much more energetic in the morning."

Country life has brought newfound pleasures. One of them is a deluxe bathroom with a deep tub and eight-foot-wide sliding glass doors that look out onto the mountains. Inspired by wooden soaking tubs in Japan, the bath surround is teak, a naturally water-resistant wood. The floor features handmade Arts and Crafts tile. "For me the greatest luxury is a separate shower and bathtub. The former is for every day, the later for special occasions," Rennolds explains.

A sense of light and space pervades the house, from the copious windows to the classically modern furnishings. "I prefer furniture that is light and airy with very sculptural forms," she says. "The first pieces I bought were twentieth-century classics like Alvar Aalto's blonde-wood Pension chair, whose framework is curving and linear."

Having space to entertain is also a boon for the architect. "I had been acquiring furniture, linens, and dishes for the house for years, so it was wonderful to be able to use them," she says. "A highlight was having eighteen for Easter dinner last year and using the family china."

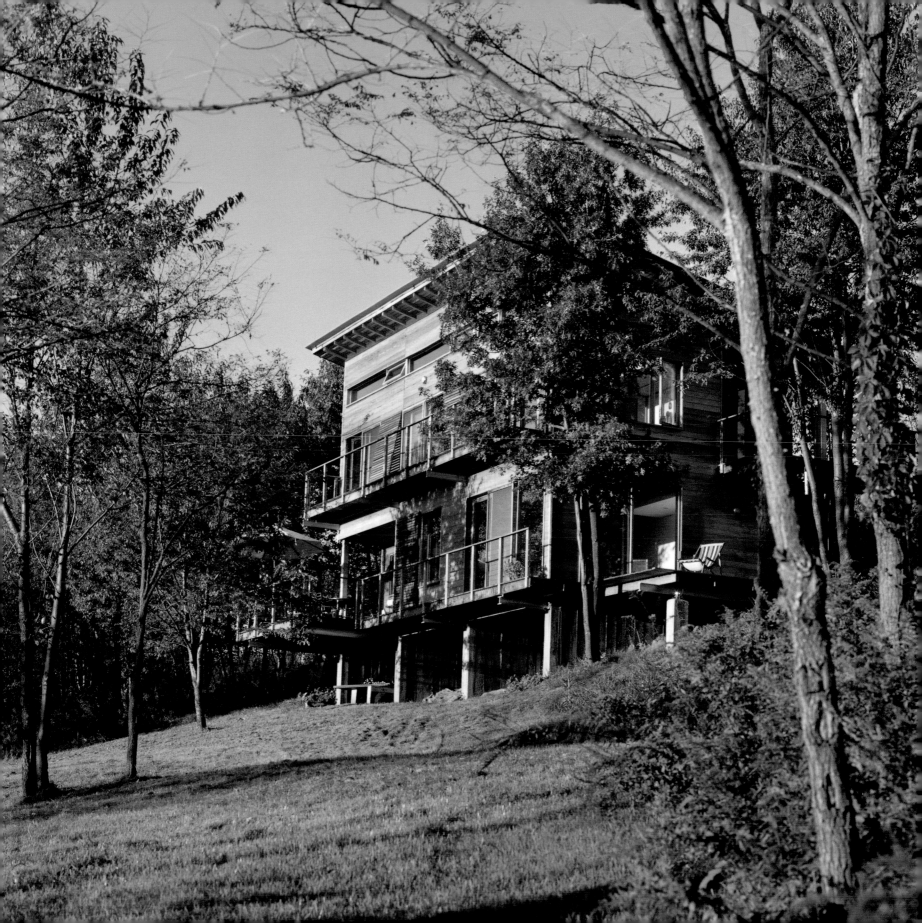

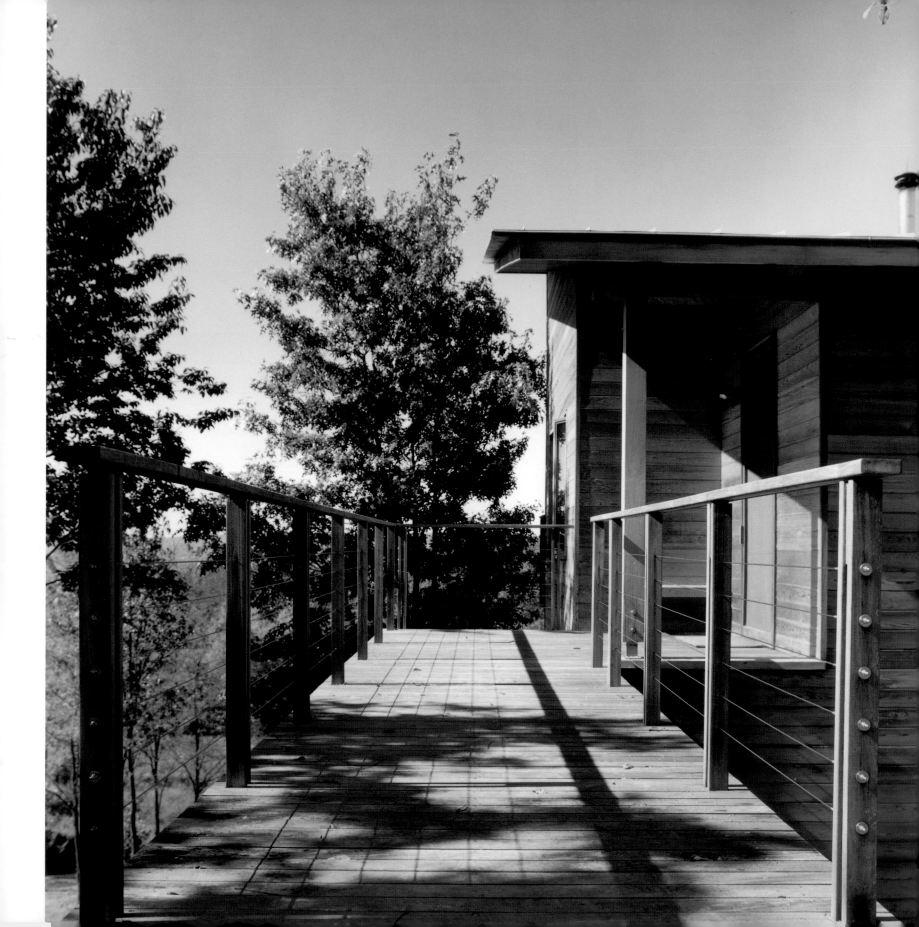

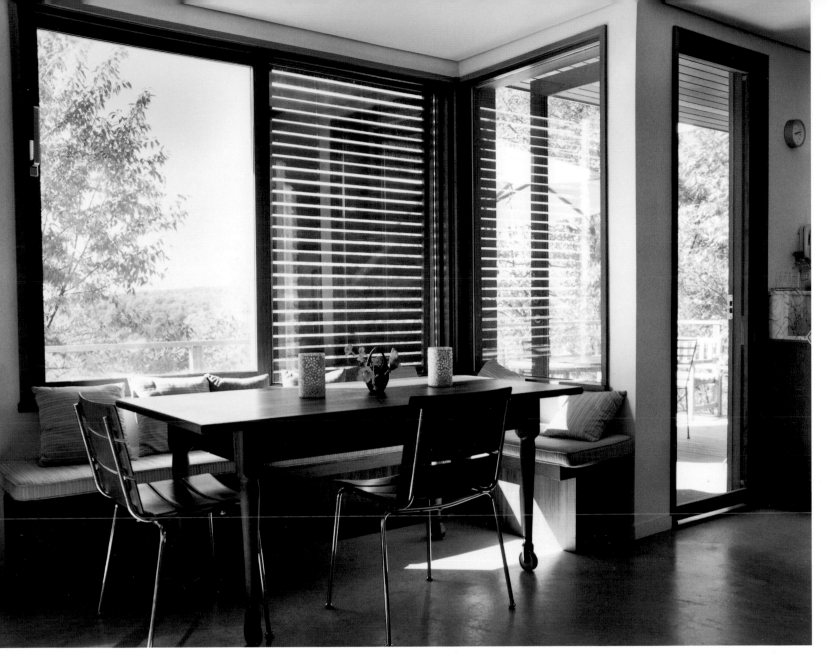

To take advantage of views, Rennolds designed a dining area with built in benches. Warm wood tones brightened by sunlight combine to make the area especially inviting.

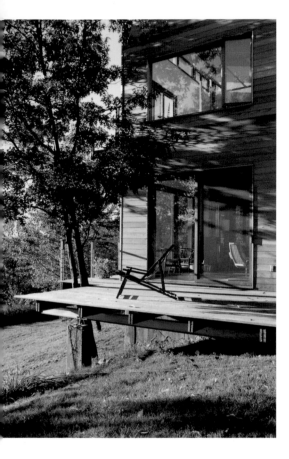

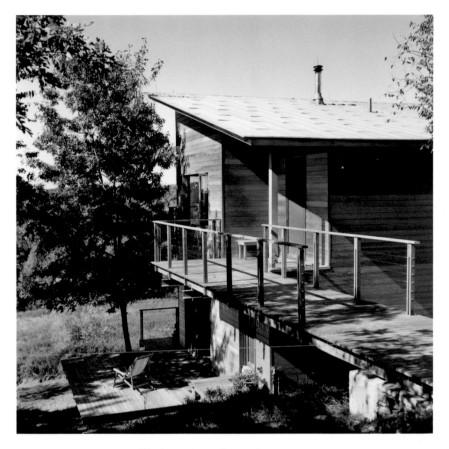

THIS PAGE AND OPPOSITE: The house is cantilevered over a hillside to preserve the integrity of the original site and afford maximum views of the Hudson Highlands. Generous deck space and sliding glass doors provide a seamless integration between indoors and out.

OPPOSITE: Access to the house is via a wooden footbridge, which emphasizes the secluded nature of this modern shed.

THIS PAGE: In keeping with the handcrafted feel of the house, an open staircase of repurposed pine and stainless steel joins the bedrooms upstairs to the main living room below, where sunlight floods the open space.

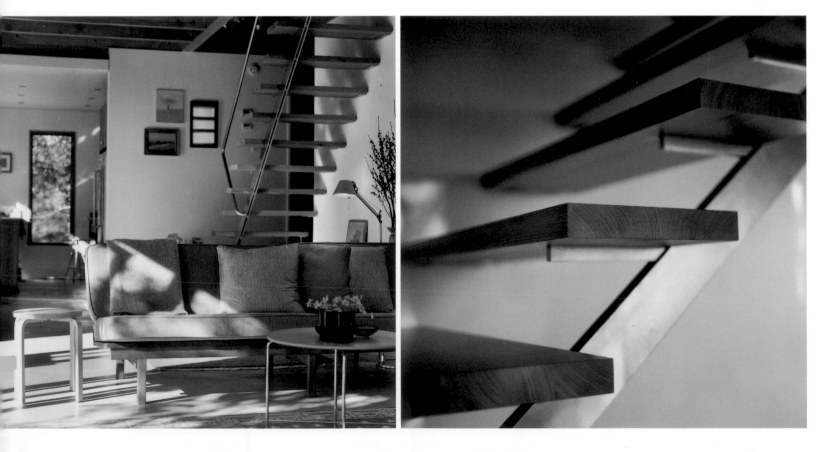

THIS PAGE: Rennolds used copious wood throughout the house. The master bath includes a sunken teak tub with floor to ceiling windows; the downstairs bath has an oversized wood sink.

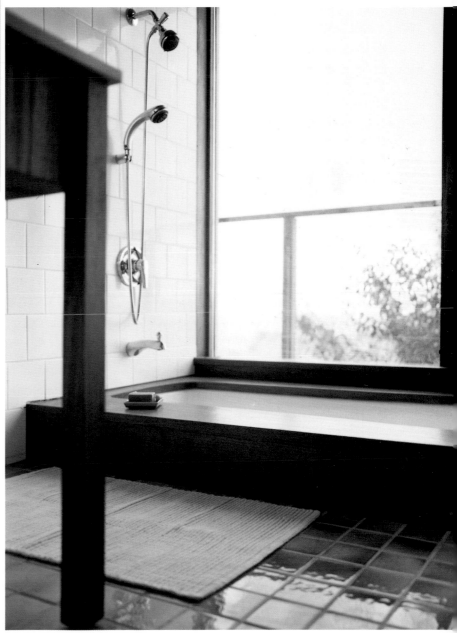

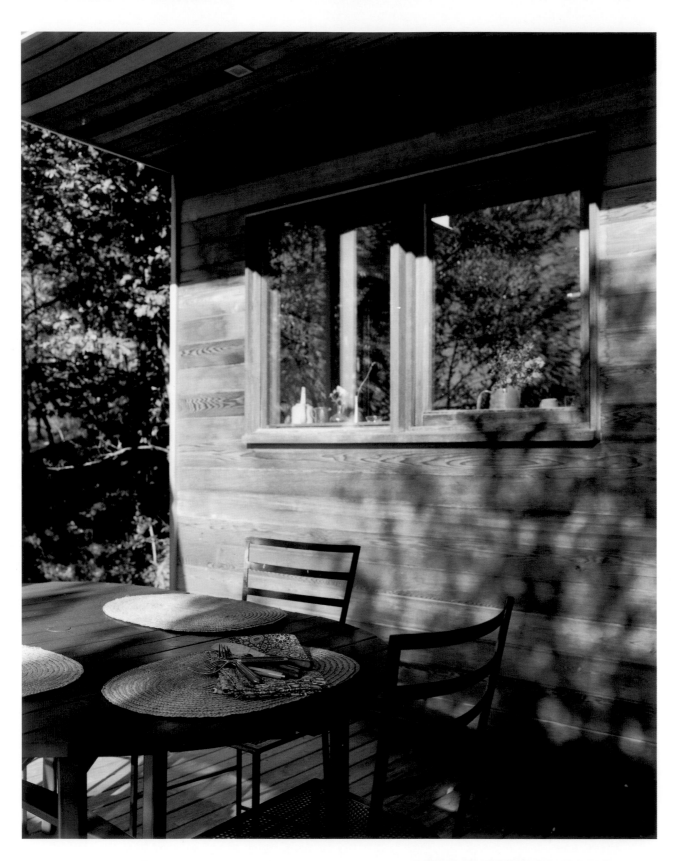

AT HOME IN THE HUDSON VALLEY RENNOLDS HOUSE

OPPOSITE: Autumn light sets the deck aglow,
an ideal spot for dining outdoors.

THIS PAGE: Handmade vases in tones of sea and
sky provide colorful touches in the house.

TRAILER LIVING

DAVID DIAO AND MAUREEN CONNOR

Ten years ago, David Diao, a conceptual painter and an aficionado of modern architecture, was walking down Park Avenue when he ran into a friend. Word had it there was a Marcel Breuer house for sale in Salt Point, New York. "I wasn't looking to buy a country house," Diao remembers. "I'm basically a city person. But the idea of owning a Breuer was infinitely interesting to me."

When Diao saw the house, he says, "I was a little disappointed because it was quite run-down." Nonetheless, he and his wife, sculptor Maureen Connor, bought it—defects and all. "I knew it would be a lot of work, but I also knew it was a great opportunity." The purchase, he says, "was a total fluke."

It would take a good deal more than a picturesque idyll in the country to wrest the urban couple, who maintain two lofts in Tribeca, from Manhattan, even for weekend respites. But this was no ordinary house: it had the stamp of one of the greatest twentieth-century architects, and is probably the only structure in America built around a Spartan trailer. In the words of Le Corbusier, Breuer's mentor, it is truly a "machine for living."

The house's original owner was the true visionary. Just after World War II, artist Sidney Wolfson bought fifteen acres of farmland in the Hudson Valley, where he parked his Spartan trailer. A few years later, he persuaded Breuer to design a house to complement the vehicle. The architect created a floating box of a house propped up on a fieldstone-block foundation. He clad the walls in tongue-and-groove cypress and built a central fireplace of rough native stone. Sliding glass walls open onto a recessed balcony and a thicket of pine trees.

A decade later, Wolfson had a larger studio built a hundred yards away to complement—but not compete with—the original building. Artist Tip Dorsel built the structure to which Diao added a metal cladding. It includes a large studio, two bedrooms, a living room, and a kitchen.

Diao undertook extensive renovations to bring the Breuer building back to its original luster. The process was a natural one for the artist, who has renovated several lofts in downtown Manhattan over the years. "I have always been involved in design and interiors and in bringing back places that have seen better days," he explains. "I was keen on trying to preserve its integrity without doing anything egregiously new, so I redid the outside envelope, restoring the cypress siding and rubber roof."

Today, a long winding drive leads to the compound, situated quite a ways off the road. Thick woods have grown in around the houses since they were built. Behind the buildings, a footpath leads down to Wappingers Creek, where Diao and Connor go boating and swimming in the summer.

As modern as they are, the low-slung structures sit lightly on the land; both are built on a human scale and of modest proportions. Furnishings in the Breuer house are comfortable, sparse, and of the period. A Knoll sofa and Isokon long chair built by the architect fit nicely around the stone fireplace; a sleeping nook, dining area, and bathroom complete the generous one-room space. Diao and Connor use the trailer, which features original plywood paneling and a recently updated stainless-steel kitchen, for cooking and to house guests. A screened porch off the trailer is a peaceful spot for relaxing in summer.

The studio, which features thirteen-foot ceilings and an entire wall of glass looking out onto the woods, is an ideal place to paint, Diao says. "I love working in the studio. I get affected by the country; sometimes I use different colors here than when I'm working in the city. I love blasting music and the sheer pleasure of doing whatever I want."

The couple enjoys the play between both houses. "We feel we are the luckiest people because we get to look upon and admire the Breuer building from the other house," Diao reports. "We like the fact that we stay in the house and use the studio for big parties. Sometimes we have breakfast in the trailer and then cook dinner in the studio. There are many possibilities."

Having preserved Breuer's original structure for posterity, Diao feels it may be time to move on. At some point, he plans to build his own place, and he envisions these structures as a potential place of study for art and architecture students. "In the beginning, I was overwhelmed at the idea of living in a house built by one of the most important architects of the twentieth century," he confesses. "Nine years later I'm still thrilled by it. I do believe that if we hadn't come along it would have been torn down, as many Breuer houses have been. In one sense, I feel we saved the house."

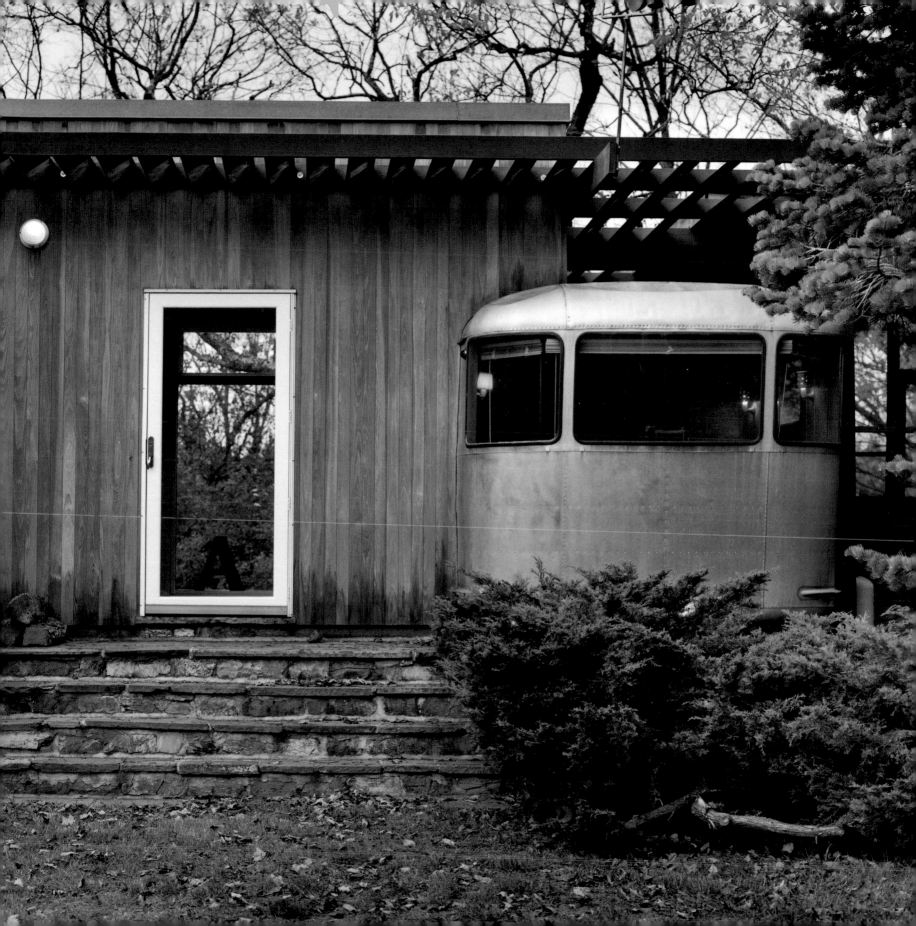

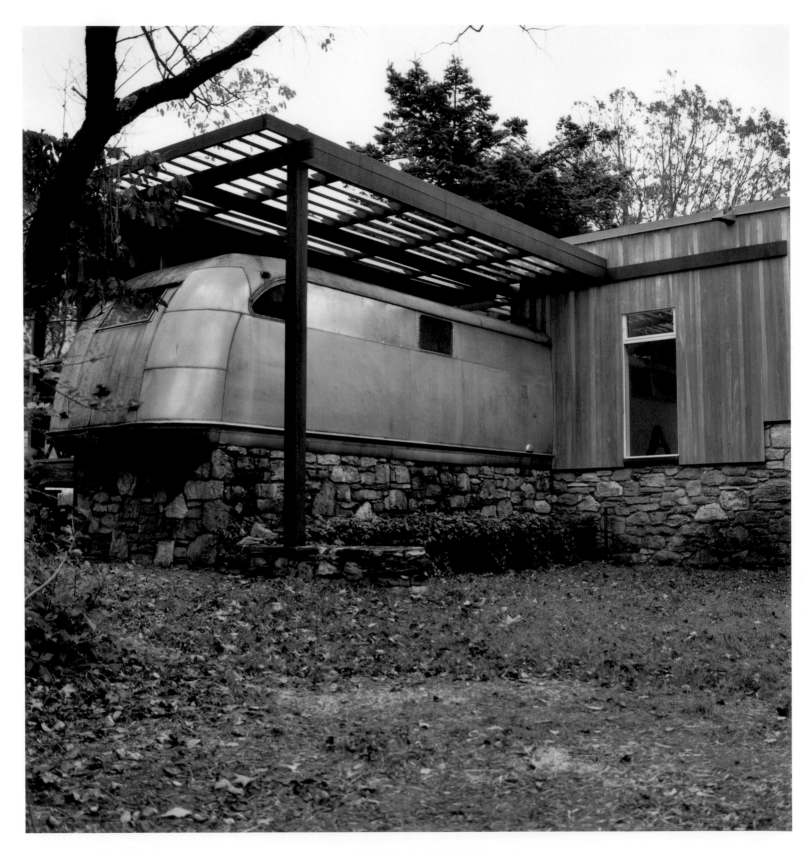

AT HOME IN THE HUDSON VALLEY DIAO/CONNOR HOUSE

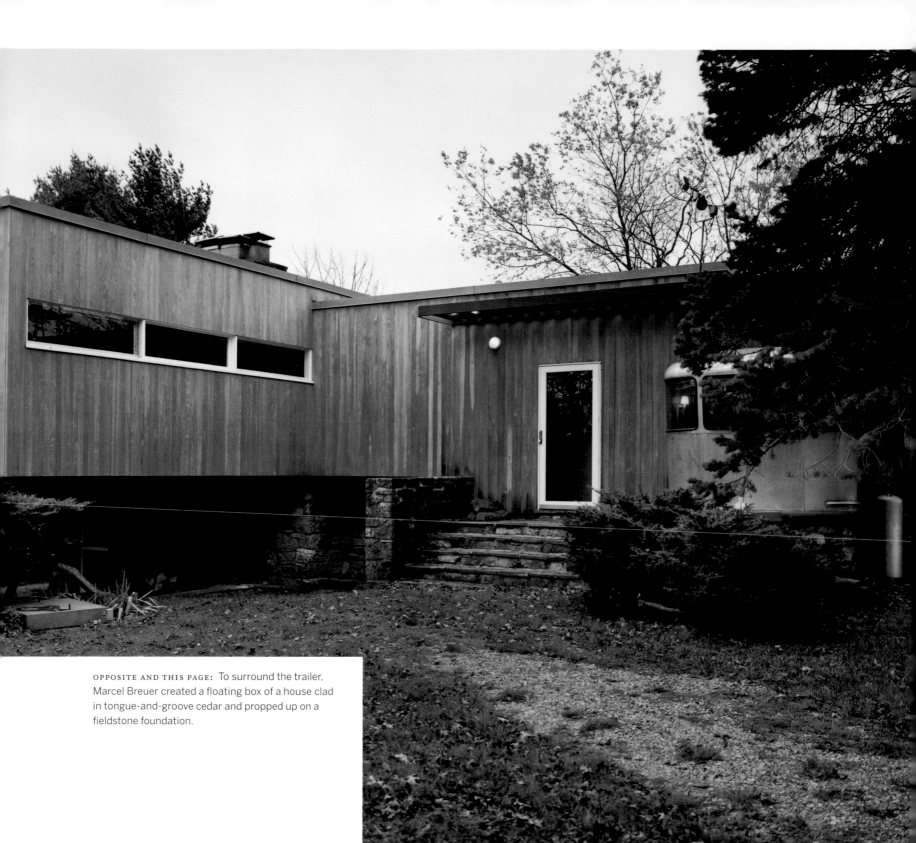

OPPOSITE AND THIS PAGE: To surround the trailer, Marcel Breuer created a floating box of a house clad in tongue-and-groove cedar and propped up on a fieldstone foundation.

23

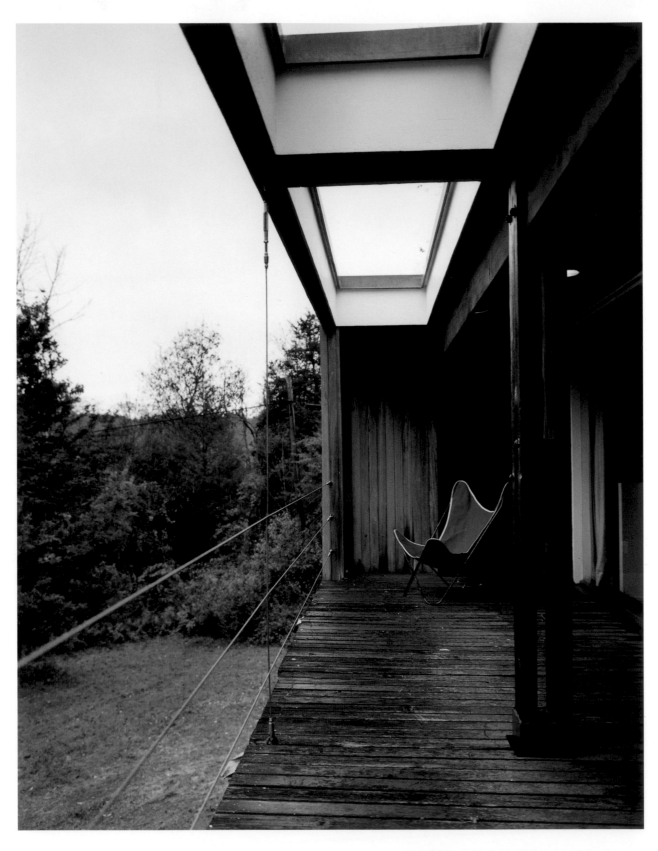

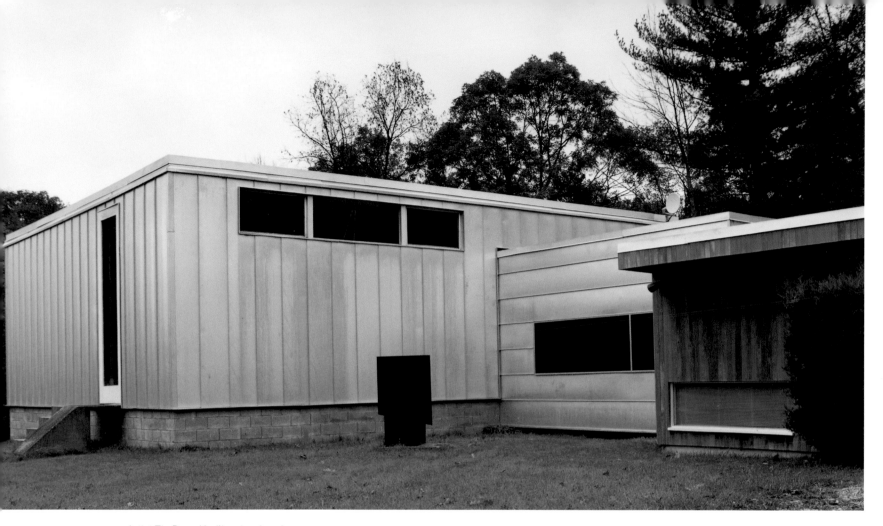

ABOVE: Artist Tip Dorsel built a structure to
complement the Breuer house, to which
Diao later added metal cladding. Both designs
feature a boxy profile and juxtapose metal
with wood.

OPPOSITE: A recessed, skylit deck joins the house
to the wooded grove beyond via floor-to-ceiling,
sliding glass doors.

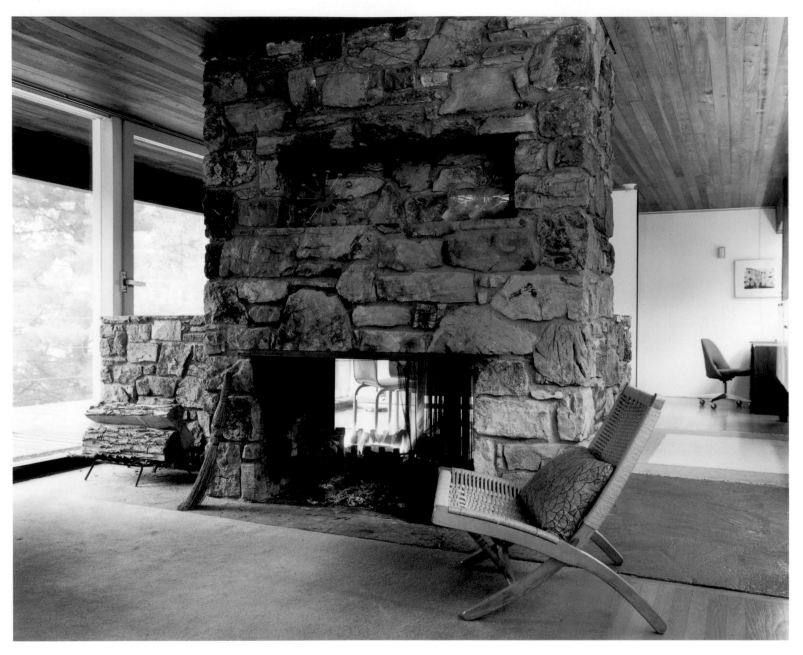

Breuer's one-room living plan utilizes a two-sided fireplace to divide the living room from the dining area. Ceilings of cypress wood add richness to the open space.

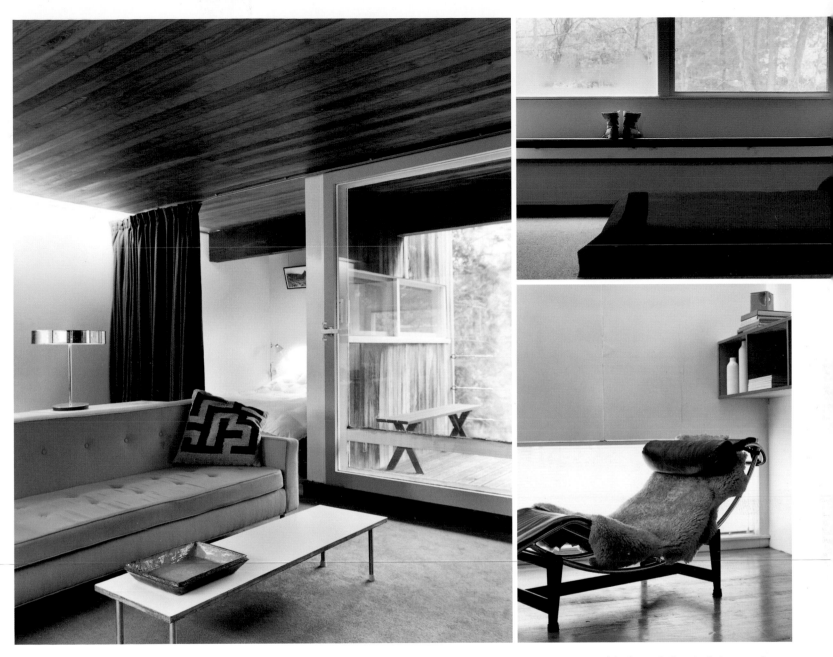

The house is simply furnished with mid-century pieces. Behind the living room is a small sleeping nook. Floor-to-ceiling windows provide ample light throughout.

TOP AND BOTTOM: A bedroom in the studio is sparsely furnished; a classic Le Corbusier lounge chair anchors the studio living room.

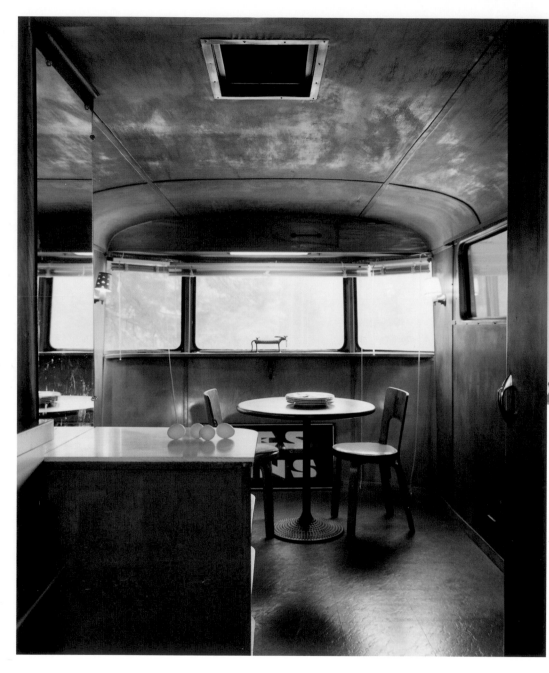

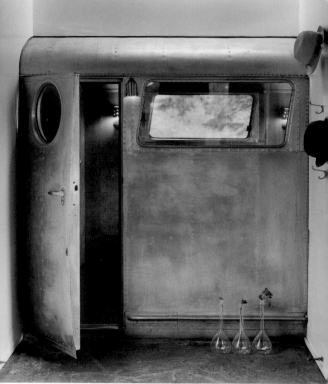

THIS PAGE AND OPPOSITE: The Spartan trailer, built in the 1940s, features plywood paneling that has since been restored. Diao installed an updated stainless-steel kitchen complete with stove and dishwasher. The original wall lights give the interior a warm amber glow.

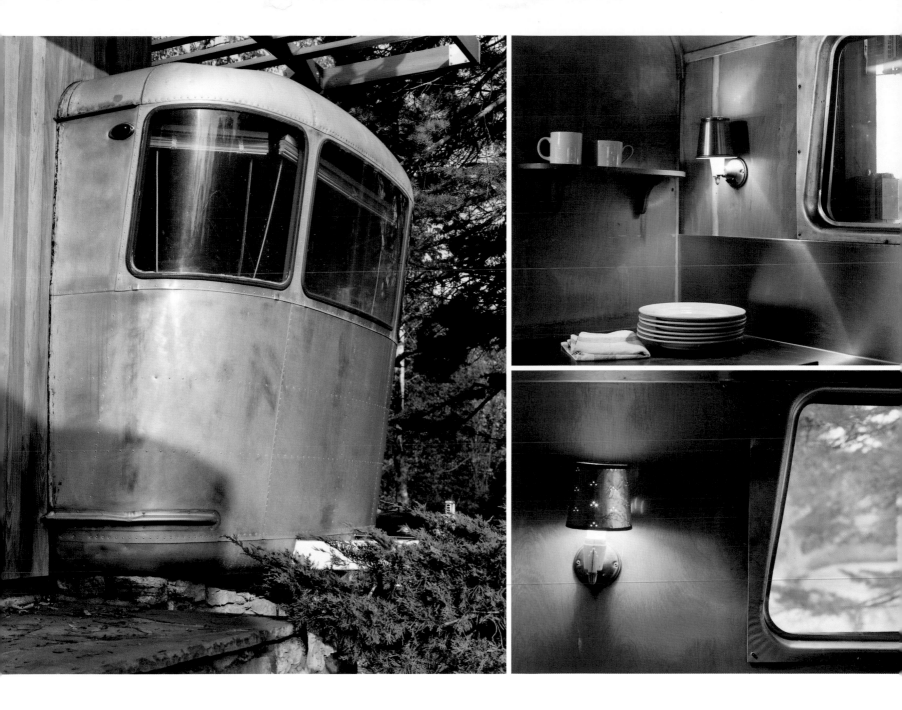

HOUSE 3
BAROQUE VISIONS
VINCE MULFORD

For many New Yorkers, a move to the Hudson Valley signals an escape from city stress and a desire for a quieter life—even if just for the weekend. But for antiques dealer Vince Mulford, setting up shop in Hudson, New York, had an energizing effect. He spent a quarter century in rural Malden Bridge, New York, before turning up in what he considers the big city. "This is my Manhattan," Mulford declares of the bustling river town, now chockablock with trendy stores and restaurants. "Growing up we didn't have neighbors. It blew my mind that you could walk across the street and get a cup of coffee. It's wonderful to live in this kind of community."

Ensconced within the preserved string of town houses on busy Warren Street, Hudson's main drag, Mulford's home and shop are in a 1760 brick building that was once a private home; a century later it was pressed into service as a department store. By the time Mulford took ownership six years ago, the building had fallen into major disrepair. "The place was a hovel," he remembers.

But Mulford, who loves all things old, didn't want to erase the building's past. Its history, faded and moldering as it was, appealed to him immensely. While some new home owners might sandblast and whitewash their way through the renovation process, Mulford treaded lightly. In the living room, he removed from the walls layers of fabric from the 1930s. Underneath, the plaster had been tinted by the material; rather than paint over it, Mulford left the color in place, leaving a faintly frescoed look on the walls.

The rooms in Mulford's home are more poetic than practical. Lighting, provided by tiny table lamps, delicate wall sconces, and multiple candles, is low and atmospheric. Floorboards are loose and creaky. The vibe is a thoroughly original mix of Parisian atelier, New Orleans bordello, and forgotten American farmhouse. Deep red furnishings mingle with gilded, waxy candelabras; crumbling brick walls are juxtaposed against wide-plank flooring; walls are unfinished or sheathed in antique tapestries.

Mulford uses the capacious ground floor for his store, Vincent Mulford Antiques, where his oversized displays are among the most dramatic in town. Above the store is a ballroom that features original pressed-tin paneling covering the walls and the ceiling. A ten-foot-long, solid wood bar, a disco ball, and mirrored sconces provide just the sort of eccentric atmosphere Mulford relishes; he holds community parties here several times a year.

Twelve rooms make up Mulford's living space; each is as atmospheric and unexpected as the next. In the kitchen, where Mulford rarely cooks but his two house cats take regular meals, a refrigerator and stove from the 1930s stand gracefully on slender enameled legs. An old freestanding stone sink is adorned with original brass fittings; industrial-era lamps salvaged from gas stations light a collection of antique silver trays. "I like the '20s and '30s era for kitchen and baths," the antiques dealer explains. "I prefer to think of kitchens as rooms of furniture rather than just a place with cupboards everywhere."

Mulford favors neither form nor function; rather, he is compelled by surface. He prefers rough over smooth, imperfect over polished, and the older and more tactile, the better. "I love old surfaces. They tell the history of a place. I once found an antique console covered in gesso and gold. It had been singed in a fire and it was just brilliant."

Each room serves a distinct purpose: off the kitchen, guests gather in the sitting room, which is marked by an antique bar. Two decorative fireplaces and a globe-shaped lantern adorn the television room; cutouts of wood painted like palm trees make the dining room festive. Upstairs, there is a study with an antique scroll desk for paying bills and a tiny office for computer work. A canopy bed and French windows lend flourishes to the master bedroom. A small sitting room is designated for napping and reading.

As Mulford explains it, there is no rhyme or reason to his style—except perhaps to celebrate faded grandeur. "I buy things that jump out and talk to me," he says. "I like things that look as though they might have come out of a grand home. All my things have a personality of their own."

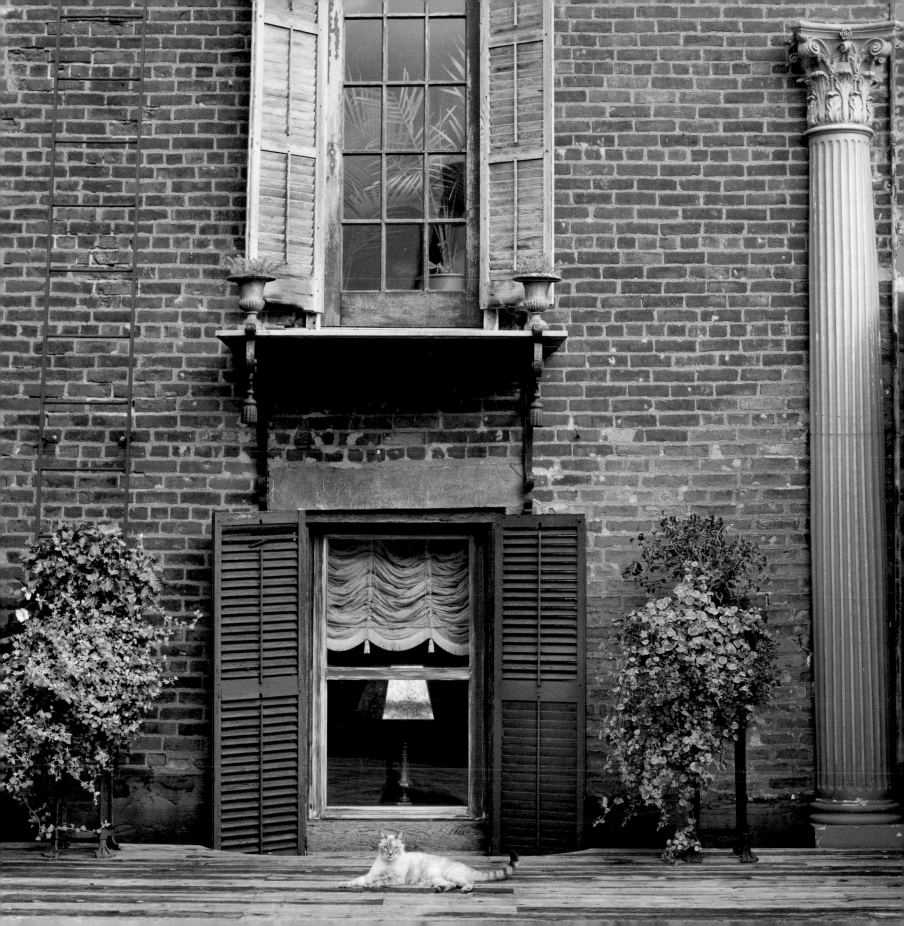

THIS PAGE: Wrought-iron furnishings and a replica of the Eiffel Tower suggest a Paris-meets–New Orleans theme on Vince Mulford's outdoor deck.

OPPOSITE: A ballroom paneled entirely in pressed tin is a vestige of the Victorian era; cranberry-colored curtains and candle-and-mirror scones add drama to the room.

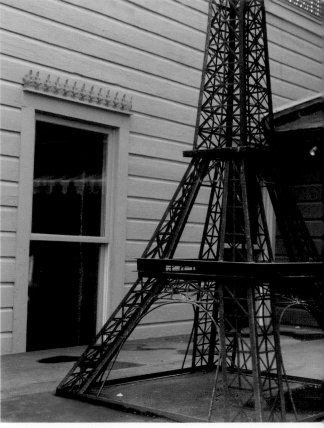

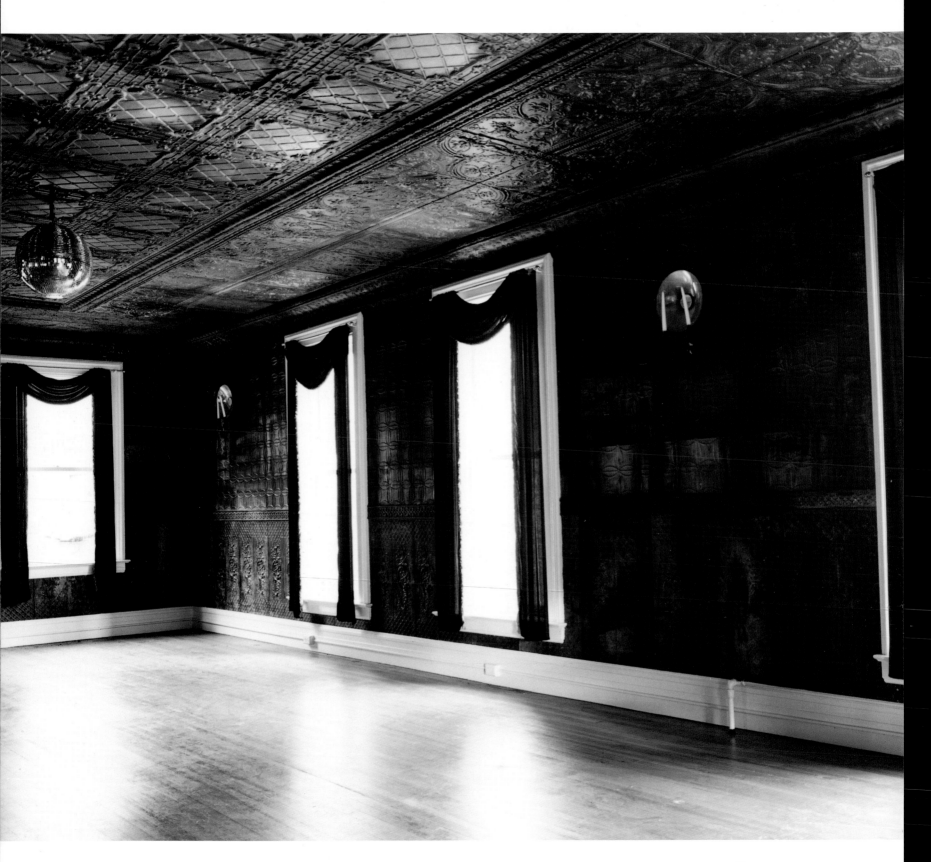

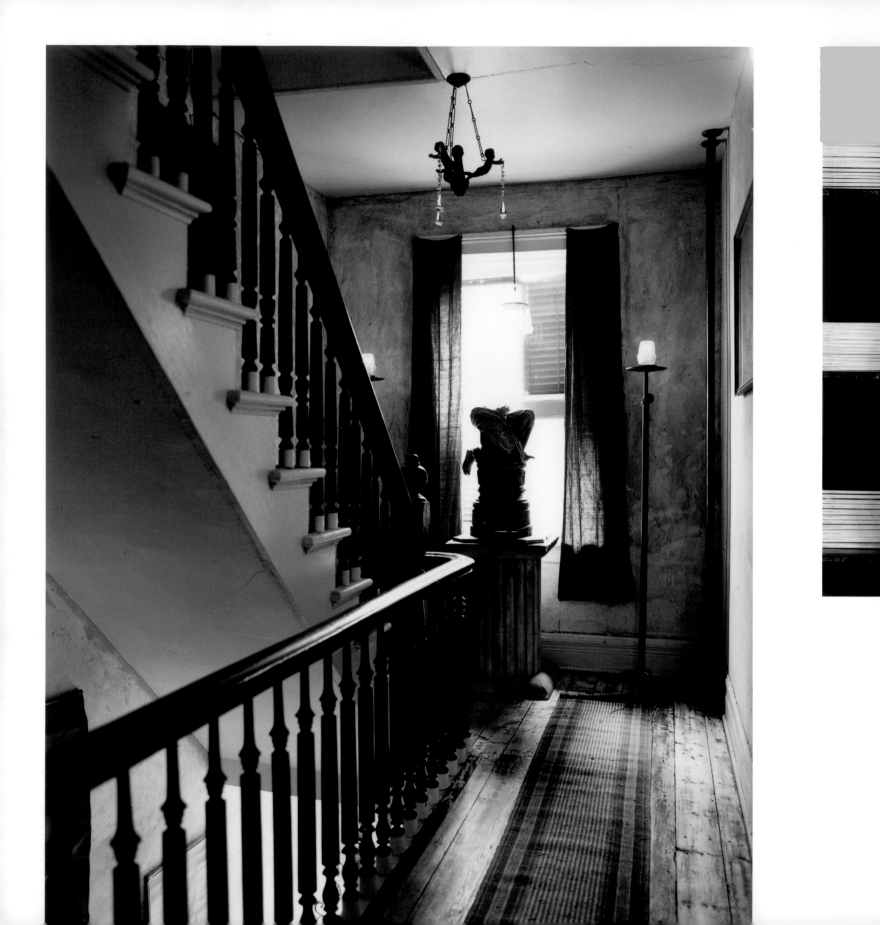

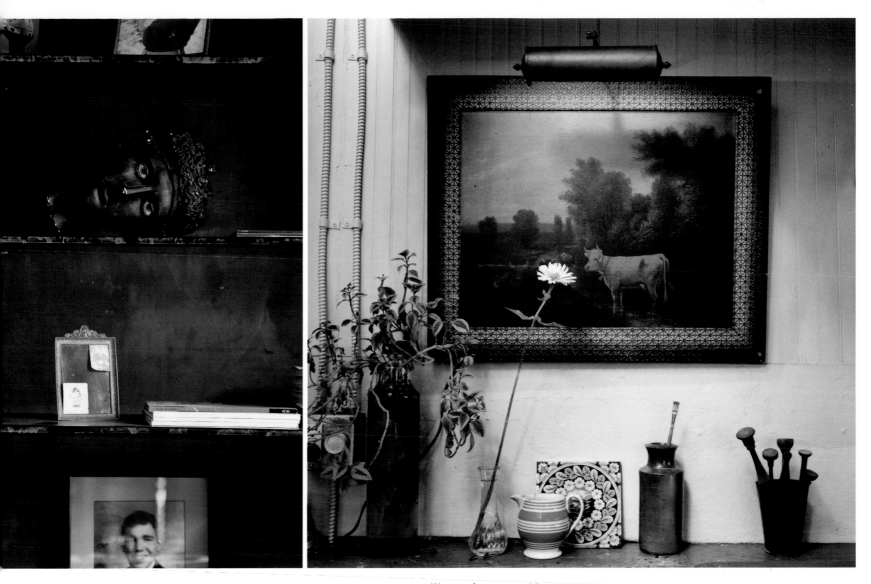

OPPOSITE AND THIS PAGE: Worn surfaces, eccentric artifacts, and dramatic touches create a rich, multilayered interior. Tall candlesticks and a delicate chandelier light up a moody hallway; old wood floors are juxtaposed with rough, unfinished walls. Mulford's computer room is defined by a deep red wall and display shelves. A vintage oil painting in the kitchen adds character to an already eccentric room.

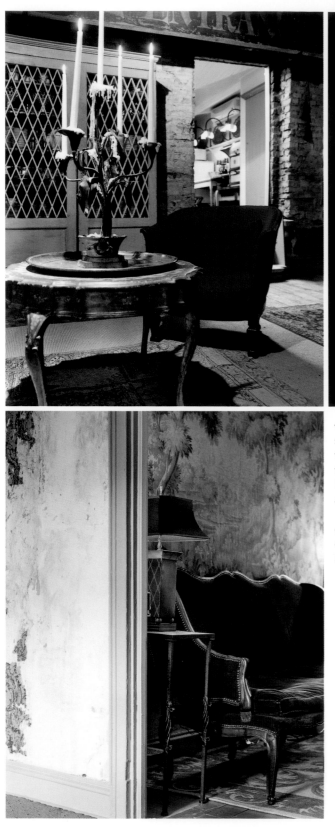

THIS PAGE: Living spaces in Mulford's home are a study in texture and patina. Clockwise from top left: the sitting room features an original brick wall and wood floors; a globe light fashioned from animal hide illuminates an atmospheric room; an antique tapestry adorns a wall upstairs.

OPPOSITE: 1930s-era appliances in the kitchen are set off by an old-wood worktable, silver platters on display, and enamel lights salvaged from old gas stations.

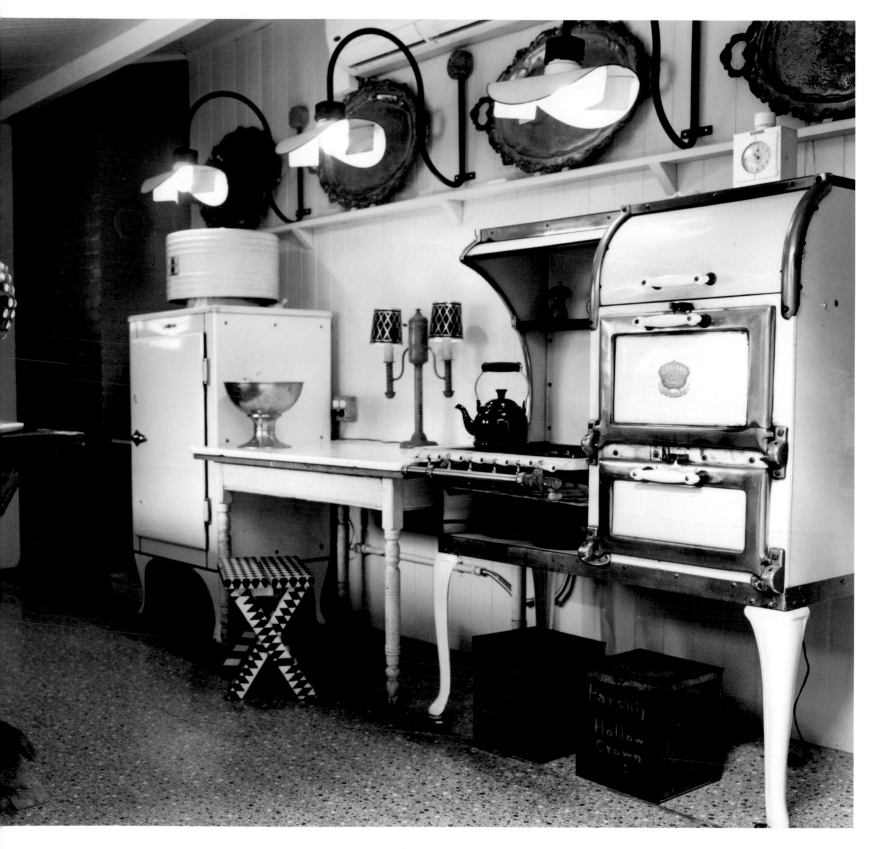

SHAKER SIMPLICITY

DENNIS WEDLICK AND CURT DEVITO

Sometimes scale works in reverse: the smaller the house, the bigger the impact. This is certainly true for architect Dennis Wedlick's eight-hundred-square foot cottage on eleven acres of rolling countryside in Columbia County.

Set in an open meadow and surrounded by lush woods, the house looks like something out of a storybook. The steeply pitched roof, pierced dormer, and prow-shaped front provide whimsical touches that give the house a playful feel. The design is practical, too, with plenty of living space cleverly configured into the two-story structure. The cedar-clad cottage is compact and cozy, with two bedrooms and a sleeping loft upstairs, a versatile living-dining area, and small kitchen downstairs. To save space, the architect joined the two levels with a spiral staircase.

Building on a small scale was just the point for Wedlick and his partner, Curt DeVito, who bought the land together in 1989, when, for both of them, money was scarce. Both were drawn to the rural nature and simple life afforded by the area. "We liked that we were close enough to the river to get that great quality of light," Wedlick recalls.

The couple built a compact structure using affordable materials, but they splurged on light and views, which makes the house seem larger than it is and provides an almost seamless connection to the outdoors. Four floor-to-ceiling windows on two walls seem to extend the small living room out into the landscape for an airy, indoor-outdoor feel. "We think of the view of the countryside as the decoration for the interior," Wedlick says.

Wedlick was inspired by the straightforward aesthetic of Shaker design, at once pretty and practical. "The Shakers were modernists, and they were great craftspeople," he says. To bring that sensibility home, the architect used honey-colored pine for the flooring, trim, and sections of paneling. Every room is flooded with natural light, and there are hand-crafted wood furnishings throughout the house.

Wedlick and DeVito recently built a modern barn next to the cottage, designed exclusively for entertaining. The twenty-by-twenty-five-foot timber structure has a capacious living area and kitchen; the space is anchored by a long trestle table and has comfortable wicker furnishings and wide-open views of the landscape. On all four sides, oversized garage-style doors slide open to create the effect of a large screened-in porch. "It's a seasonal building, and we use it only in the summer," the architect points out. "We close the barn down every winter, which brings some ceremony to the property."

Great entertainers, Wedlick and DeVito enjoy the laid-back social life of the Hudson Valley. "We don't really go out to dinner. We do lots of pot-lucks," the architect says. The low density of Columbia County and the fact that it is a working community rather than a resort town make it especially appealing to the couple. "There are no villages that have chichi restaurants, and no mountains to ski on. Here, everybody gardens, and nurseries are the most popular place to bump into people—it's incredibly unpretentious. This place is romantic, but not artificial."

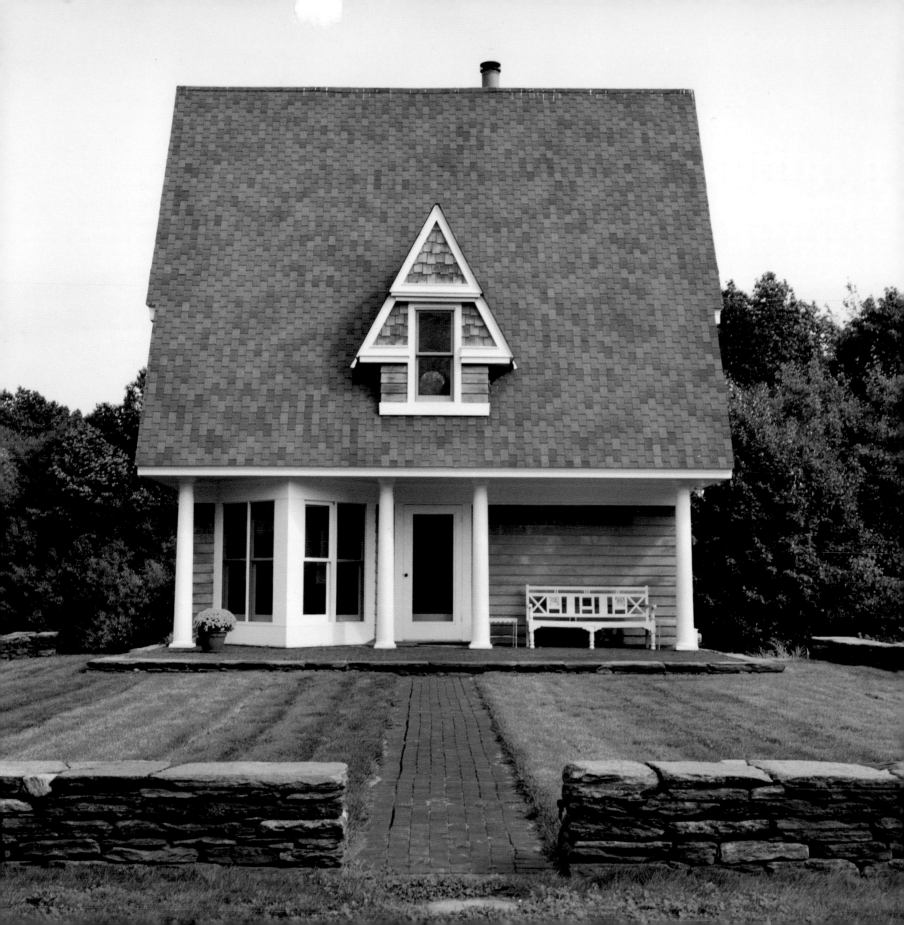

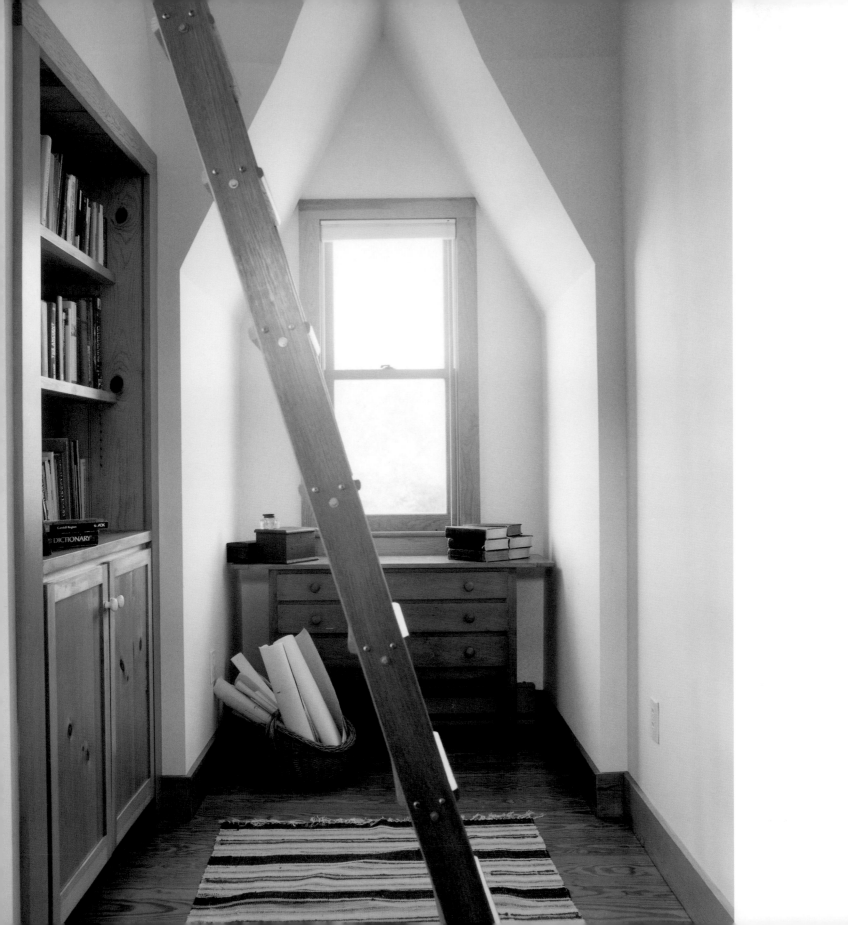

OPPOSITE: Shaker touches figure throughout Wedlick and Devito's home. A pierced dormer upstairs gives the house a fairy-tale look; a rolling ladder leads to a sleeping loft.

THIS PAGE: The guestroom is simply furnished with a writing desk and chair; the dining room at dusk shows off the bucolic view beyond; the stone wall, which uses flat stones instead of the usual round ones, is a twist on the traditional New England version.

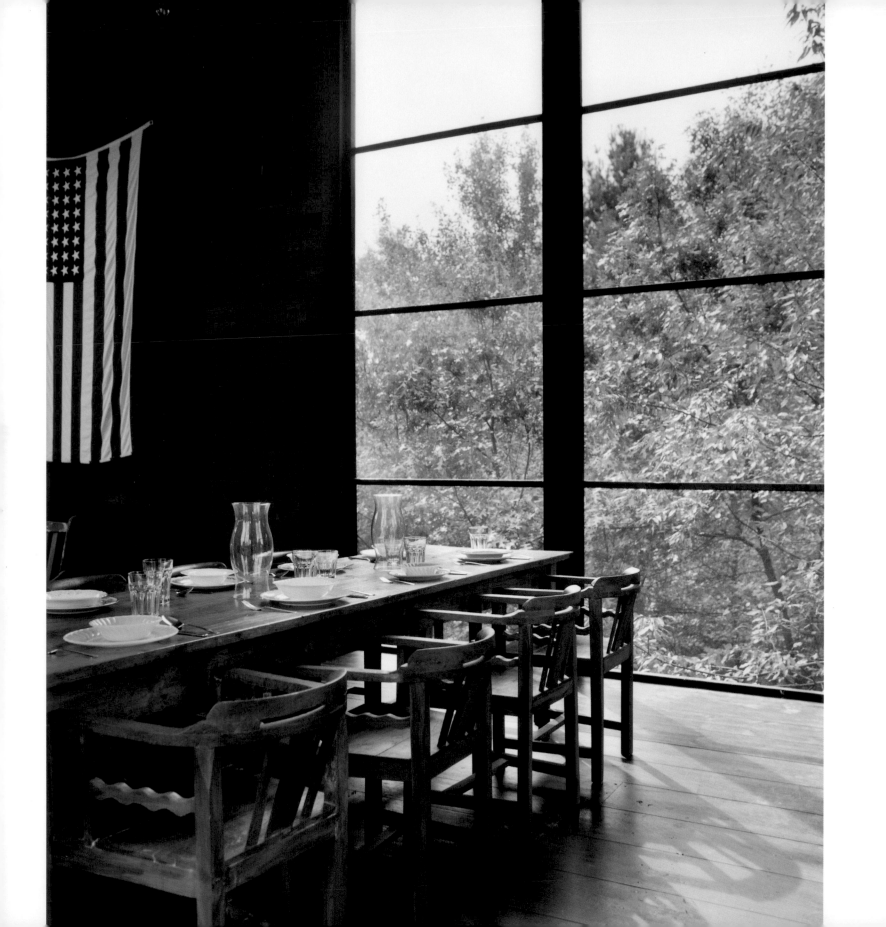

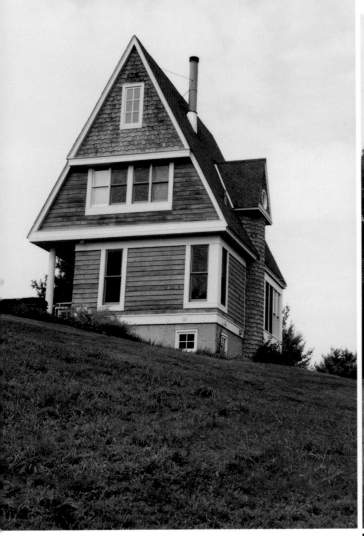

OPPOSITE AND THIS PAGE: Wedlick designed a modern barn for entertaining guests in summer; the structure features garage-style screened windows for an indoor-outdoor effect. A view of the main house from the back shows off its beautiful setting within a rolling meadow.

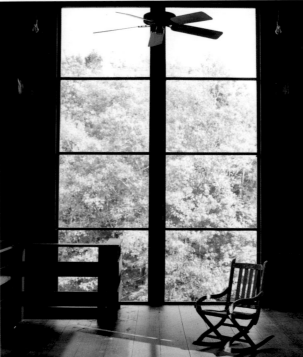

43

COLD COMFORT

MARTINA ARFWIDSON AND DAVID WEISS

When Martina Arfwidson and David Weiss purchased a neglected turn-of-the-century home in Coeymans, New York, two years ago, they knew they had their work cut out for them. Everything needed major repairs, from the plumbing and the plastering to the floors and the roof. What the couple didn't realize was what hidden treasures within the house their renovation efforts would reveal.

Built as a summer retreat in 1906 by Edward Easton, a prominent judge in Albany, the house, dubbed Shad Island for its proximity to the Hudson, has grand Palladian proportions, with original columns in front and stunning symmetry inside. The entryway features a grand-central staircase of burnished wood that leads to a generous light-filled landing above.

Many of the house's graceful architectural details were apparent from the start. In the dining and living rooms, original fanlights with leaded glass grace the arched doorways; delicately carved wood paneling adorns the walls. Ceilings reach ten feet, and there are six working fireplaces throughout the three-bedroom home.

During the yearlong renovation, Weiss was working with contractors to take up layers of linoleum in an upstairs bath when they found original marble mosaic tiles. In the attic, serendipitous excavation exposed two original fireplaces that had been closed off behind brick walls. Weiss also uncovered a cache of original windows and doors in the house's barn. To Weiss, a self-described "serial renovator," these discoveries were thrilling.

Once the renovation was complete, Arfwidson set to work painting and furnishing the house. The co-owner, with her mother, of the cosmetics company Face Stockholm, Arfwidson is a Swedish native who came to New York twenty years ago. As she describes it, the house immediately put her in mind of her homeland. "It reminded me of the houses in the Swedish countryside, with its large windows, wood details, and great proportions."

Arfwidson sought colors that wouldn't detract from the house's plentiful natural light and architectural details. In the kitchen, she chose light gray tones for the walls and floors, colors that beautifully reflect light coming through a large picture window. For the rest of the house she selected mellow grays, sage greens, and creamy robin's egg blue, shades that marry well with the house's dark wood floors.

Selecting furniture that would work with the scale of the house was a challenge for Arfwidson, who had been used to living in small apartments. For the master bedroom, she found two wrought-iron canopy beds from an old Vermont girl's school in nearby Hudson, for which she had a custom mattress made. In the dining room, a large nineteenth-century Italian table offsets the room's original crystal chandelier.

To create a special retreat, the couple converted an upstairs bedroom into a luxurious bath outfitted with an original soaking tub, a stone shower, and a pedestal sink. Arfwidson warmed the room with a Victorian-style daybed, antique candlesticks, and a gilded mirror. "Bathing puts me right," she says. "I'm always cold, and the highlight of my day is crawling into a hot tub each night and lighting candles. This is my meditation room."

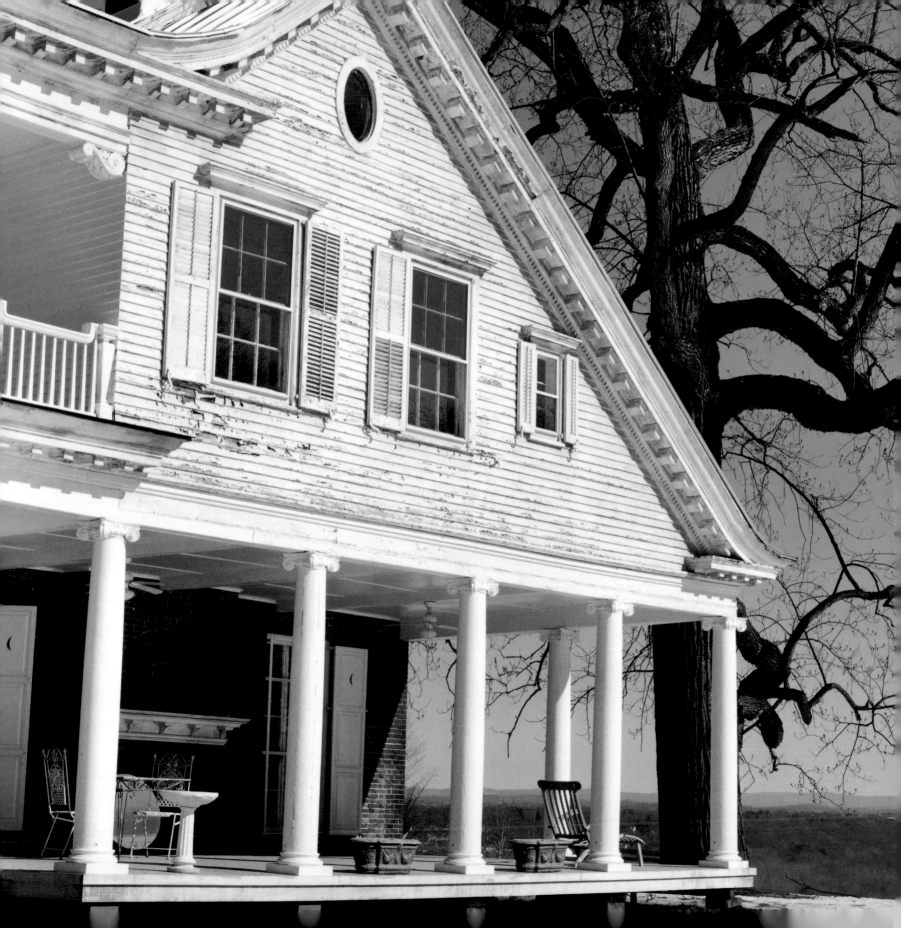

FRENCH CUISINE
Petite Auberge
COCKTAILS

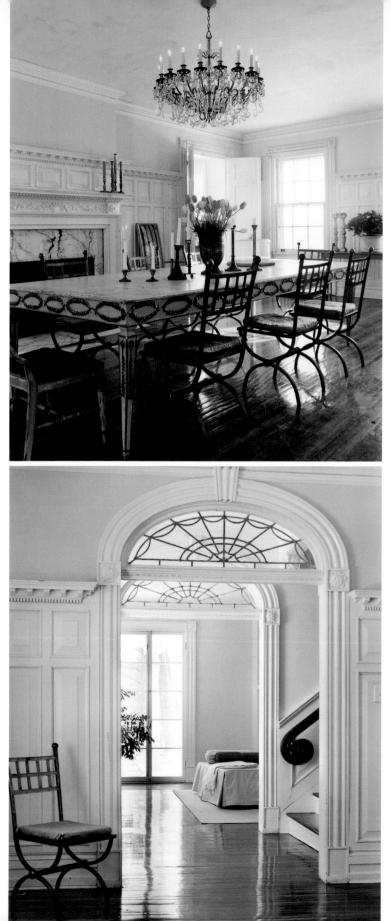

OPPOSITE: A turn-of-the-century summer cottage sits at the banks of the Hudson at the edge of Arfwidson and Weiss's property.

THIS PAGE: Period details prevail throughout the 1906 home. In the dining room, carved wood paneling and an original marble fireplace have been lovingly restored; original fanlights with leaded glass grace the entryway.

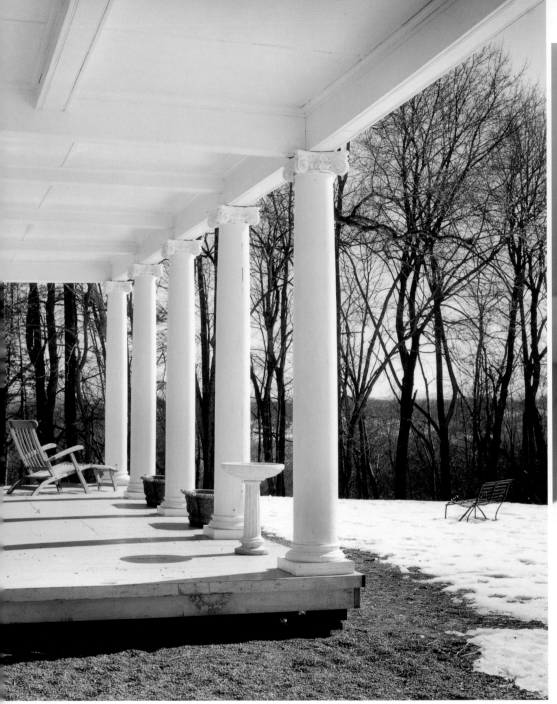

ABOVE AND OPPOSITE: The kitchen features cool tones of grays and blues; elegant marble mingles with stainless-steel appliances and an industrial-style limestone sink. Painted floors put one in mind of Arfwidson's native Sweden.

LEFT: An open porch with classical columns looks toward the Hudson River.

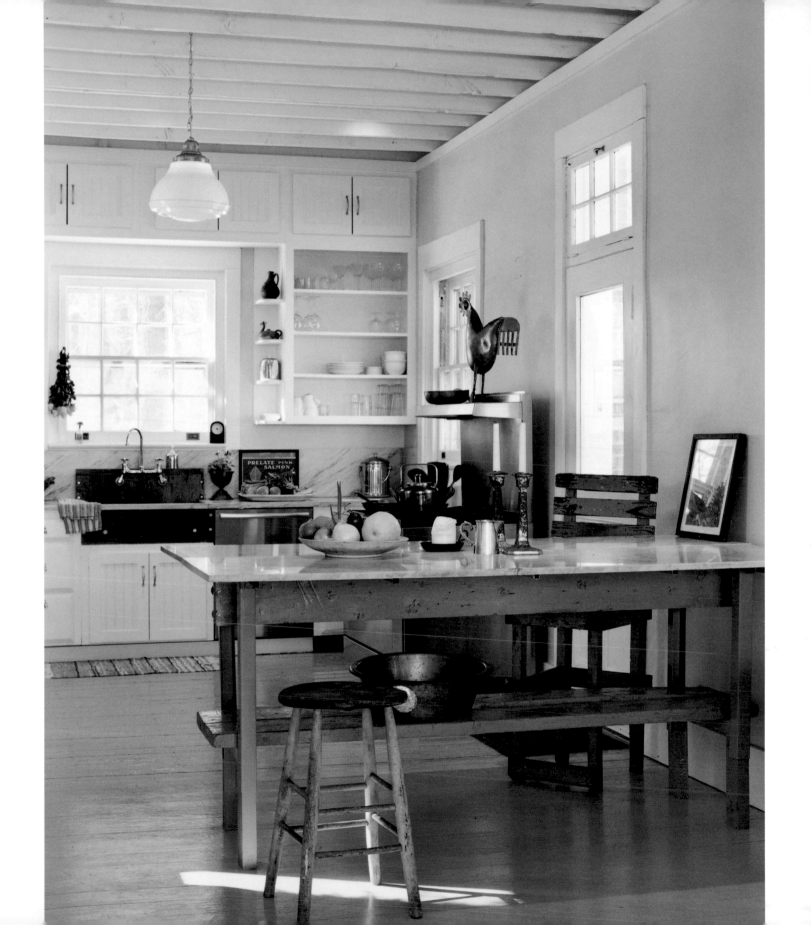

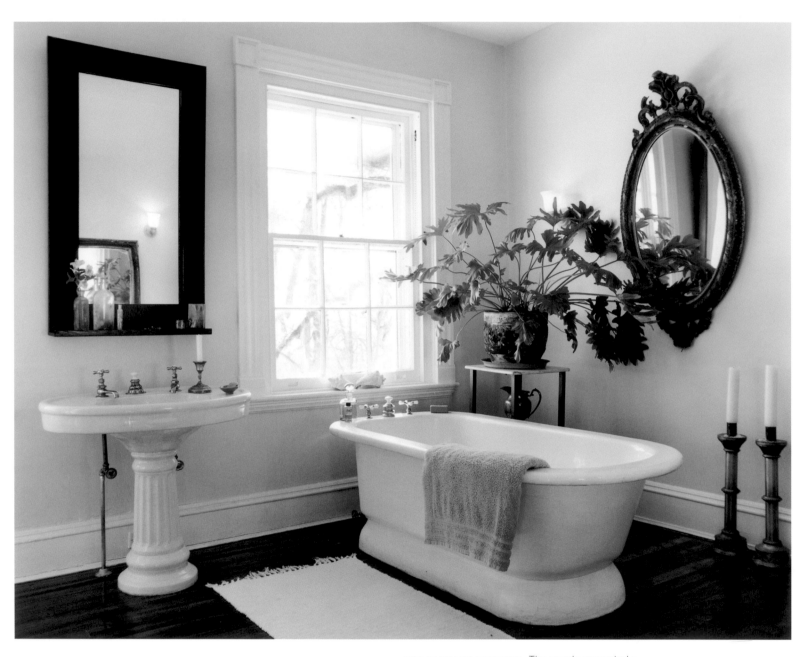

THIS PAGE AND OPPOSITE: The couple converted a bedroom to create a luxurious bathing retreat. A deep, two-person tub and pedestal sink sit grandly in the generous room. Original pewter faucets and beautiful antique mirrors add elegance.

ZEN PALACE

STEVE MENSCH

Imagine living so close to a waterfall that merely opening a window can let in a persistent roar that almost drowns out conversation. That's how closely architect Steve Mensch and his family commune with nature on a spectacular wooded site in Rhinebeck, New York.

Mensch remembers his first encounter with the fifty-foot falls. It was a winter day ten years ago, when he was looking for a site on which to build. "It had that crystalline, magical stillness of untouched whiteness. And the falls! A heart-stopping gigantic sculpture, roaring with the waters of the melting snow. I felt as if I were somewhere on the Rhine and immediately imagined a modern version of one of crazy King Ludwig's castles."

Building on such a dramatic site required a careful plan, one that coexists with nature but does not overtake it. Mensch's vision for the one-hundred-acre property does just that. From the wooded plot, Mensch and his partner, Greg Patnaude, carved out shady groves and scenic vistas punctuated by water-lily ponds, footbridges, and intimate paths. The compound comprises a total of nine wood-frame, pavilion-like buildings, including a main living space; an architectural and painting studio for Mensch; a music studio for his wife, Pam; living quarters for Mensch's four grown sons; a guesthouse; and a pool house.

The main house is a copper-roofed glass pavilion that perches fifty feet above the ground, atop a three-story concrete structure adjacent to the waterfall's dam. Mensch used copper for the roofing material "because its color and patina blend well with the water and woods." In addition to the main floor, the structure encompasses two levels for bedrooms and one for a screening room. With glass walls that fit neatly into pockets, the main living space—an open kitchen, dining area, and living room—embraces the falls, with staggering views of the water and woodlands beyond. Mensch says he chose dark mahogany for the framing and ceiling, and unpolished granite for the floors "to create a quiet, contemplative mood."

A flagstone path leads out from the pavilion to a sitting area at the top of the falls, from which one can survey a 360-degree view of the surrounding land. Sitting here, one has the sensation of floating on water, suspended halfway between the grounded structure of the house and the infinity of nature; it is a peaceful and rarely afforded perspective.

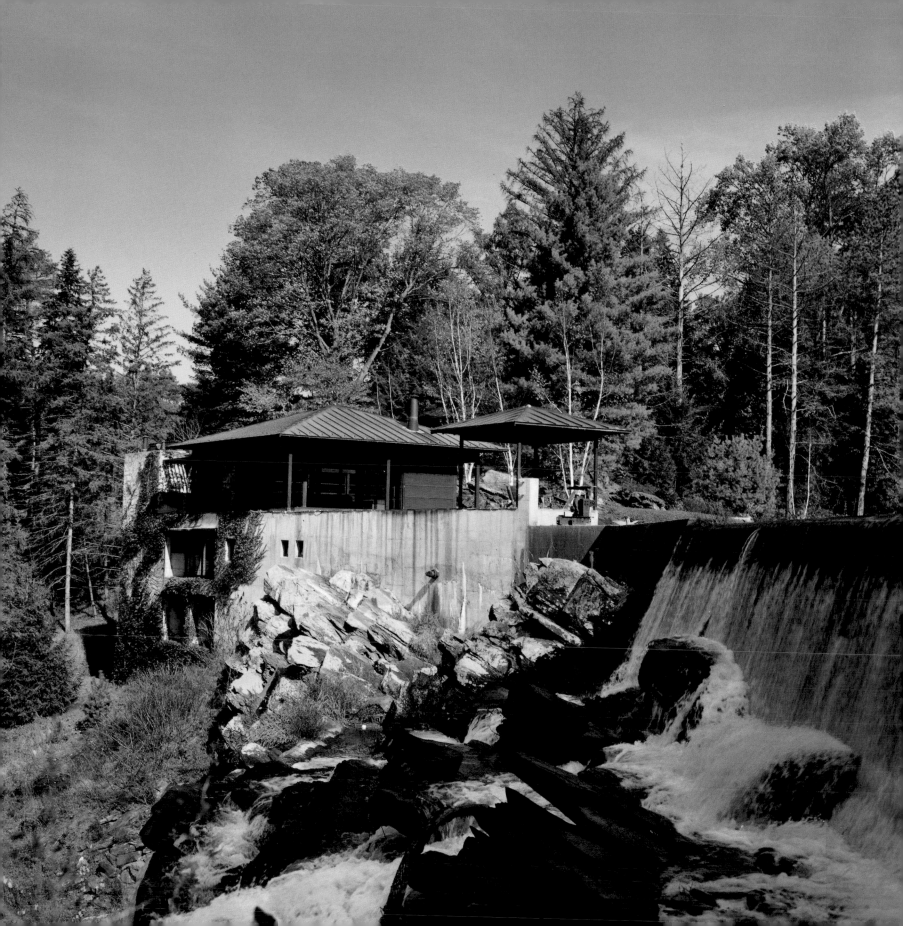

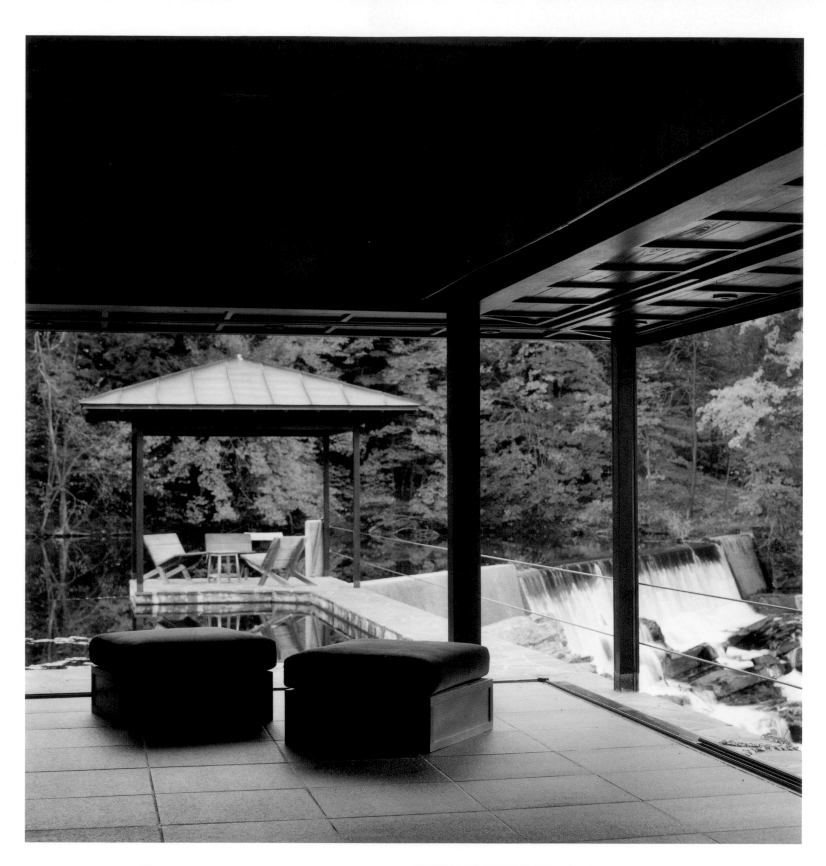

Mensch's studio is an open-air space with
a panoramic view of the woods beyond.

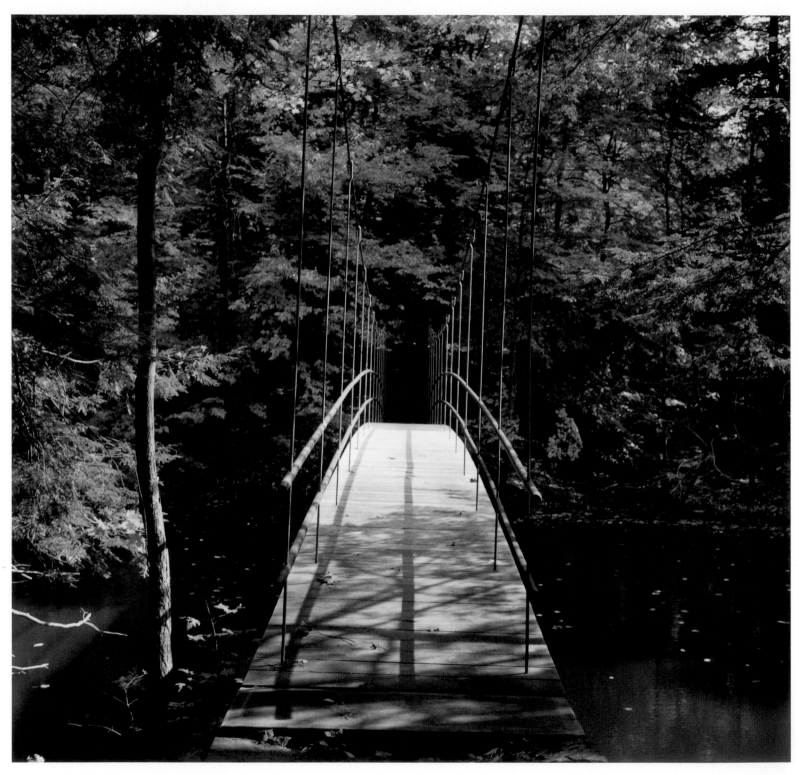

A wood suspension bridge leads to guest quarters and a pool house.

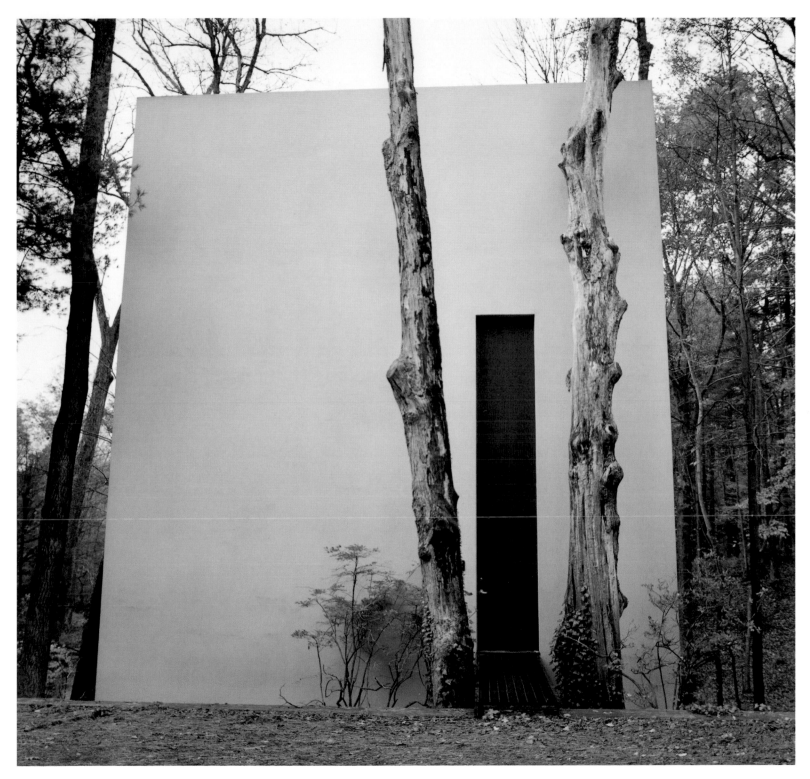

Mensch designed his studio with an oversized door to emphasize the verticality of the trees.

FAMILY RETREAT

JOAN K. DAVIDSON

Every Thanksgiving, Joan K. Davidson's generous home on the Hudson River plays host to her extended family—nearly thirty-five people in all, who gather for a festive holiday at this bucolic retreat known as Midwood.

With twelve bedrooms and varied sleeping bag places in the three-story house, there is room a-plenty for her four children, twelve grandchildren, and assorted siblings, aunts, and cousins.

Built in 1888 by the prominent Livingston family as a summer retreat, the house sits on eighty-seven acres of woodland, open fields, and rolling meadows and has an up-close-and-personal view of the Hudson River and Catskill Mountains. With its formal, Federal proportions and location two miles off the road, the house and its setting are nothing short of majestic.

Davidson, a prominent philanthropist, activist, and former commissioner of parks under Governor Mario Cuomo, bought the house in 1987 after a Hudson Valley neighbor urged her to see the place. "Just coming up the driveway on a cold rainy day I knew I loved the setting," she recalls fondly. "But then, unexpectedly, the house was wonderful too." Built as a vernacular version of a grand Hudson River mansion, it is, Davidson says, "a spacious and eccentric house with a lot of character, irresistible from the start."

The house was mainly in good shape when Davidson purchased it, with original floors, fire-places, and moldings intact. In addition to some minimal restoration, Davidson built a second kitchen, doubled the space of her parlor, and added a whimsical tower, which became a children's playroom.

Davidson has filled the house with a mix of antiques, family memen-tos, piles of books, and art. Each room reflects the house's role as a place for joyful family gatherings. Portraits of her sons and daughter grace the living room and entryway, a grandchild's play log rests on the fireplace mantle, and a wall of family photographs and children's drawings makes an eye-catching tableau on the second-floor landing.

The cozy kitchen has the feel of what the house might have been like one hundred years ago, with its original coal-burning stove, as well as a generous pantry featuring original cabinets. A rustic Swedish farm table gives the room an old-fashioned appeal, as does the iron chandelier. Here, Davidson enjoys country breakfasts served on beautiful hand-thrown pottery made by her friend, New York City ceramicist Joan Platt.

Rain or shine, snow or wind, Davidson retreats to Midwood from Manhattan for long weekends year-round, and she especially loves the winter season. "The air is clear and you can celebrate the bones of the trees, and the light is glorious."

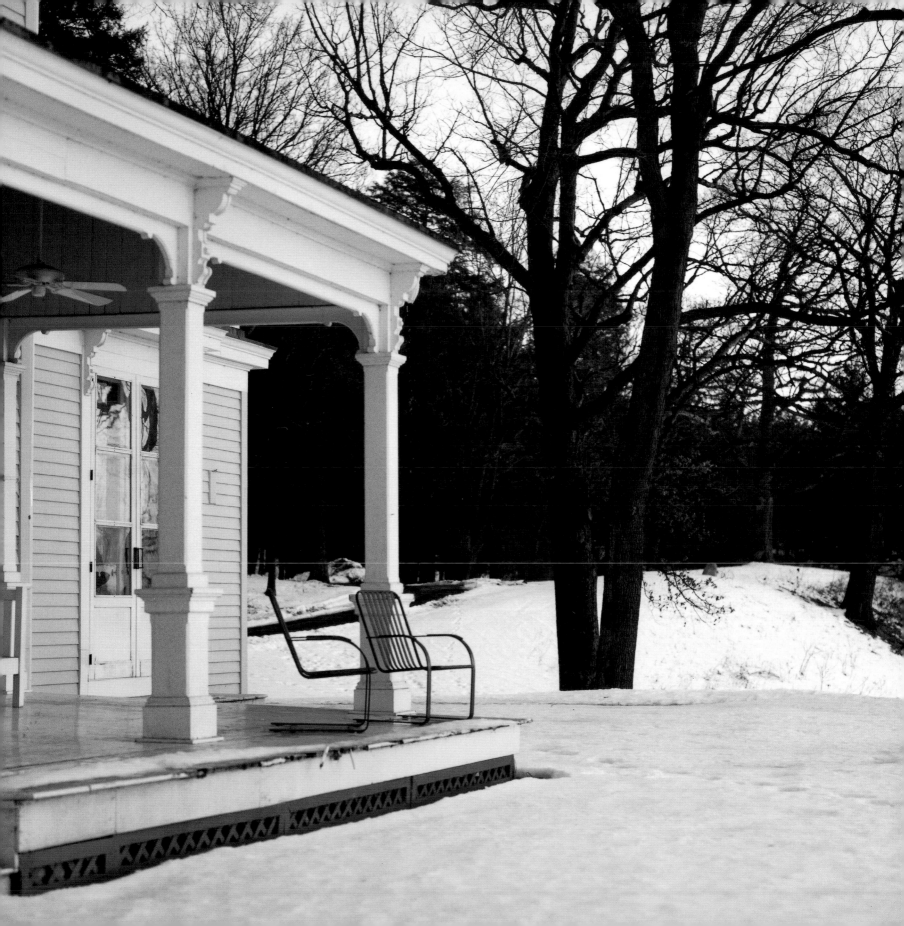

ABOVE AND OPPOSITE: Joan K. Davidson's 1888
home sits just steps from the Hudson River and enjoys
a majestic view of the Catskill Mountains.

RIGHT: A wood sculpture by Gonzalo Fonseca adorns
the house's façade.

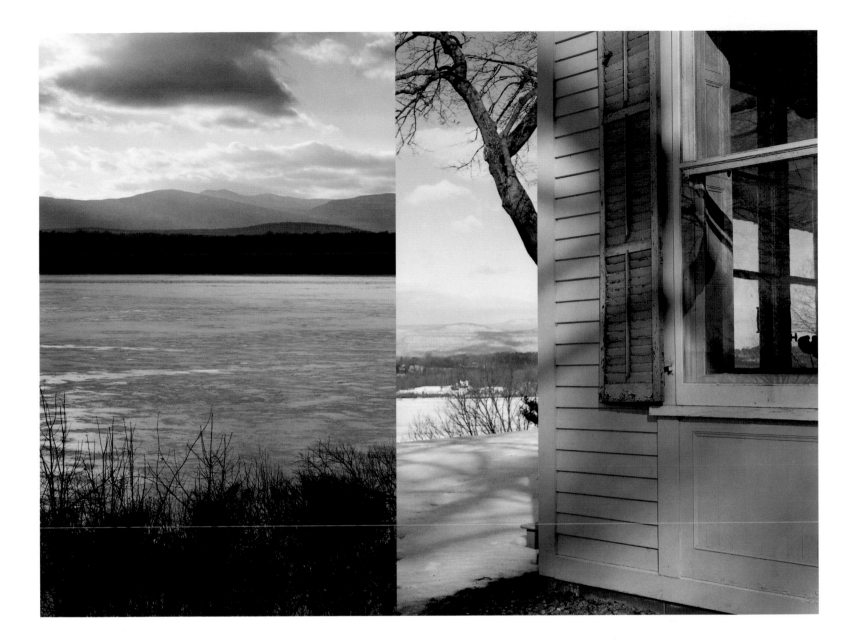

THIS PAGE: A portrait of Davidson's daughter, Betsy, graces the entryway (below, left); one of her son, John Matthew, enlivens the living room (below, right). Both paintings are by Horacio Torres. A hand-painted bird motif adorns the living room walls (right).

OPPOSITE: Davidson's living room centers around an original brick fireplace.

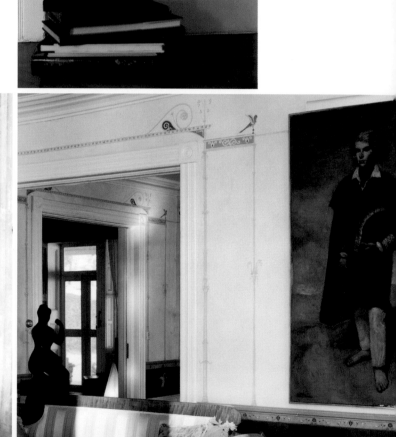

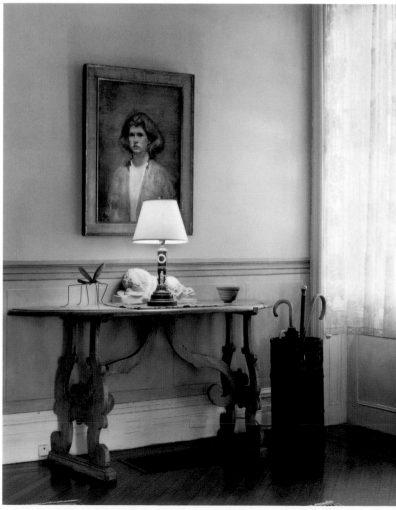

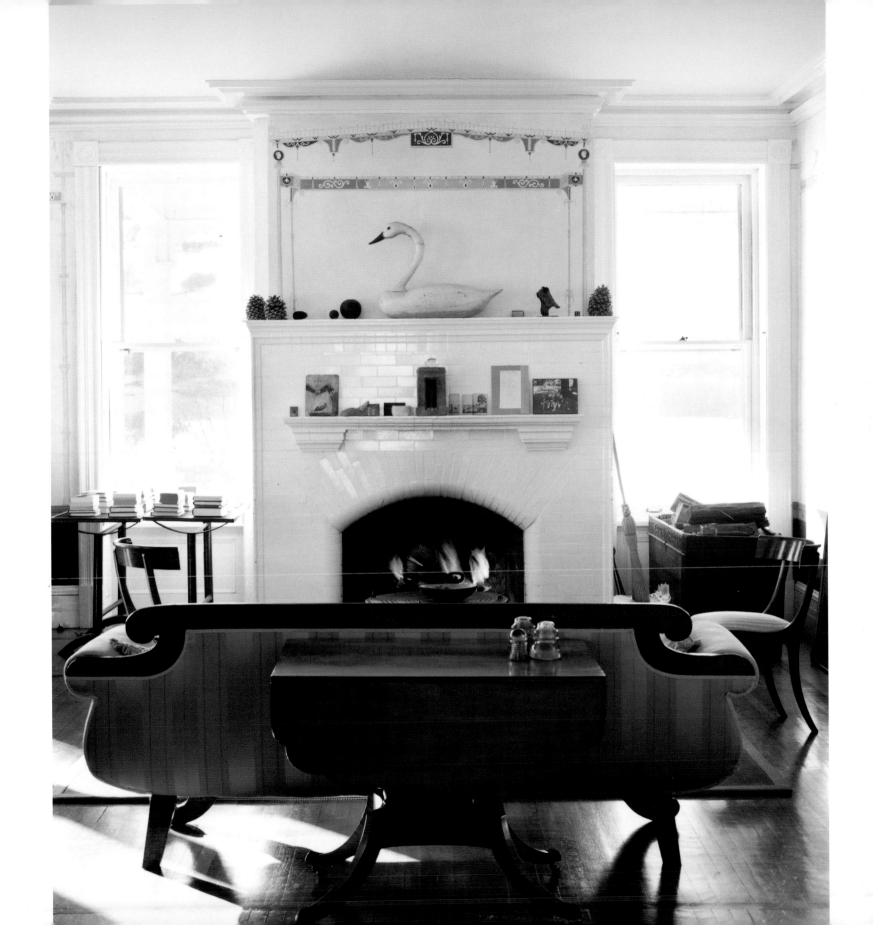

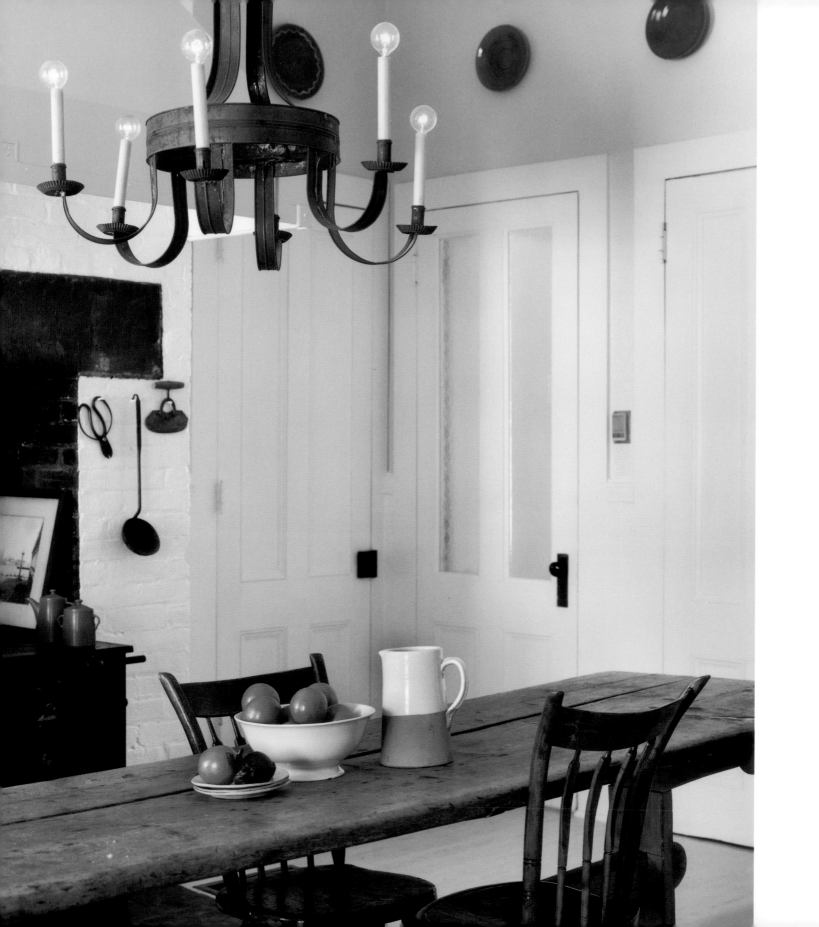

THIS PAGE: Hand-thrown pottery by Joan Platt complements the handmade quality of the furnishings. Original cabinetry fills the pantry.

OPPOSITE: With its original coal-burning stove, the kitchen has a warm, rustic atmosphere. A Swedish farm table sits beneath an iron chandelier.

69

AT HOME IN THE HUDSON VALLEY DAVIDSON HOUSE

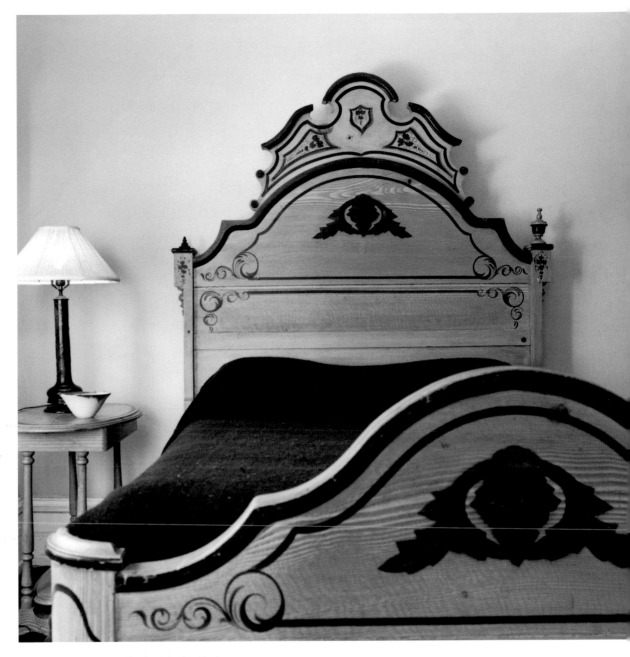

ABOVE: A hand-painted bed, original to the house, makes for cozy sleeping quarters.

OPPOSITE: A bamboo bedroom set from the turn-of-the-century outfits one of Davidson's many guestrooms.

VICTORIAN FOLLY

HUNT SLONEM

If Tim Burton were to collaborate with Ismail Merchant and James Ivory on a film, they might set it within the eccentrically furnished rooms of artist Hunt Slonem's vast Victorian mansion in Ulster County, New York.

The thirty-room house, set high above a bend in the Hudson River, is a formidable sight. Built in 1873 by brick merchant John H. Cordts, whose family remained in residence for nearly one hundred years, the house has ten bedrooms and a cast-iron crested tower. When Slonem first saw the property, he said, "I was floored just coming up the driveway." After purchasing the house four years ago, Slonem wasted no time filling it with his vast collection of nineteenth-century antiques and contemporary art.

To breathe new life into the house, Slonem made unorthodox use of color throughout. He painted a downstairs parlor a rich red to complement a suite of nineteenth-century Gothic furniture and an ornate 1860s candelabra. "This place could look dreary, so I decided to perk things up with color," the artist says. He had the kitchen painted tangerine, and the breakfast room the vibrant hue known as Paris green. In the black sitting room, walls painted a dark charcoal create a dramatic backdrop for Slonem's neo-Gothic, three-seater black sofa, which once adorned a Louisiana plantation. Slonem's black-and-white canvases of butterflies and rabbits grace one wall.

One of the artist's favorite spaces is a sitting room off his bedroom, a regal-looking room furnished with American art nouveau pieces made in Chicago. Heavy green brocaded curtains create a stagelike environment for a nineteenth-century bust of Elizabeth Habsburg, which glows brilliantly in the corner window. Slonem painted the walls a deep coral to complement the light-pink ceiling, from which hangs an ornate chandelier original to the house.

Throughout the theatrical space, colorful portraits, marble busts, and whimsical artwork by both Slonem and others add eccentric drama. In the second-floor hallway, Slonem has hung an art collection ranging from black-and-white photographs of Divine to original Warhol prints. "I'm someone who hates bare walls," he jokes. "It's interesting for me to see the art in a different context."

Although he is known to invite as many as thirty-eight people to the house for a seated dinner in the formal dining room, Slonem says he uses the house mostly as a silent retreat from New York City, where he maintains a downtown loft. "It's good for me to get out and breathe fresh air by the river," he explains.

Slonem has done considerable work on the house, from restoring the gazebos to reclaiming the garden. Each weekend, a new project takes hold: a fresh color for one of the bedrooms, a new treasure to hang on a wall. With each endeavor, the place takes on more of the owner's dramatic flair. Or as Slonem tells it, "Friends say I don't decorate—I glamorize."

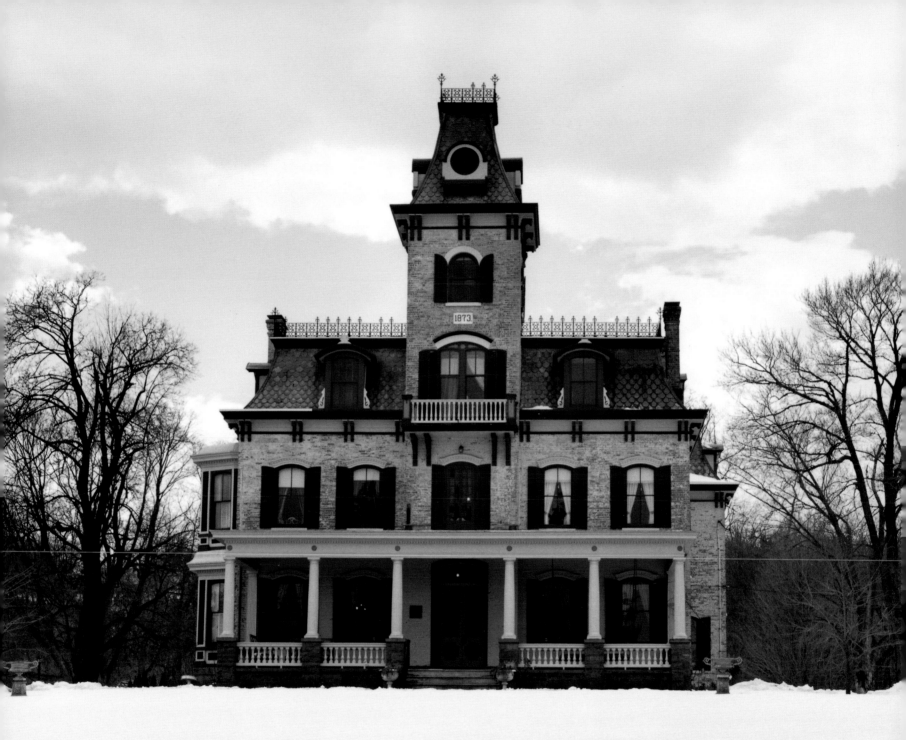

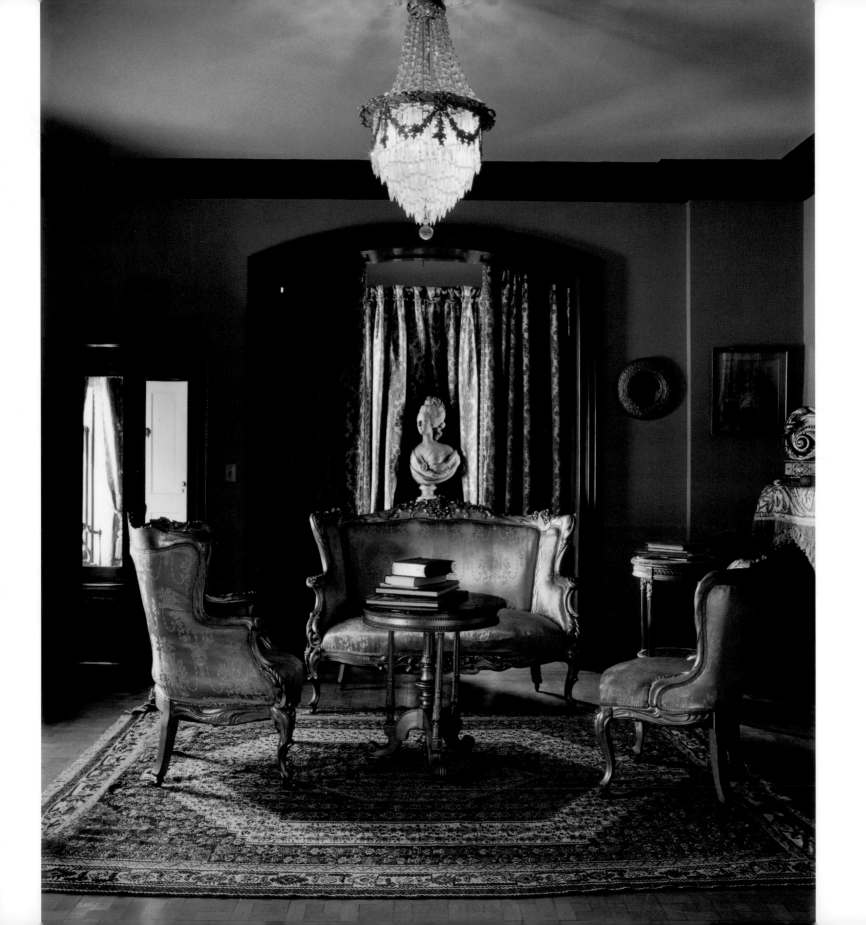

OPPOSITE: Gilded glamour: American art nouveau furnishings give the sitting room off Slonem's bedroom a regal feel.

THIS PAGE: Dramatic flourishes prevail. Bright pink curtains enliven a guest room; Parisian-style green walls and Slonem's paintings embellish the breakfast room; a gilded statue presides over a downstairs hallway.

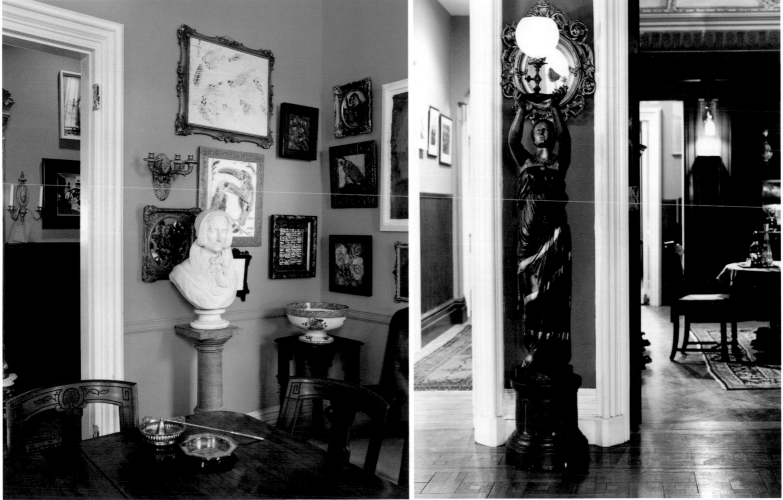

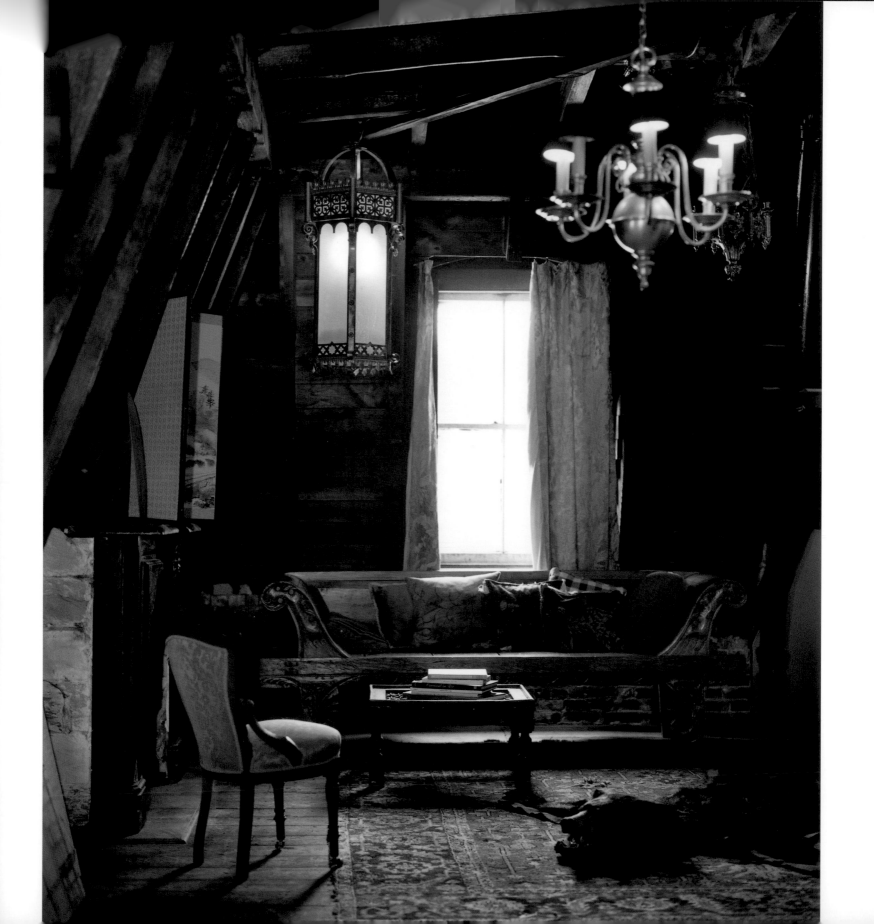

OPPOSITE: In Slonem's library, exposed beams and eccentric lighting create an atticlike atmosphere; a bearskin rug and eclectic antiques add to the mood.

THIS PAGE: A Gothic Victorian chair is right at home in Slonem's black sitting room; the artist's canvases line the library walls; a bust of Elizabeth Hapsburg glows in the art nouveau sitting room.

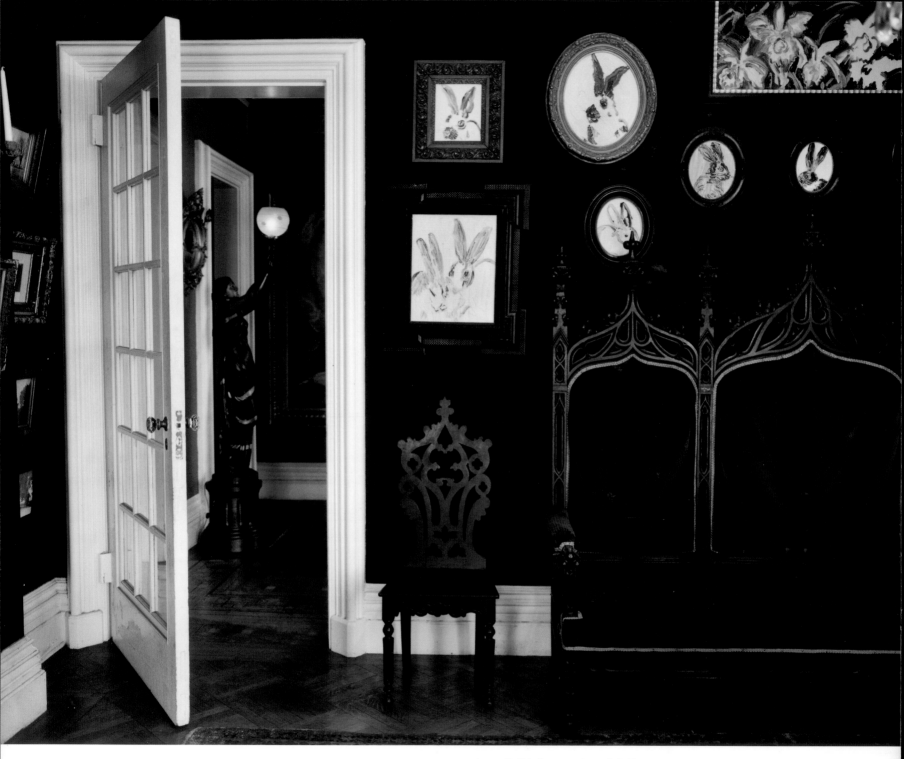

ABOVE: A neo-Gothic three-seater sofa is the center-piece of Slonem's black sitting room; the artist's rabbit paintings add levity to the space.

OPPOSITE: The formidable mansion features a cast-iron tower from which to survey comings and goings on the river.

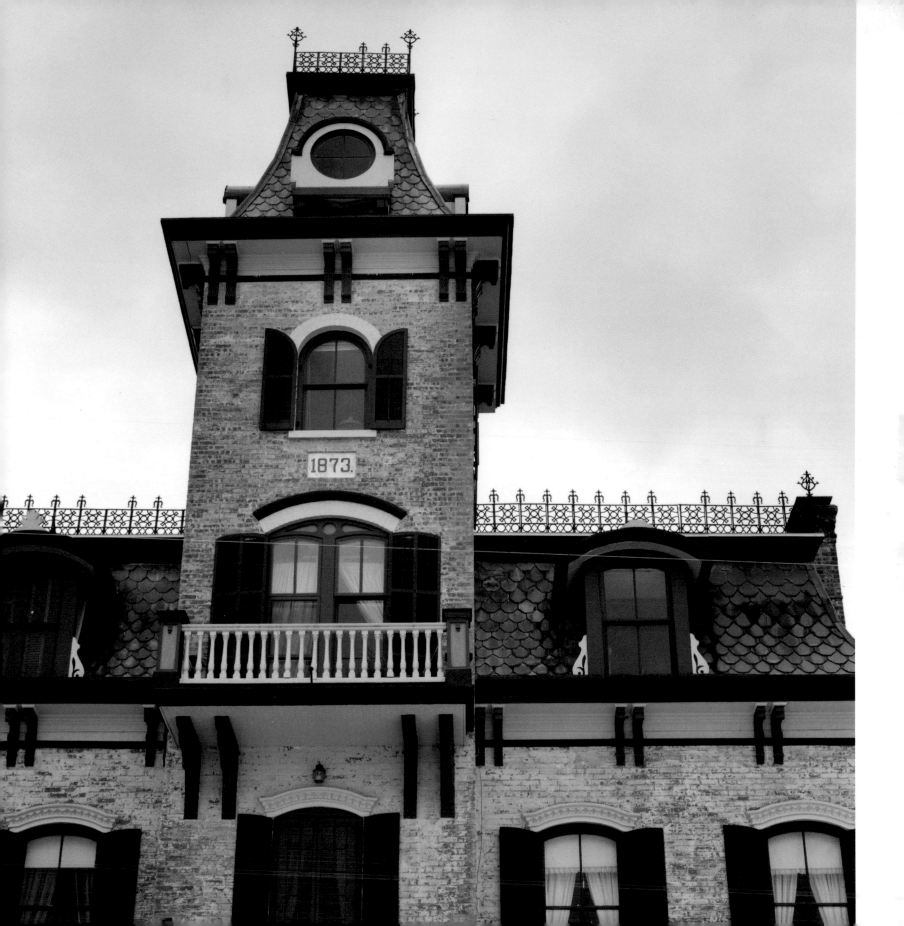

MODERN COUNTRY LIVING

AIMEE SZPARAGA AND RICHARD NOCERA

New York City can take its toll on the soul. After a decade of living in Manhattan, Aimee Szparaga, a former magazine writer, and Richard Nocera, a painter, had had enough of paying out nearly all their income to rent and restaurants. "We had met our wits' end in New York and wanted a mental makeover," Szparaga remembers.

The couple looked for a way to enjoy a bucolic lifestyle and pursue creative endeavors. Opening an intimate, chic bed-and-breakfast in the Hudson Valley seemed to be the answer. Szparaga found the property on the Internet and was immediately taken with it. Consisting of a 1929 house originally built for a New York senator and a barn the couple could use as an office and studio, the property, on four acres complete with a pond, herb gardens, and vineyards, seemed perfect for their needs.

Located in Saugerties, New York, the four-bedroom villa, with its stucco walls and red-tile roof, has the feel of a house in Tuscany. When it was sold in the 1960s to wildlife artist Tom Beecham, he enhanced the property with stone footpaths, fruit trees, flowers, and herbs.

Once the eight-month renovation was complete, Szparaga set about creating what she calls a "modern country retreat." She filled the living room, anchored with a blue fieldstone fireplace, with classic modernist furnishings such as a vintage Knoll sofa and reupholstered mid-century chairs. A collection of books and games, as well as handmade Jonathan Adler pillows, make the room feel homey.

Each of the four guest rooms suggests a unique style. Shiyou—the room's name means "remedy" in Japanese—puts one in mind of Asia, with warm celadon walls and streamlined chocolate-brown wood furnishings.

The Grange has an old-fashioned farmhouse feel, with an antique iron bed; the Solarium is a sun-drenched getaway; and the Flat is an airy loft-style room done in minimalist-chic decor.

But the real heart of the Villa at Saugerties is the kitchen, where guests gather around a farmhouse table for Szparaga's soul-satisfying breakfasts of waffles, scrambled eggs with herbs, and fresh fruit. She also keeps batches of freshly baked cookies on hand for weekenders, who help themselves to refreshments during their stay.

With the majority of the inn's business occurring on weekends, the couple is free to pursue other interests during the week. Nocera creates large-scale, oil-based canvases in the studio barn, and Szparaga writes and does menu planning. Together, the erstwhile New Yorkers have created a life in balance: a relaxed existence in nature that is steeped in sophisticated style.

THIS PAGE AND OPPOSITE: Grounds at the Villa at Saugerties
are comfortable and countrified. A small pond is filled with
lily pads, an errant rooster flies the coop; an old water pump
suggests country living; the barn recedes into the surroundings
at nightfall.

OPPOSITE AND ABOVE: A bright pink pantry in the villa reflects the owner's modern flair; vintage mason jars are a hallmark of country life.

AT HOME IN THE HUDSON VALLEY SZPARAGA/NOCERA HOUSE

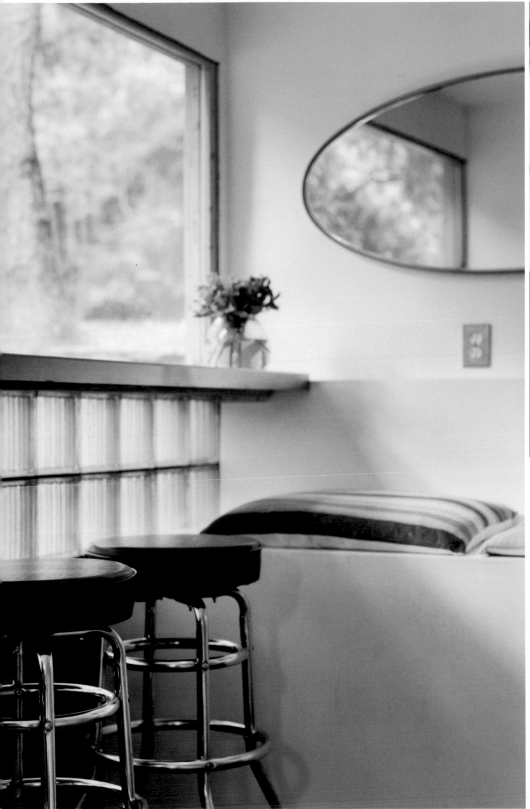

THIS PAGE: The breakfast bar looks out onto the wooded grounds.

OPPOSITE: A cozy corner for two in the kitchen, the primary gathering spot at the Villa at Saugerties.

AT HOME IN THE HUDSON VALLEY SZPARAGA/NOCERA HOUSE

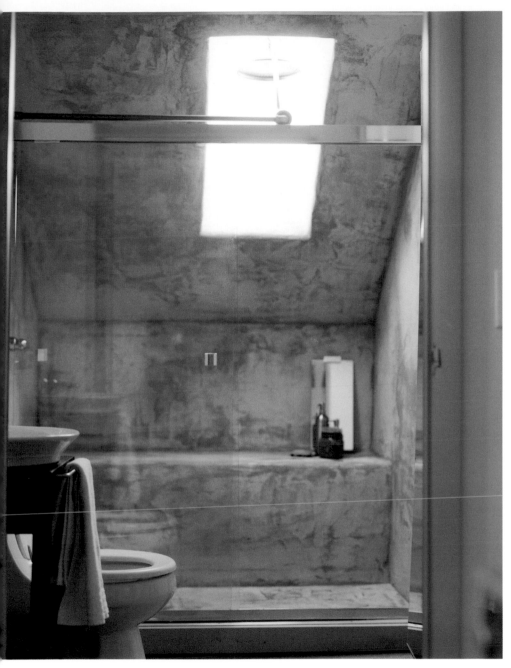

OPPOSITE: Clean-lined, modern furnishings with cozy touches prevail.

LEFT: A bathroom with a concrete shower and skylight offers a generous space.

CLASSICALLY CONSIDERED

FRANK FAULKNER

To say that Frank Faulkner admires old houses is an understatement of large proportions. He is so keen on historic buildings, he has purchased and lived in eleven of them in the Hudson Valley in the last twenty years.

Four years ago, Faulkner was about to sign a lease on a grand Victorian home when he came across a nineteenth-century church and neighboring lyceum for sale in Catskill, New York, that he couldn't resist. So he didn't.

Although he has since sold the church, Faulkner has made the 1826 lecture hall his full-time home. An abstract painter, Faulkner had lived in Manhattan for thirty years but sold his loft there to move to the country. He was drawn to the soaring, light-filled space marked by lovely arched windows, large rooms, and impressive sets of massive double doors.

"I love old houses and old surfaces, particularly neoclassical buildings. I like the proportions and the architectural vocabulary," he explains. Faulkner completely renovated the lyceum. He repaired the roof, replastered the walls, replaced the cracked windows, and installed a new central heating and air-conditioning system. He refinished the diagonally laid wood flooring and lacquered it, using a high-gloss, neutral light gray "to activate the light."

The painter made creative use of the unconventional space. At the center is a main room, capacious enough to hold one hundred people, which Faulkner frequently uses for entertaining. To the side is a sitting room warmed by an oversized fireplace, which Faulkner describes as "my station." It is joined by a modest bedroom. An area that was once used as a stage is now a dining room. The large kitchen features original cabinetry but has been updated for modern cooking.

To play up the grand proportions—the space is thirty-five hundred square feet, with fourteen-foot ceilings—Faulkner left the windows bare and created a central seating area in the main room, with furnishings covered in white canvas and several antique tables piled with art and history books. Small lamps are placed just where one might need them. "I love anchoring a seating area with pools of warm lamplight," the owner says.

Neoclassical busts punctuate the grand room, as do nineteenth-century portraits of New York society members. Smaller chairs and stools are carefully positioned to the side and can be pressed into service for large parties (Faulkner often hosts benefits for local causes.)

Classically inspired vignettes abound. Faulkner created what he calls a book terrarium—an antique, glass vitrine that he has filled with gorgeous old books, many of them with gilded edges. "For me, details are not about historic facts but are purely for visual effect," he says.

With so many portraits and busts, it is hard to feel alone within the vast space. To one side, a plaster replica of George Washington strikes a stately pose; a few yards away a solemn portrait of Daniel Webster has the orator puffing out his chest, as if preparing for the speech of his life.

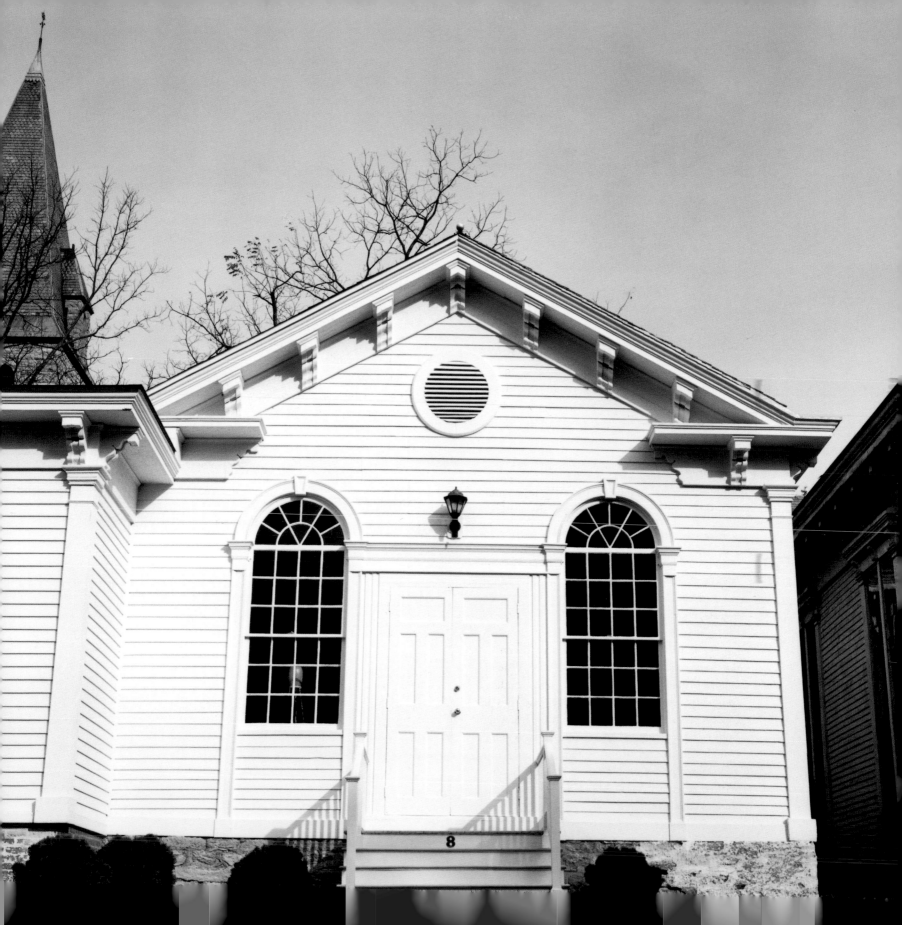

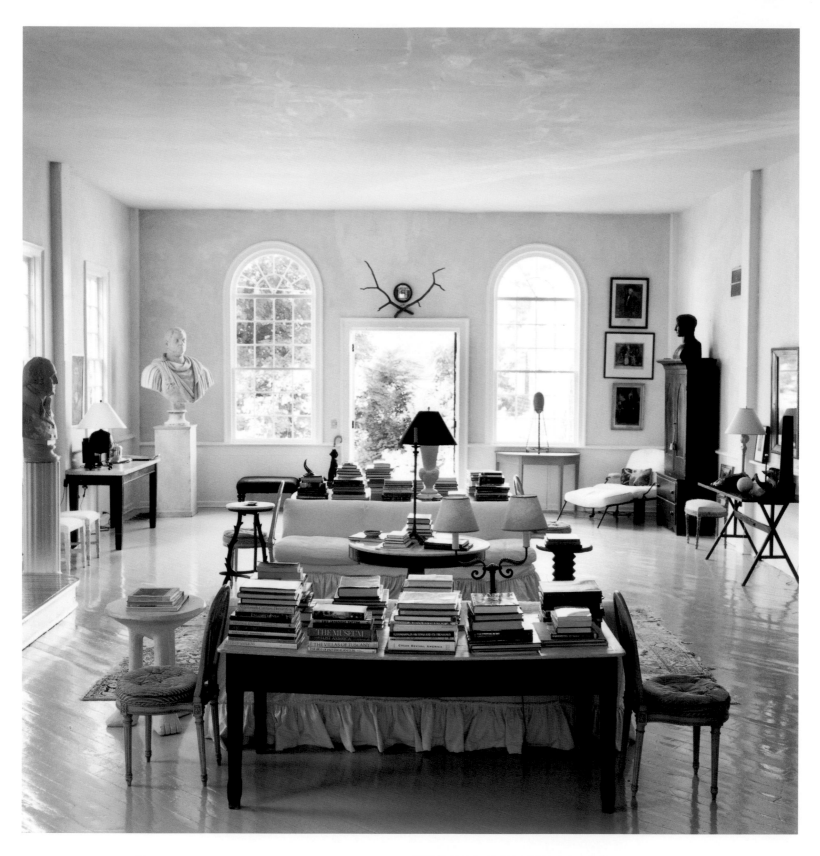

OPPOSITE AND BELOW: Faulkner's home, built as
a lecture hall in 1826, features soaring ceilings and
arched windows. To enhance the neoclassical aura,
the owner has filled the space with copious books
and busts of famous figures. The play of light on white
is a constant theme in Faulkner's home.

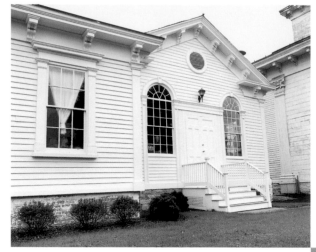

LEFT: The lyceum was built for a nineteenth-century church next door.

BOTTOM: Classical arches are a prevailing form in the lyceum.

OPPOSITE: A niche in the living room is simply furnished with a daybed, an antique portrait painting, and a candlelight lantern.

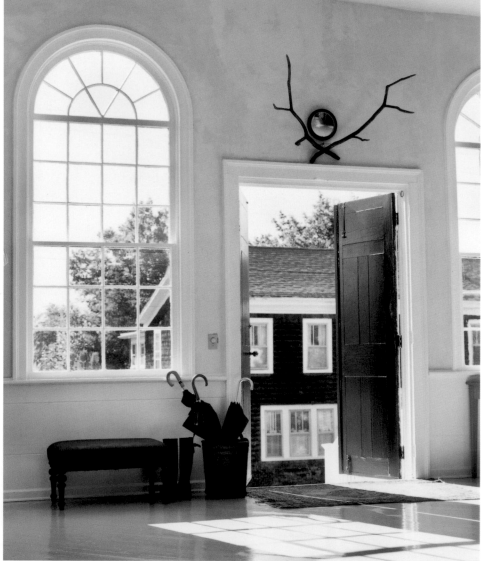

THIS PAGE: Portraits prevail in Faulkner's neoclassical home. Above: a bust of George Washington; below right: a painting of orator Daniel Webster.

OPPOSITE: Several generations of a New York family are displayed in Faulkner's bedroom.

AT HOME IN THE HUDSON VALLEY FAULKNER HOUSE

OPPOSITE AND THIS PAGE: Old books and a beautifully frayed chair sparkle in Faulkner's sunny, all-white living room.

ARTS AND CRAFTS STYLE

MARK McDONALD

At dusk in the early fall, Mark McDonald's creekside retreat in Germantown, New York, takes on a warm, welcoming glow. Within the dining room, an Arts and Crafts lantern hung from the ceiling illuminates the handsome, sturdy wood furnishings that anchor the room, throwing geometric patterns on the burnished-wood floor and setting the cream-colored walls aglow.

It is a far cry from what the original structure looked like twenty years ago, when McDonald bought the property. Neglected and nearly abandoned, the building consisted of a thirty-by-twenty-eight-foot empty box with no walls. McDonald kept the shell, including the shingled roof, and carved out a two-story dwelling with soaring windows, an open staircase, and an inviting screened porch.

"Frank Lloyd Wright's Fallingwater and Russel Wright's home Manitoga were our biggest influences in building this place," says the furniture dealer, who owns a store in nearby Hudson. McDonald began collecting Arts and Crafts furnishings, with an emphasis on Stickley designs, in 1975. Here, he has fashioned an ideal setting for his venerable collection of American pieces.

In the living room, a slate-topped table and matching leather stools are among the few examples of Frank Lloyd Wright's production furnishings. The table fits in beautifully with a 1950s Dunbar sofa and the owner's collection of American studio and Scandinavian ceramics. A Scandinavian wood-burning stove and an Alvar Aalto lamp complete the modern design picture.

The dining room is an Arts and Crafts tour de force. McDonald employed a local cabinetmaker to create cupboards of blond and ebony wood. He purchased Arts and Crafts chairs, also of ebonized wood, that were originally designed for a lake house in Minnesota; to complement the set, he designed a sturdy mahogany trestle table.

"Arts and Crafts furnishings are very masculine and country, and also sort of camp," remarks McDonald. "At the same time, the furnishings are not fussy when it comes to cold and damp."

At just under an acre, the house's long, narrow site has a lush feel provided by a mature garden filled with fragrant flowering shrubs and perennials. The house abuts a rocky ravine, which provides a cooling respite in summer and an ever-changing icy display in winter. To join the house with the outdoors, the owner built a screened porch of knotty pine with bench seating overlooking the creek, shaded by leafy trees. He also built a bluestone patio off the porch to take in the splendor of the garden.

The house is set apart from the road by a long wooden fence that runs the length of the acreage, affording the utmost in privacy and quiet. Scattered throughout the property are secluded seating areas outfitted with vintage garden furniture and offbeat art pieces. With the creek on one side and lush plantings all around it, the house nestles naturally within its secluded setting. Can there be any purer definition of a country retreat?

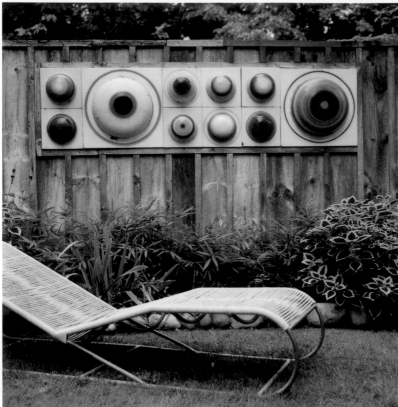

ABOVE (LEFT AND RIGHT): Peaceful nooks and
pathways define Mark McDonald's lush garden.
Fifties pop art was salvaged from the façade of
Alexander's Department Store in New York City.
A stone path leads to the creek below.

RIGHT: Vintage chairs have a beautiful rusted patina.

OPPOSITE: A private deck overlooking the creek.

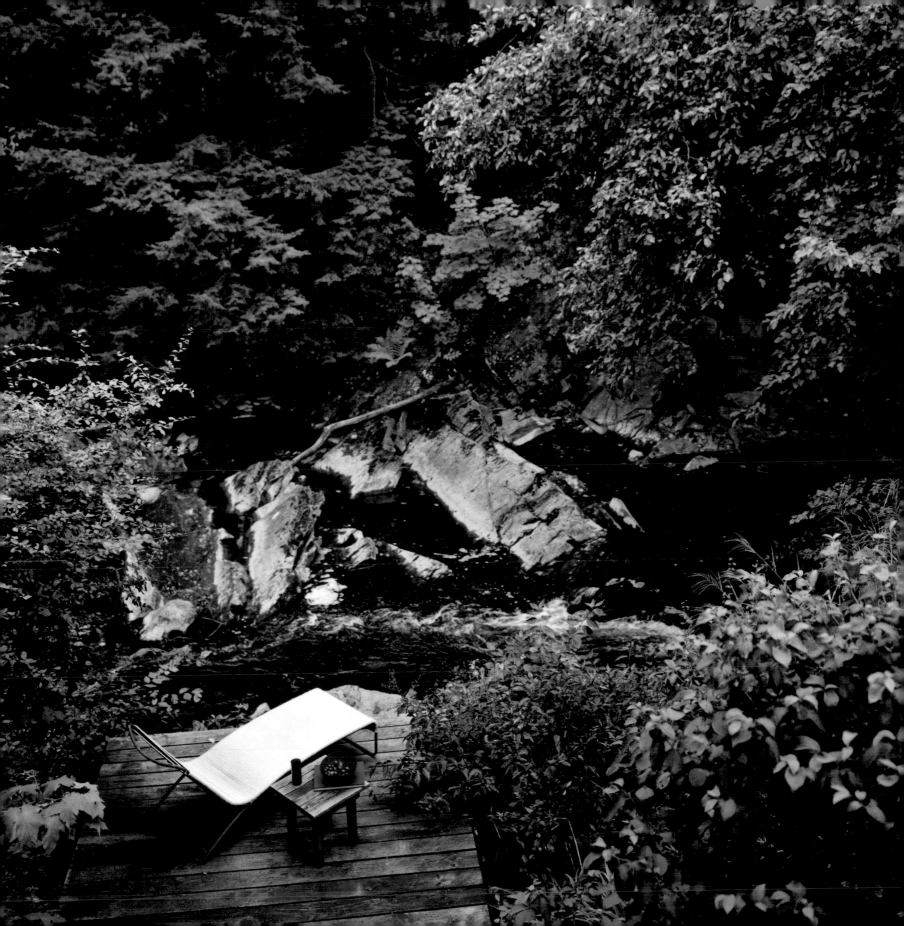

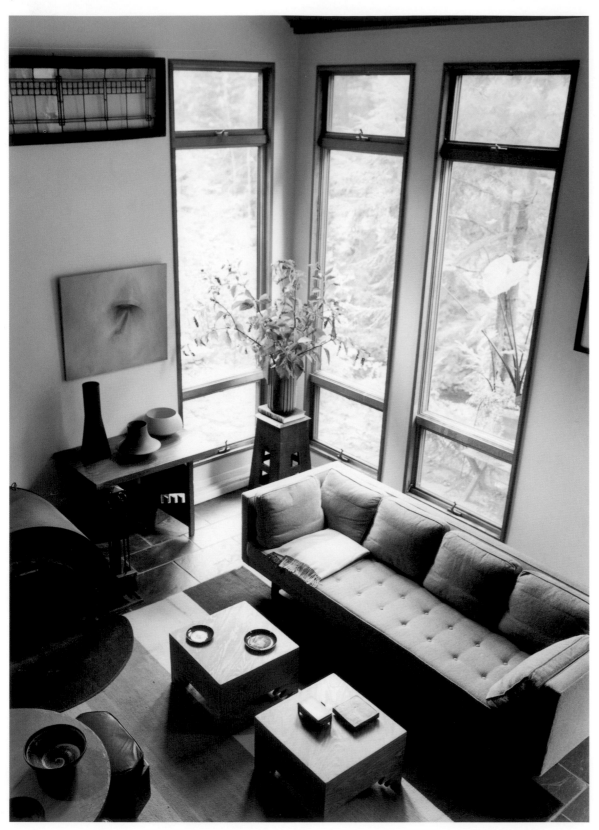

LEFT: Tall windows emphasize the double-height living room.

OPPOSITE: Arts and Crafts splendor characterizes Mark McDonald's richly furnished living spaces. Geometric shapes abound in the living room, where a Lynn Davis photograph graces the wall.

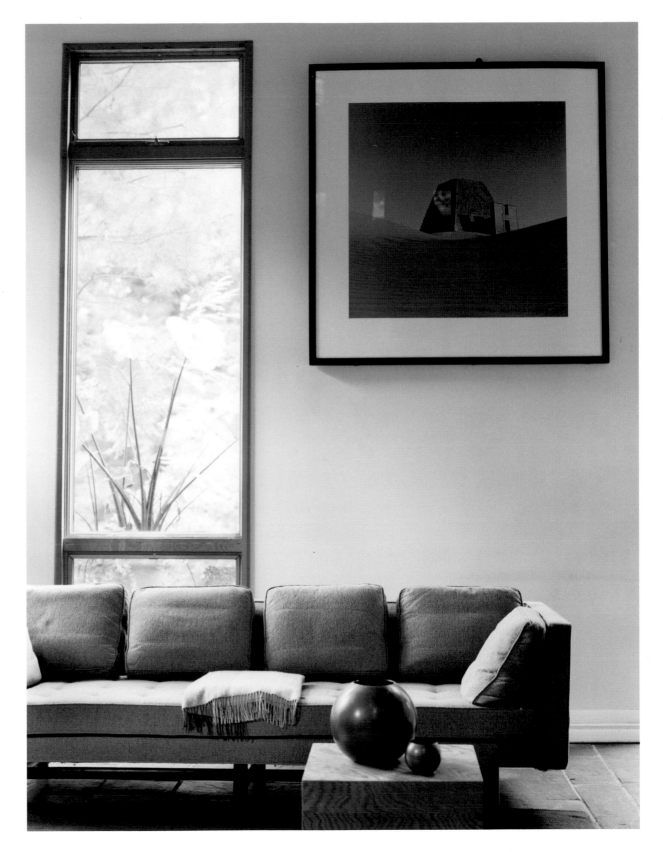

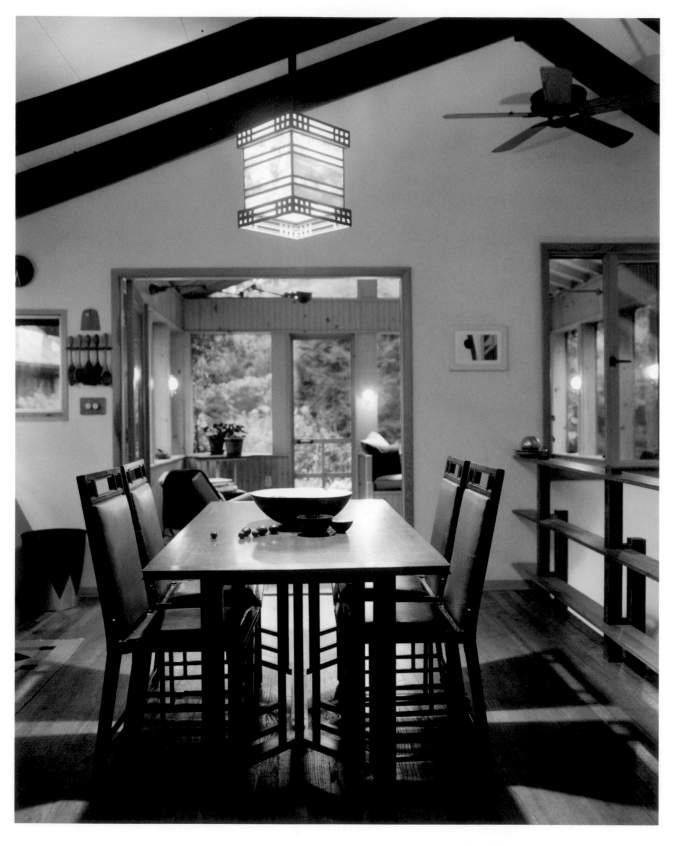

THIS PAGE: A screened-in porch with built-in benches takes in the lushness of the garden. An Art Deco light on the porch; an American Victorian "lollipop" chair made in the 1860s.

OPPOSITE: McDonald designed a mahogany trestle table to complement his original Arts and Crafts chairs built for a lake house in Minnesota.

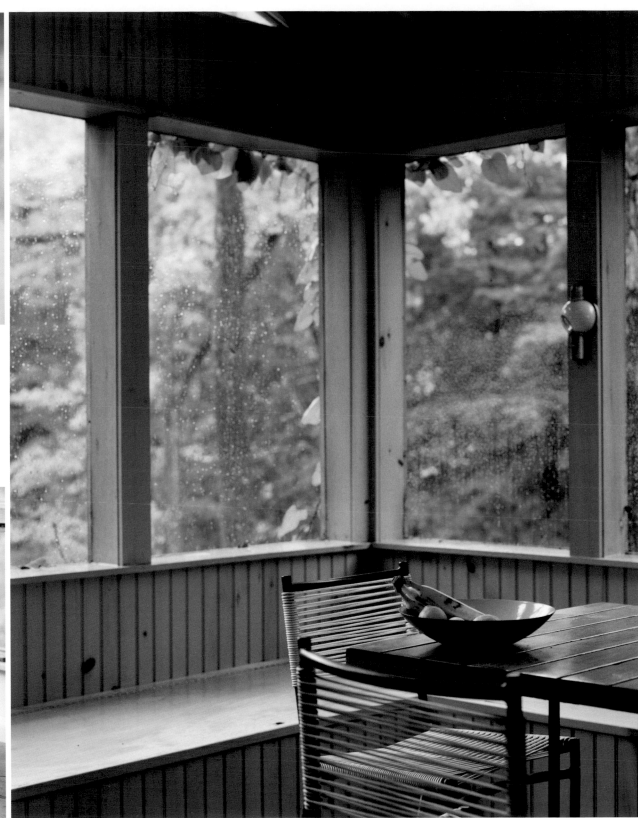

IN LIVING COLOR

MARIANNE THORSEN

More than just a weekend retreat, Marianne Thorsen's renovated farmhouse in Germantown, New York, is an homage to her native Sweden. Alive with color and filled with treasures she has collected over the years, the house is as much an expression of her personality as of her provenance.

It is also a symbol of her fortitude. When she purchased the house twelve years ago, it had been only minimally maintained for fifty-six years and was nearly falling down, though Thorsen had little idea of that at the time. "Thank God I didn't know, or I wouldn't have bought the house," she says.

Thorsen immediately went to work on the renovation of the two-story, four-bedroom house, handling most of the construction herself. "The first year was all demolition," she remembers. She rebuilt every window frame from salvaged lumber, hand-sanded and refinished all the pine floors, and even taught herself how to put up wallboard.

Set on 1.3 acres with views of the Catskill Mountains, the house's dining room was built in 1780 and had originally been a school. Fifty years later, it was expanded and turned into a farmhouse.

Today, Thorsen's rooms explode with vibrant color. She mixed all of the paint colors herself, choosing a different hue for each room. "I can see the color scheme in my head for every room," she says, "but the store never has exactly what I want. So I buy a palette and start mixing." Thorsen attributes endearments to some of her favorite spaces; one guest room is called the Opium Den for its rich, deep colors and decadent feel. Here, Thorsen bought a captain's bed, painted it rich burgundy, and attached a set of arched wooden window frames as headboards, which she then upholstered with a tufted fabric. She fashioned built-in bookcases above the bed, drawers underneath it, and closets alongside. Both the bed and the windows are draped in luxurious silk.

The sunny dining room has a strong Swedish feel. Thorsen applied no fewer than eleven colors of hand-mixed paint to suggest a soothing Stockholm-by-the-sea feel, with cool blues and grays prevailing. She also partially stripped the room's tongue-and-groove baseboards and trim to reveal a beautiful patina of old brown and blue paint. For a crowning effect, she installed a white-tiled kakelugn, a Swedish porcelain stove.

Upstairs, Thorsen created a rustic, old-world bathroom centered around an antique porcelain tub she salvaged from a fifth-floor walk-up in Manhattan. True to form, she painted it using a technique that lends a metallic look to the surface. The walls are a deep sienna, set off luxuriantly by a length of tangerine silk velvet that hangs from the window. Empty, old gilded frames adorn the walls.

Most of Thorsen's furniture comes from garage and estate sales; she constantly trolls for undervalued treasures. She picked up a set of dining room chairs for fifty cents each and then reupholstered them herself, a project that typifies her resourceful style. But while she is a true bargain hunter, Thorsen believes lavish fabrics can transform a space, and she is willing to spend money on them. "Fabrics are as important as the colors on the wall," she declares.

Thorsen says all her guests are drawn to the conservatory, which she has dubbed the Marlborough Room because she paid for it with money she saved by quitting smoking over a decade ago. Enclosed in glass and paved with slate, the room has a summery feel year-round. Even in winter, when Thorsen brings her hibiscus plants into the greenhouse-like space, the room is lush and cozy—the perfect enclave for intimate drinks or dinner with guests.

AT HOME IN THE HUDSON VALLEY THORSEN HOUSE

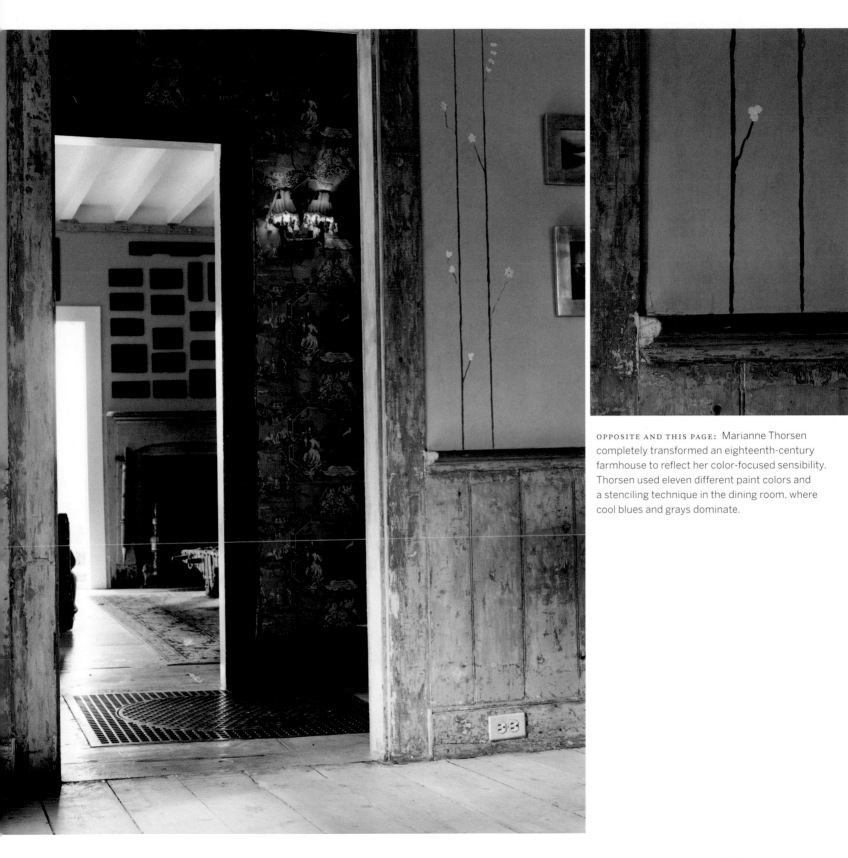

OPPOSITE AND THIS PAGE: Marianne Thorsen completely transformed an eighteenth-century farmhouse to reflect her color-focused sensibility. Thorsen used eleven different paint colors and a stenciling technique in the dining room, where cool blues and grays dominate.

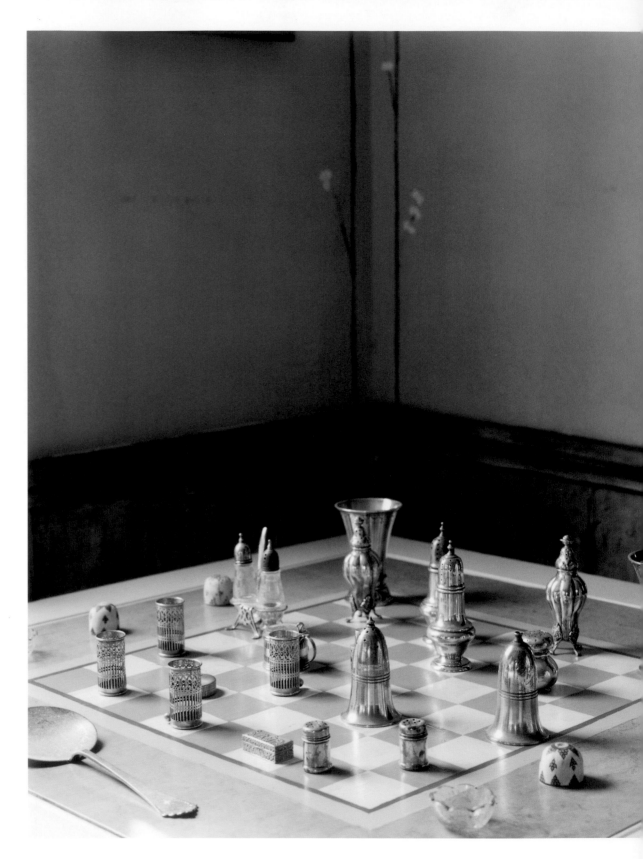

RIGHT: Silver pillboxes stand in for kings and queens on a chess table in the dining room.

OPPOSITE: Thorsen's dramatic bathroom features a salvaged and refinished tub, gilded frames, and velvet and silk curtains.

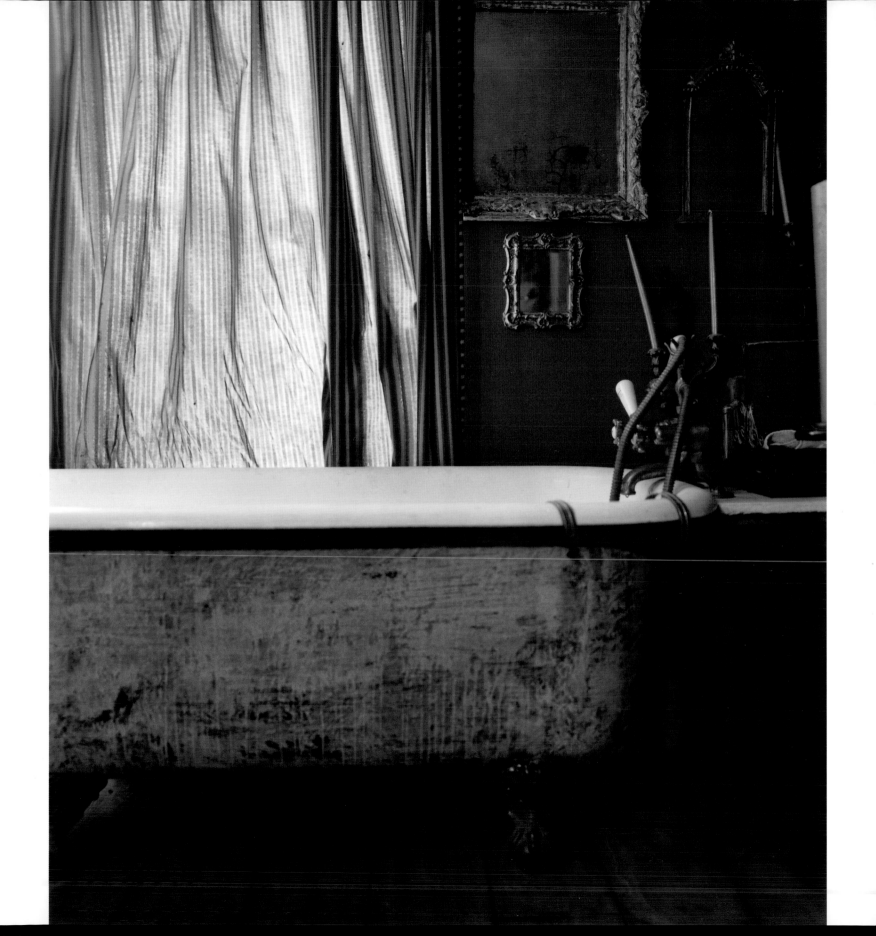

OPPOSITE: A glass-walled conservatory with slate floors offers a bit of summer even in the cooler months. Potted plants and fresh flowers give the room a garden feel year-round.

RIGHT: A guestroom is furnished with luxurious fabrics and painted a rich burgundy. Salvaged-wood window frames form a ceremonial looking headboard for the custom-made bed.

OUT OF THE BLUE

MARILYN MINTER AND BILL MILLER

When Marilyn Minter and Bill Miller began looking for a weekend retreat in the Hudson Valley a few years ago, they were shown houses that Miller could only describe as grandmotherly. "We were seeing places that we wouldn't choose on our own," he explains.

Then the idea to buy land and build from scratch came to mind, and it made perfect sense to enlist their friend Stan Allen, dean of architecture at Princeton University, who had renovated the couple's loft in SoHo nearly a decade earlier. "We figured rather than spend the money on a house, we could give it to someone like Stan and let him create something, almost like an art commission," Miller explains.

The couple found an ideal spot on which to build in Cold Spring, New York: a five-acre plot surrounded by protected land, a wooded property hard by Deer Hollow Creek. Once the site was chosen, Allen says, "We became driven by light, water, and topography. We wanted to build a very simple house, but with inflections toward the light." To that end, Allen created computer models showing exactly where the sun would fall every day of the year. "It was almost like an academic exercise to figure out the best place to put the house," Miller recalls.

In addition, the couple—and Allen—wanted a house that would be interesting from all angles. The result is a trapezoid-shaped structure with a butterfly roof and no square corners to be found. Clad in Hardy Board, a concrete composite, the house has vertical battens that throw subtle shadows while "mimicking the insistent rhythm of the tree trunks beyond," Allen explains.

Large windows define much of the south-facing wall; skylights and transoms above the bedroom doors wash light throughout the house. Light-colored maple flooring and mostly white walls amplify the sunny effect. The team also installed glass jalousies in the bathroom to catch light coming in through the living room windows.

Color is used sparingly but to dramatic effect. Miller chose a large apricot leather couch to anchor the living room; brightly colored paintings are hung on the wall. A specially commissioned shelf unit designed by Lloyd Schwan serves as both an art piece and storage unit. Panels are colored with primary hues; some are digitally laminated with photographs. A single wall in the entryway is painted light pink; the fireplace wall is pale green. Colorful accessories—pillows, throws, glassware, and flowers—provide cheerful focal points and add visual texture to the room.

In keeping with a modernist aesthetic, Miller and Minter used easy-to-obtain, cost-effective materials whenever possible. The fireplace, made of plasterboard and brushed aluminum, was prefabricated. The kitchen cabinets and coffee table are from Ikea. In the living room, shower-curtain material of lightweight nylon shields the sliding glass doors. The fabric is translucent, weatherproof, and easy to clean.

Surrounded by thick stands of maple, poplar, ash, hickory, and birch trees, the house enjoys quiet much of the day, save for the gurgling creek. On summer afternoons, the couple often ends up in a hammock by the water, where they fall asleep to the sounds of nature.

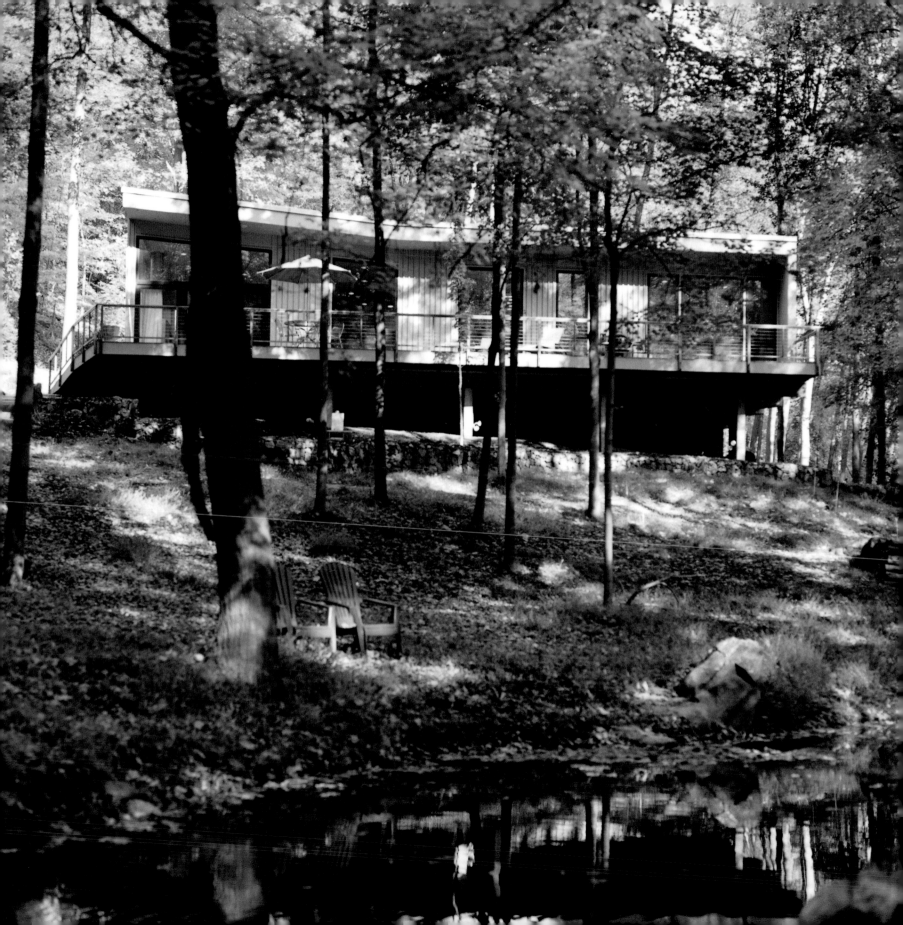

AT HOME IN THE HUDSON VALLEY MINTER/MILLER HOUSE

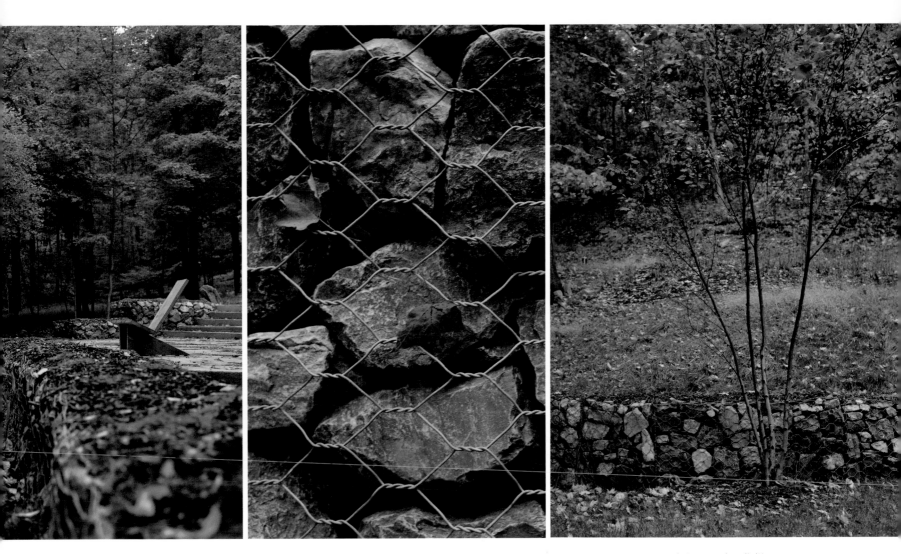

OPPOSITE AND THIS PAGE: Autumn colors light up
Marilyn Minter and Bill Miller's property. The house is
situated on Dear Hollow Creek, a pleasant spot to rest
or nap. Architect Stan Allen used stone gabion walls to
create a retaining structure around the property.

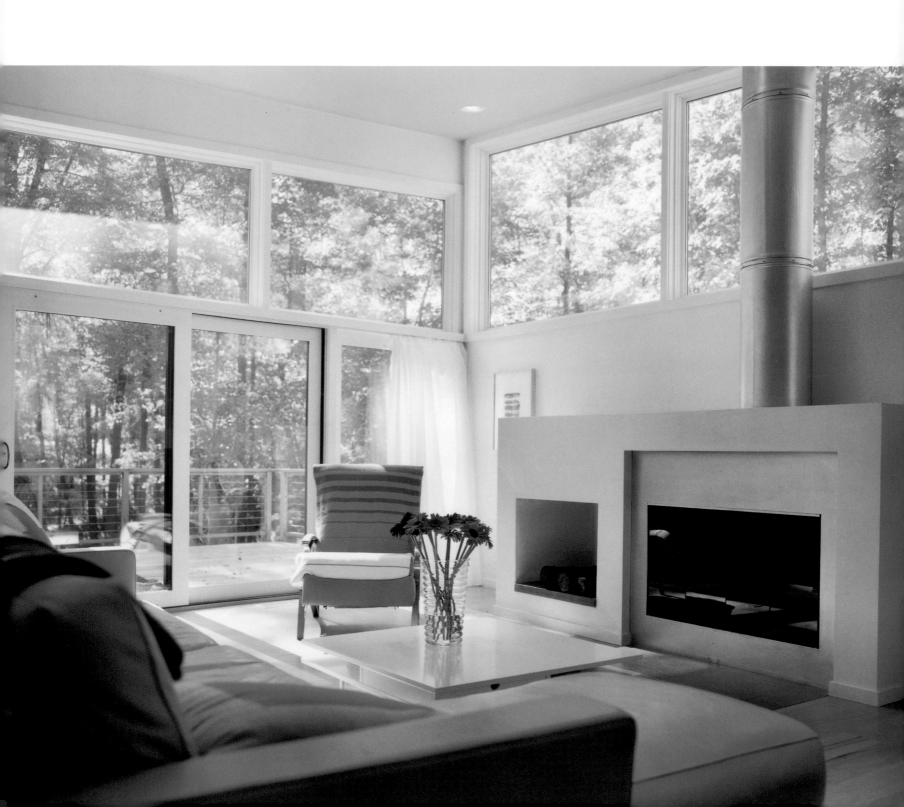

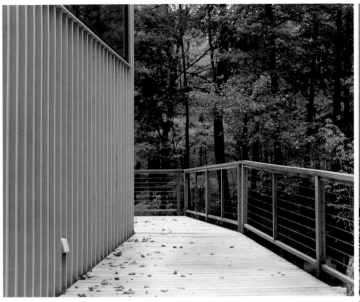

THIS PAGE: Board-and-baton construction creates subtle shadows on the house's exterior; a wraparound deck affords splendid views of nature.

OPPOSITE: Vibrant hues bring the sunny, all-white living room to life.

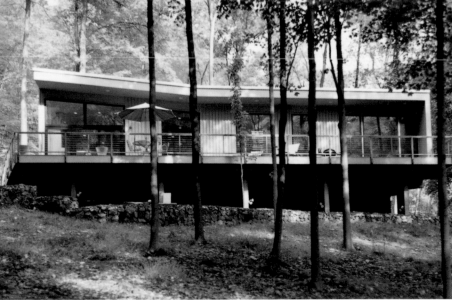

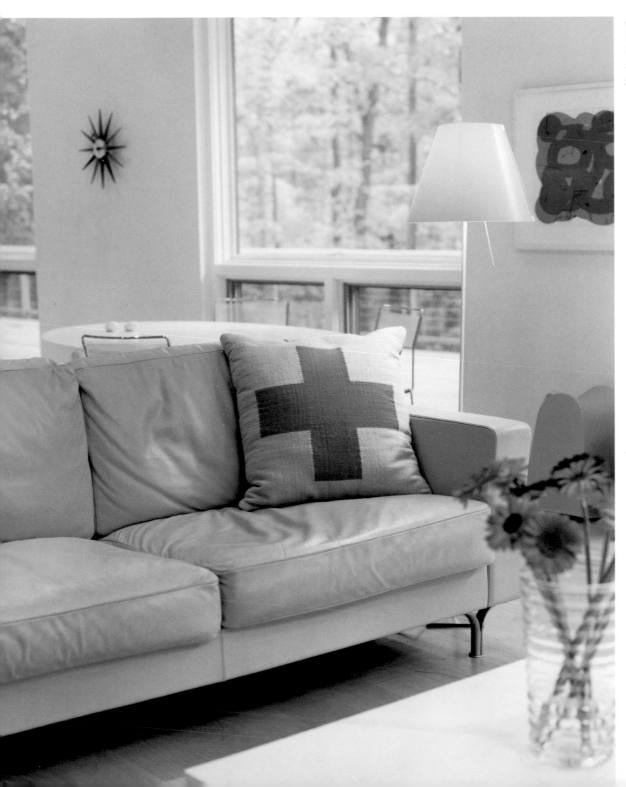

OPPOSITE AND THIS PAGE: A simple plywood
bench creates extra seating and storage in the
living room, where an apricot leather couch makes
a colorful statement. Textured pillows, throws, and
glassware bring warmth to the streamlined room.

123

THIS PAGE: Jalousie blinds in the bathroom bring light in from the hallway; a colorful wall unit by Lloyd Schwan enlivens the living room.

OPPOSITE: The sunny kitchen is lit by floor-to-ceiling windows, which reflect light onto the maple floors.

LIGHT VISION

PETER FRANCK AND KATHLEEN TRIEM

On late-autumn days, when the afternoon sun strikes the front of Peter Franck and Kathleen Triem's house in Ghent, New York, sunglasses are required. Blinding light floods the glass facade, reflecting everywhere within the whitewashed living space. Exposure to the elements is just the point: the couple's ultramodern house offers both a stark contrast to—and happy integration with—the landscape beyond.

Located on a grassy hill in a grove of birches with views of the Catskill Mountains, the site is adjacent to the Fields at Art Omi, a two-hundred-acre sculpture park for which the couple—both architects—serve as curators. With its sharp lines and minimal landscaping, their home sits as boldly on the land as the sculpture that surrounds it.

Building a house a stone's throw from an art park gave the architects a specific context. "We were very influenced by issues of contemporary sculpture and how they overlap with architecture," says Peter Franck, noting that he and his wife were inspired by Donald Judd and Richard Serra's landscape sculpture. At the same time, he points out, "This was our shot to make the house as much about what architecture could and should be."

Blending modern shapes with rustic materials was one way to integrate the two-level house with its site. The foundation was built of local bluestone and the exterior is sheathed in copper—materials "of the earth," Franck says. "Copper weathers beautifully and takes on a natural patina," he adds. "And it needs no maintenance."

To capitalize on the views, Franck and Triem built a wall of windows facing southwest, toward the Catskill Mountains, creating a passive solar heating system. They angled that side to catch direct sun in winter and more diffuse light in summer. Inside, the ceiling soars to fourteen feet in the loftlike living space that comprises a living room, dining area, and kitchen.

For evening lighting, the couple chose fluorescent lights recessed into the ceiling. "We like the linear architectural quality of florescent lights," Franck says. Gallery lights illuminate the couple's large art collection, and all of the lamps can be dimmed. "It can be very bright or intimate; it's a hugely flexible system."

White marble terrazzo floors add sparkle to the interiors. Custom lacquered cabinets shine in the kitchen; mostly white walls are punctuated by casement windows and contemporary paintings. "We wanted a clean, minimalist space," Franck says. The couple used color sparingly: one wall of avocado green adorns the modern chimney, and a sky blue wall behind the bed in the master bedroom mimics the outdoors.

Downstairs are bedrooms for the couple's three young children, Sebastian, Adrienne, and Genevieve. There is also a "messy room," where the kids are allowed to do art projects and paintings. With lots of room to roam—twenty-five hundred square feet in all—the Francks built what they call an open family plan, with no doors on any of the rooms, including the bedrooms. "Openness was a guiding issue," Franck says. This allows for some unbound play: the children ride their tricycles around the living room, zooming up and down the uncluttered space. "It's funky," Franck says. "And it's a very good family life."

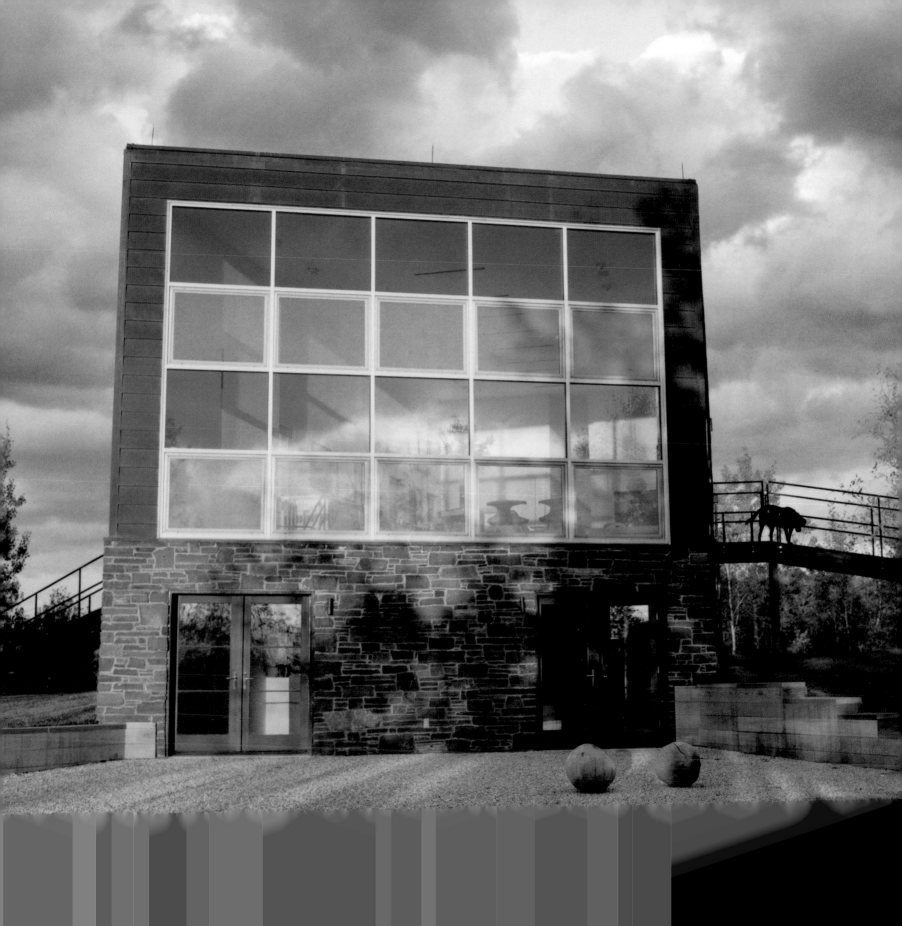

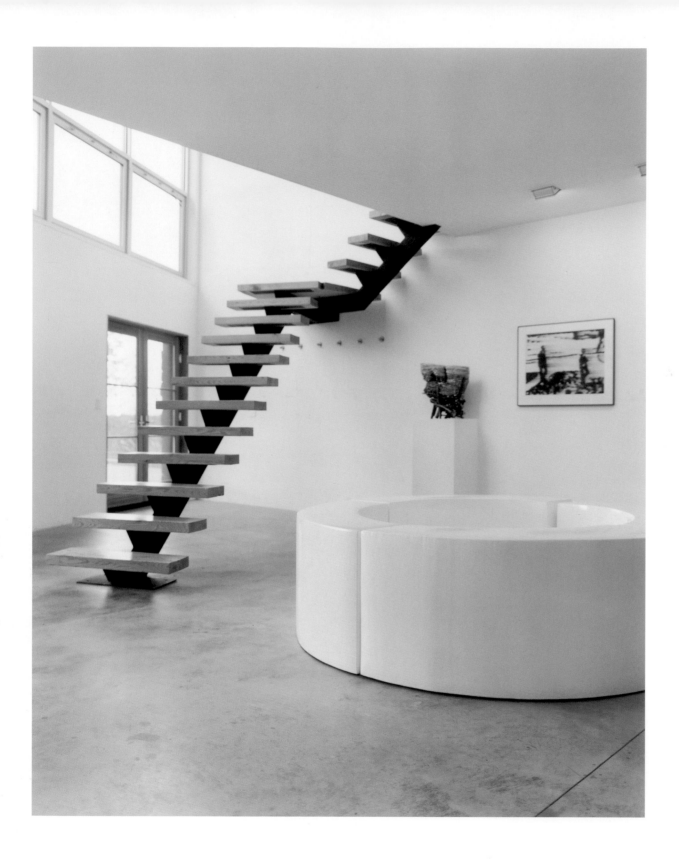

AT HOME IN THE HUDSON VALLEY FRANCK/TRIEM HOUSE

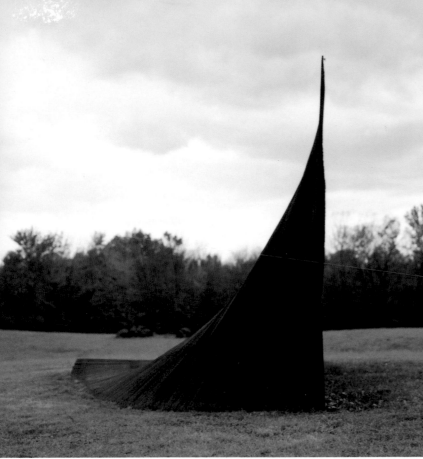

OPPOSITE: A white, foam-sprayed polyurethane sculpture by Donna Nield titled "Quartered Circle" doubles as a sofa in the family's downstairs living space, where a painting by Triem from her "Surveillance Series" graces the wall.

THIS PAGE: The family lives adjacent to the Fields at Art Omi, a sculpture park where works by William Anastasi (left) and Philip Grausman (below) dot the landscape.

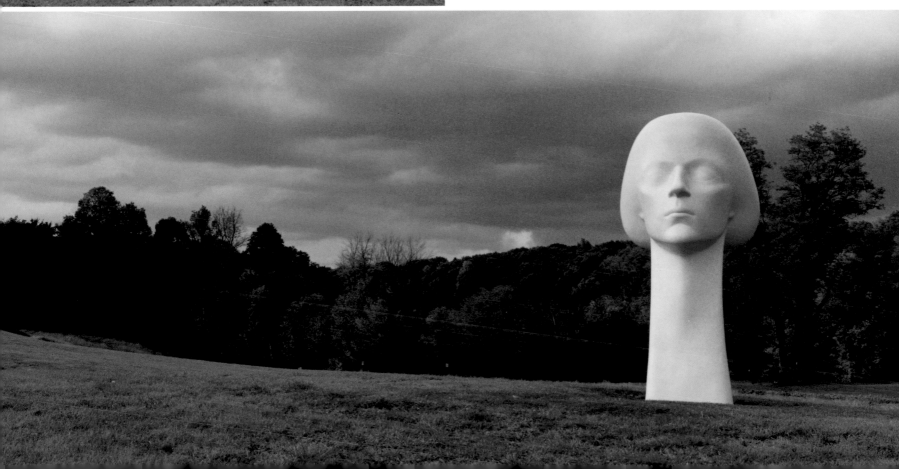

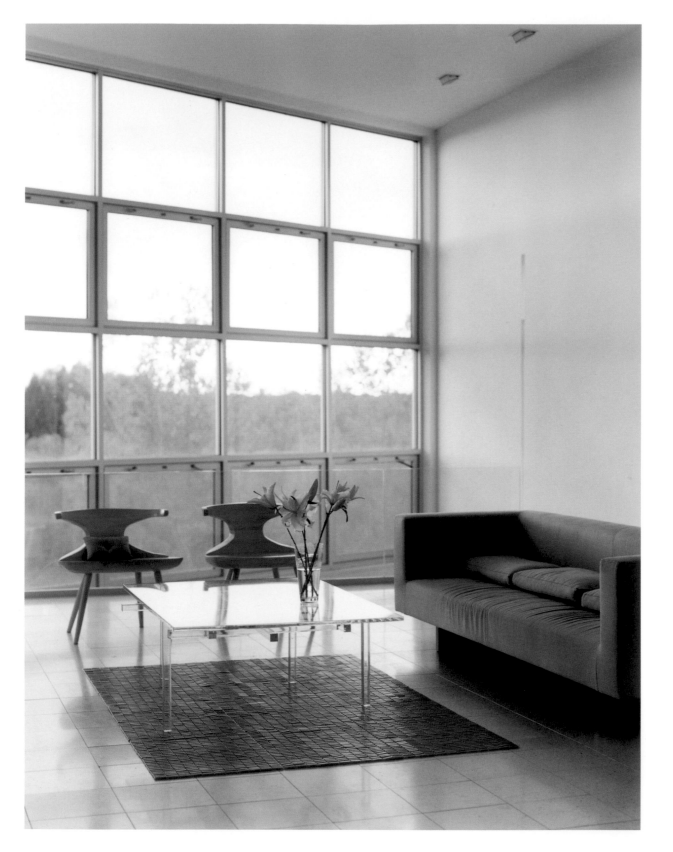

THIS PAGE: On the house's lower level, a photograph by Erica Baum entitled "Untitled (Suburban Homes)" and one by Richard Barnes titled "Unabomber Cabin, Exhibit A" are displayed on the gallerylike walls. Storm clouds are reflected in the house's glass facade at dusk.

OPPOSITE AND LEFT: Peter Franck and Kathleen Triem designed the hand-carved oak chairs and Lucite coffee table in the family's loftlike living space.

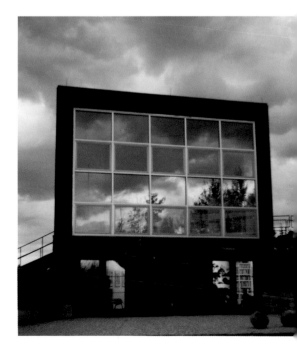

AT HOME IN THE HUDSON VALLEY FRANCK/TRIEM HOUSE

OPPOSITE: Terrazzo floors and white walls create a sparkling environment in Peter Franck and Kathleen Triem's main living space. Skylights and casement windows bring in plenty of light.

BELOW: Jene Highstein's "Inverted Cone" stands amidst the autumn trees.

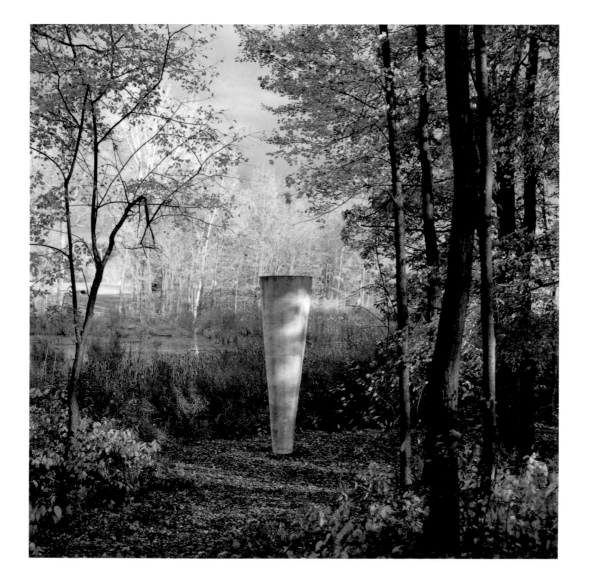

FEDERAL PROPORTIONS

WARNER JOHNSON

"When you buy a two-hundred-year-old house, you have to update it," Warner Johnson deadpans about his classical Georgian manor house in Claverack, New York, which serves as his weekend retreat. In fact, renovation on the 1780 home was minimal; the graceful brick house with Greek Revival columns was in excellent shape when he bought it five years ago.

"It was a true gem, with all the early features intact," Johnson points out. As was typical of the time and style of architecture, the house was built in a "four over four" plan, with a double parlor, dining room, and kitchen downstairs and four bedrooms on the second floor. The symmetry is echoed through-out the house, with rooms exactly the same square size, and a working fireplace in each.

Set on sixteen acres, the house sits close to the road but has a capacious backfield surrounded by woods. Visitors are encouraged to approach via the side entrance, created from an old farm road. For a dramatic effect, the driveway wends through thick woods that open onto a lush greensward. At the edge of the property is an old crab-apple grove and small pond. "It's a real treat to have so much land and still be right in the village," Johnson notes.

To make the house more comfortable, John-son updated the electrical system. He also restored the original "scrubbed" floors by sanding down the wood and leaving the planks unfinished, as was customary at the time of the house's construction. As for furnishings, Johnson prefers an uncluttered look, so the rooms are sparsely appointed with eclectic antiques. "It is a rather formal house, and I thought dressing it down would help to warm it up," he explains. In this way, he emphasizes the house's graceful architecture and period details: ceilings soar to fourteen feet; thick classical moldings adorn the windows and mantles.

Dramatic colors bring the house to life. Johnson chose historic hues from both American and English paint manufacturers, emphasizing what he calls muddy colors—shades that would have been used at the time the house was first inhabited but that somehow still look modern today. Creamy earth tones prevail, adding richness to each room. Card-room green enlivens the double parlor; the dining room has an orange-yellow glow; an upstairs bedroom is pretty in Dutch pink.

Johnson makes the trip to Claverack from his apartment in Harlem almost every weekend, frequently inviting guests up from New York. In the winter, he puts on intimate dinners in what was the house's original kitchen in the cellar, seating guests around the open hearth on old bistro chairs he picked up in Paris. "I light candles, we get a roaring fire going, and I serve a nice winter stew. It's great to remove oneself from the everyday grind of the modern world. You really get the essence of what it would have been like in the house during that time."

In the summer, Johnson says, he lives on the screened back porch. Scattered with comfortable chairs and tables, it is a peaceful spot in which to enjoy a cold drink and watch the parade of wildlife pass through his open field.

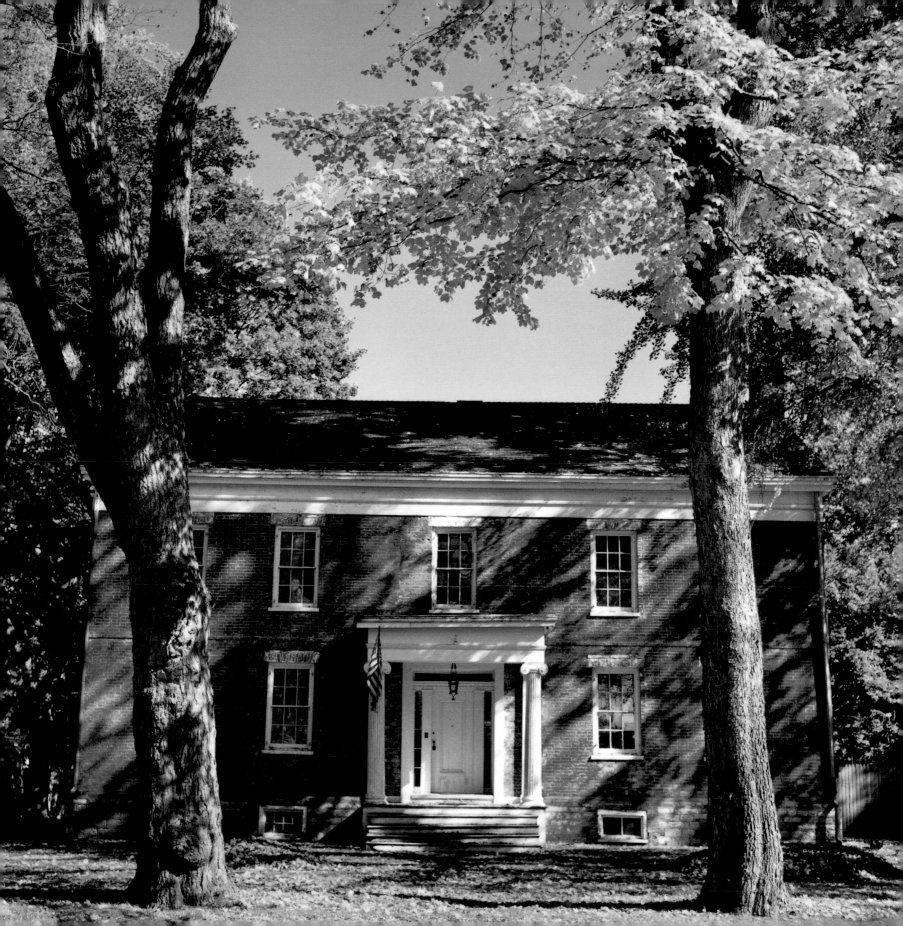

THIS PAGE: Johnson's atmospheric kitchen features wood floors and a brick hearth; work boots and Wellingtons dry out on the porch.

OPPOSITE: A fanlight in the attic is original to the 1780 home.

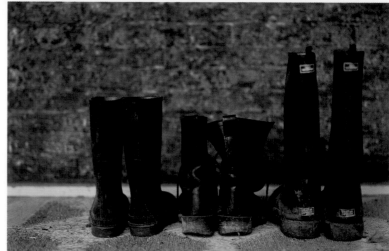

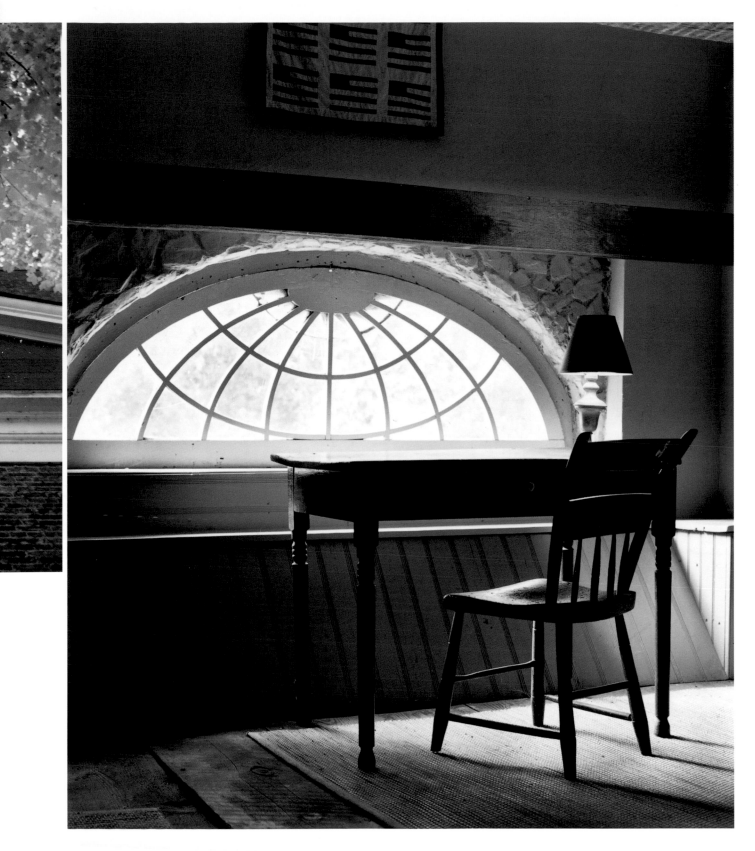

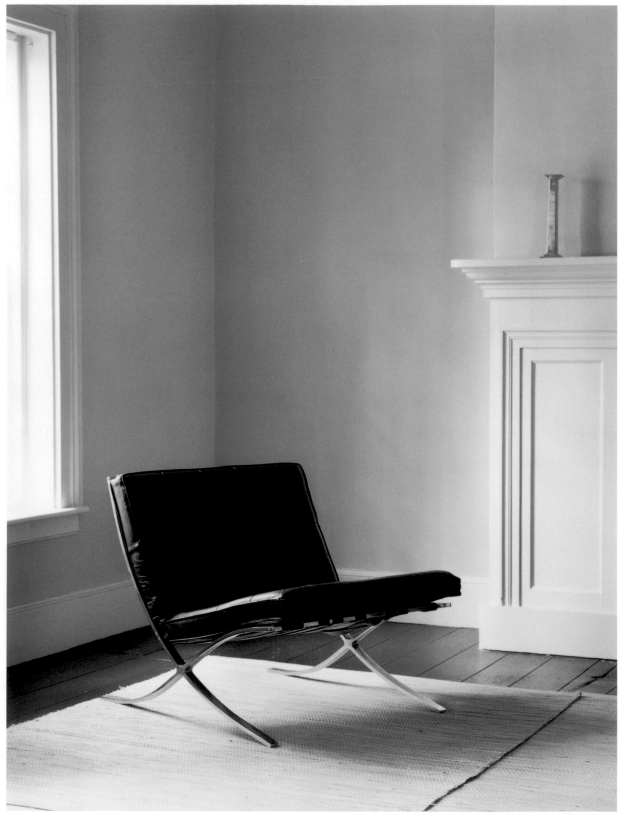

A Mies van de Rohe chair defines the simply furnished "Barcelona" guest room upstairs.

French memorabilia bedecks the "Paris" room, where reproduction Eiffel Towers abound.

Rich, deep hues on the walls define Johnson's Federal style home, where golden tones enliven the dining room.

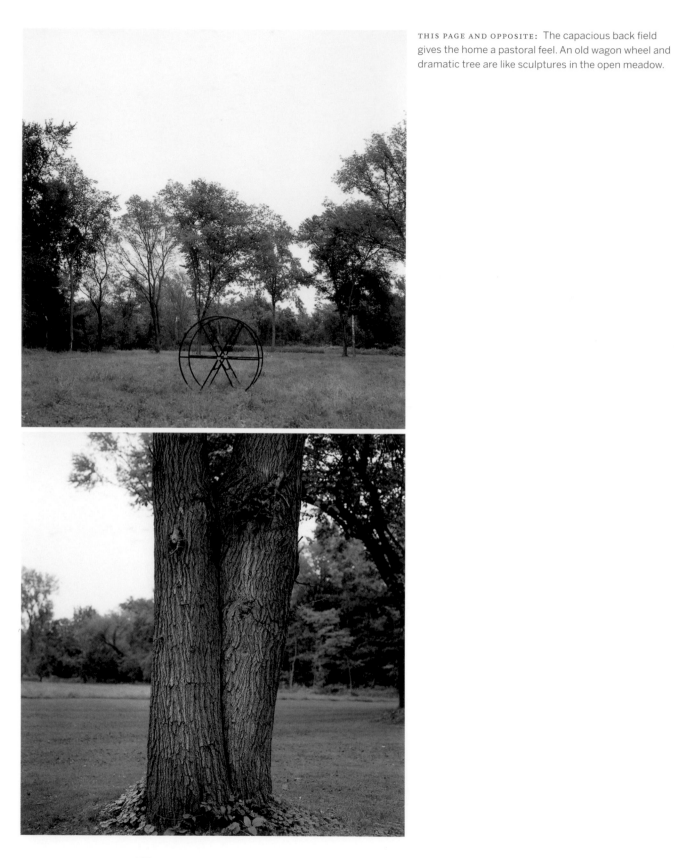

THIS PAGE AND OPPOSITE: The capacious back field gives the home a pastoral feel. An old wagon wheel and dramatic tree are like sculptures in the open meadow.

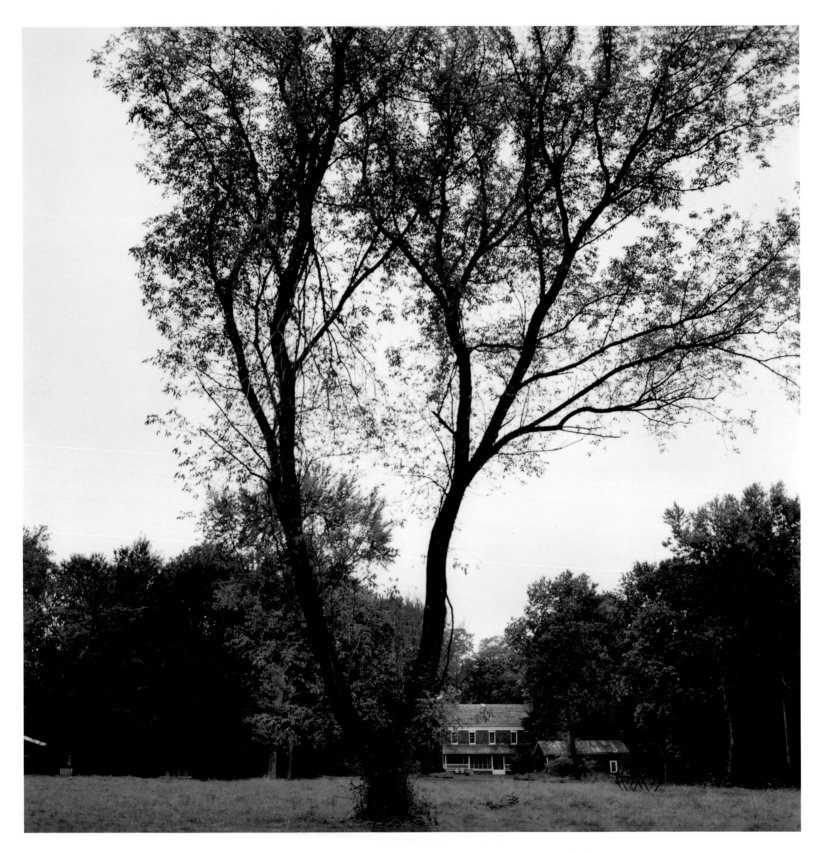

141

AT HOME IN THE HUDSON VALLEY JOHNSON HOUSE

THIS PAGE: On the back porch, sea-grass carpets and Parisian bistro chairs create an appealing outdoor dining area.

OPPOSITE: Earth tones on the walls give Johnson's home a welcoming feel, especially in the living room, where a stately chair makes a striking display against a clay-colored wall.

FAMILY FARM

CHRISTOPHER BORTUGNO

One unfortunate development in the Hudson Valley is that many local farms have disappeared as real estate prices and demand for land increases. But one family farm that will never see development is Bortugno and Sons in Kinderhook, New York.

In business since 1950, the farm, known as Glencadia, was recently placed under a conservation easement and will remain forever agricultural. Ever since he took over the family business, Christopher Bortugno III has been rising daily at four A.M. to milk the 180 Holstein and Jersey cows and to tend the property's vast cropland. With the help of his father, brother, and one hired hand, the farm produces more than eight hundred gallons of milk a day.

After a thirteen-hour work day, an exhausted Bortugno retreats to his 1810 Georgian brick home, set amid the farm's barns and silos, a house he renovated himself over many years. The building had been vacant for more than two decades when, in the early 1980s, Bortugno decided to make the place his home. During the years of neglect the ceilings had caved in, walls had crumbled, and a sumac tree had taken root in the basement.

Bortugno tore down the walls on the ground floor to create a single living space, created a cathedralized ceiling where there had once been an attic, and erected balustrades around the second floor. He kept the original brick walls and all the original trim, adding Carolina yellow pine floors upstairs and down. He converted the cellar, with its original brick flooring, into a cozy kitchen.

With little cash to spare for furnishings, Bortugno learned creative acquiring early on. He has been trolling auctions, flea markets, estate sales, and even the local dump for years, unearthing unusual treasures. He found an old claw-foot tub at a local dump and painted it a beautiful olive green; a wrought-iron grate with gilded dragons, salvaged from an old theater in Manhattan, adorns his second-floor balcony.

A keen cook, Bortugno regards his kitchen as a place of pride. He picked up a ten-burner 1929 Garland stove from a local music academy, and it's now the centerpiece of his moody and atmospheric cellar. He found an industrial stainless-steel table at the local Pizza Hut and a stainless-steel sink from an old Dutch inn. Bortugno's collection of antique chafing dishes in copper, silver, and nickel hang on the walls.

Some lucky finds appeared right on the property, such as an 1860s Glenwood Oak cast-iron stove, which Bortugno unearthed from the stable. He found the replacement pieces he needed at a local auction and painted the stove a glittering silver. The ornate piece provides much-needed heat during the winter, when Bortugno burns through four and a half cords of maple, pine, and oak wood from the property. For Bortugno, resourcefulness is a necessity on a farm. "Being a farmer means you have to be the plumber, electrician, mechanic, and even the veterinarian," he says.

In the evenings, Bortungo does odd jobs around the house, and often enjoys cooking and entertaining for a crowd, serving hearty fare in his beloved chafing dishes. As a yearly tradition, on the Saturday before Christmas, Bortugno lights kerosene lanterns and places them in all the windows to welcome 140 people for cocktails and dinner.

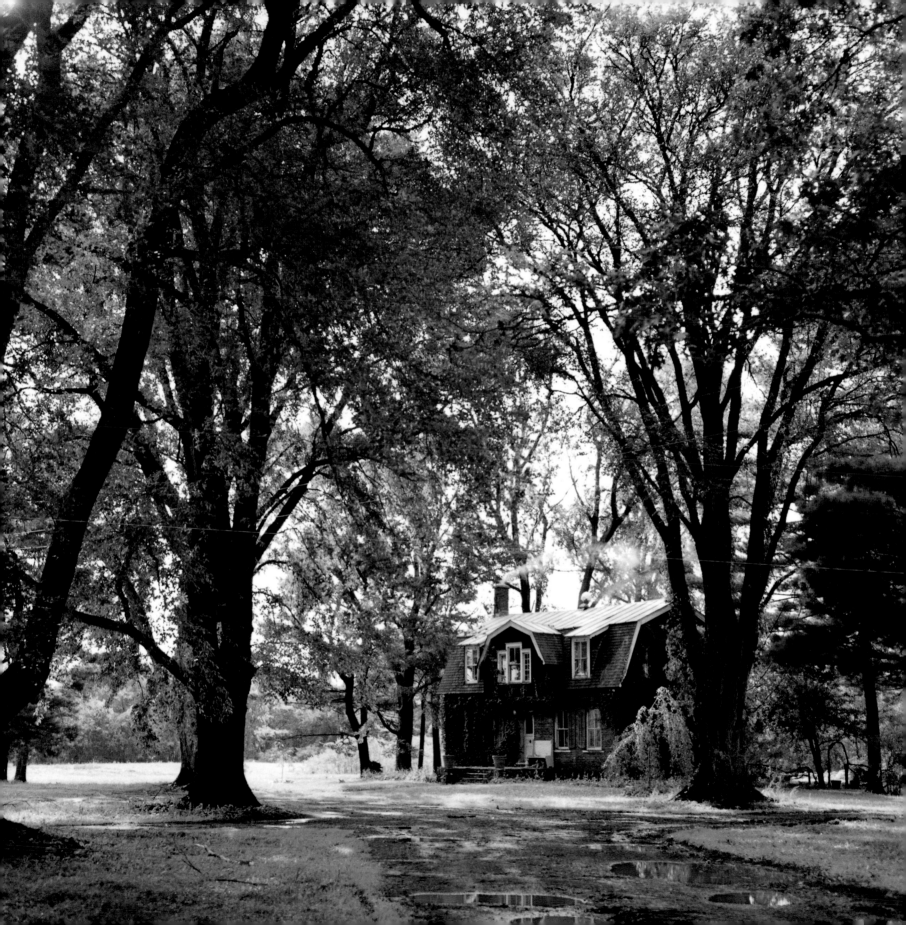

THIS PAGE: The weathered façade of Bortugno's 1880 Georgian brick home takes on many textures.

OPPOSITE: A kerosene lamp is a romantic fixture in the ivy-covered windows.

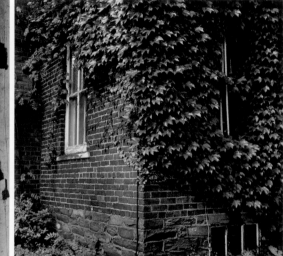

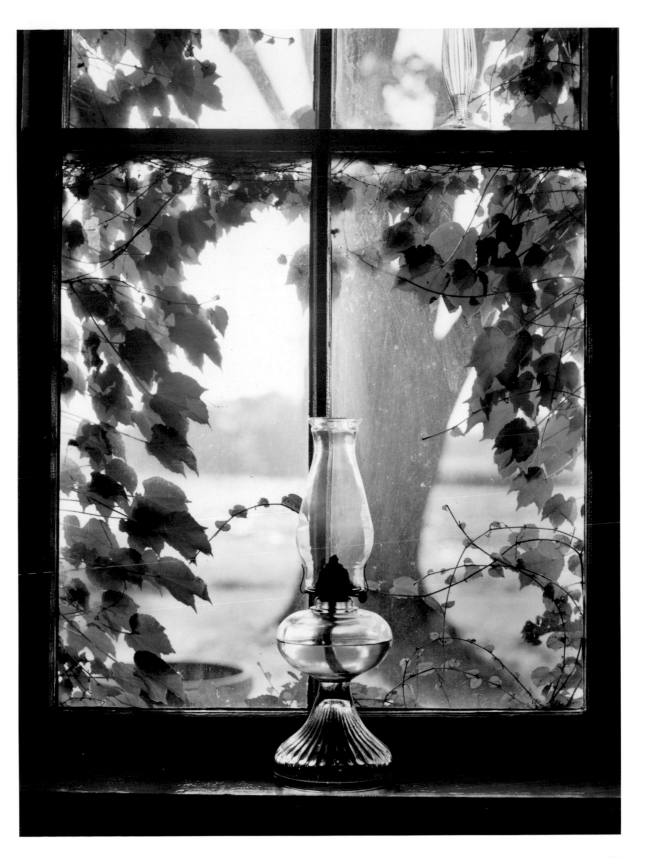

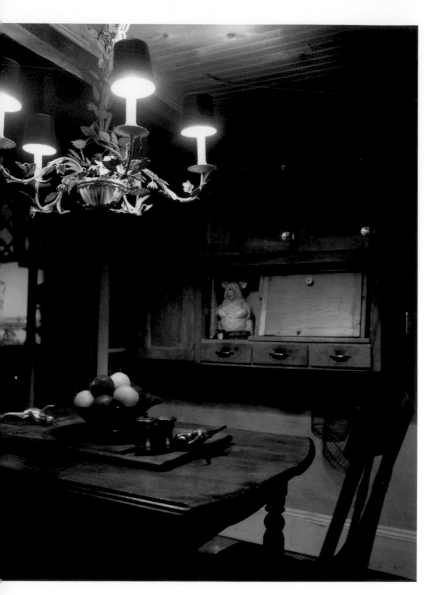

Bortugno's atmospheric cellar kitchen features
a salvaged chandelier.

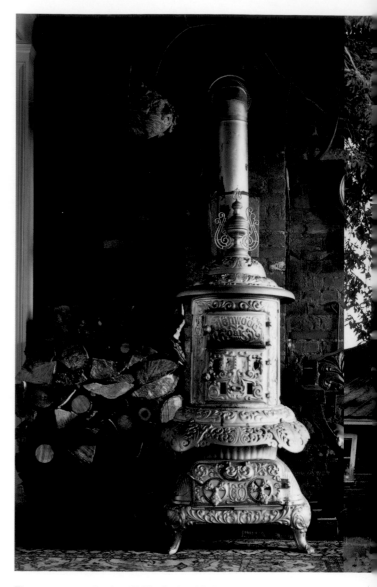

The owner unearthed an 1860s Garland Oak cast-iron
stove from one of the barns.

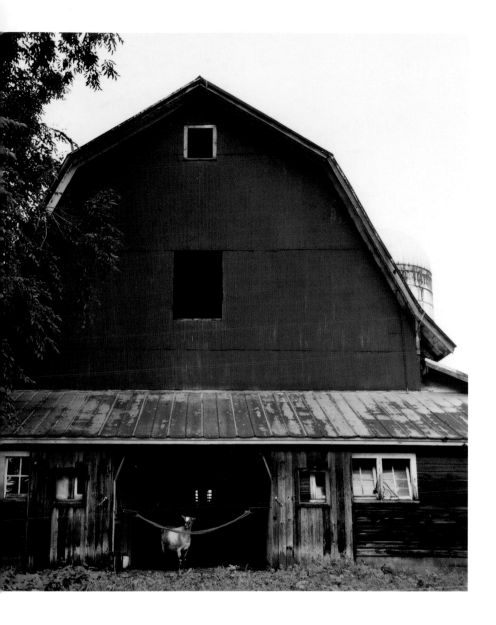

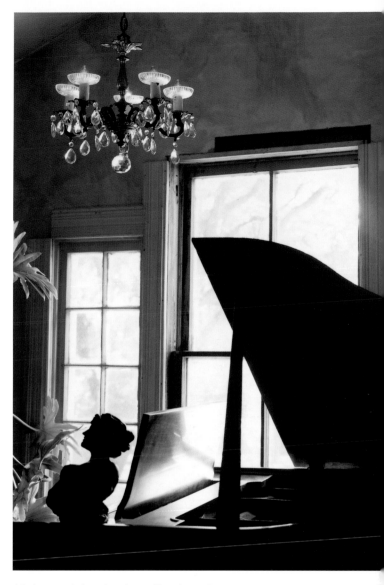

A baby grand piano is a decorative element
on Bortugno's upper floor.

THIS PAGE AND OPPOSITE: In business since 1950, Glencadia Farm has 180 Holstein and Jersey cows. A few of the old barns on the property have been restored; a vintage gas pump suggests the dairy farm's early days in business.

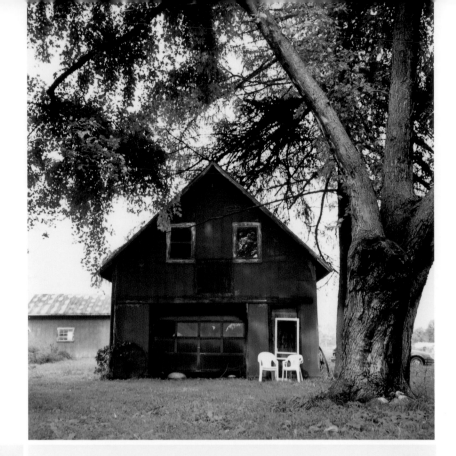

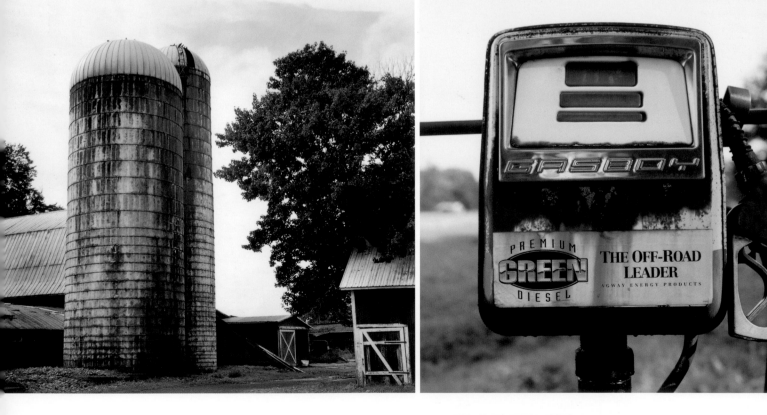

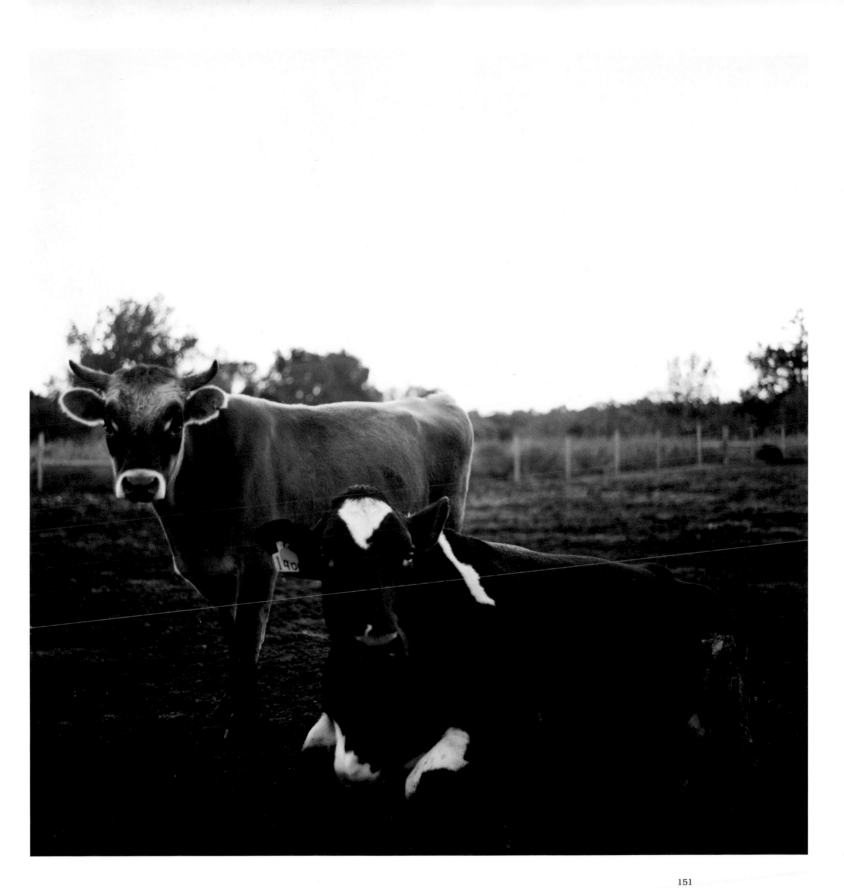

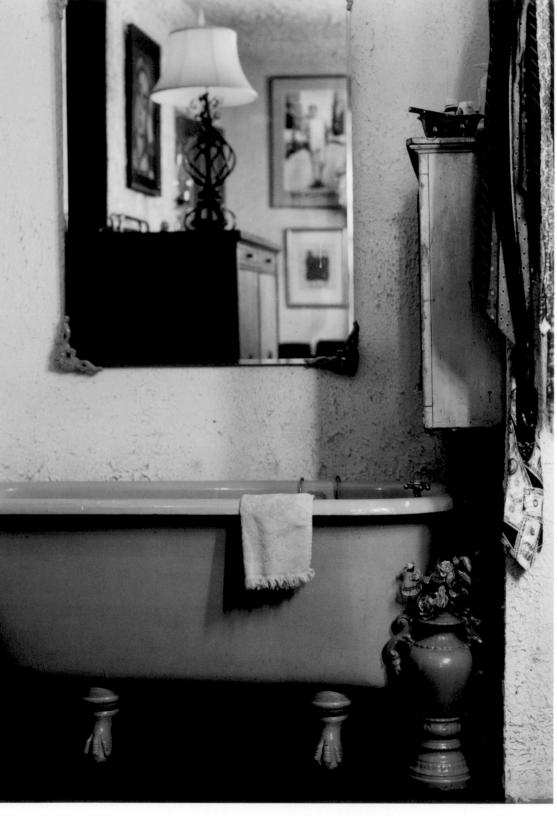

AT HOME IN THE HUDSON VALLEY BORTUGNO HOUSE

OPPOSITE AND BELOW: A moody quality pervades
Bortugno's home: a gargoyle from Mexico; a vintage claw-
foot tub and assorted antiques in the bathroom; a massive
chandelier hangs from the upper-story ceiling.

STAINED-GLASS STUDIO

MARK BEARD

When, on weekends, artist Mark Beard travels to Catskill, New York, from his home in Manhattan to paint, he retreats to an 1840 neoclassical church with soaring ceilings and graceful stained-glass windows. "I've always liked neoclassical buildings, and I just loved this church," Beard says of the building he purchased two years ago.

With five thousand square feet and thirty-foot ceilings, the church offers plenty of room for working on and storing large canvases. But there are practical concerns: the space is difficult to heat in winter, and although a bathroom had already been put in, Beard has only a rudimentary kitchen, with a microwave, hot plate, and mini-refrigerator. The furnishings are minimal, too: several large sofas covered in drop cloths create a central seating area, and a makeshift bedroom has been fashioned from what was once the choir loft.

The church—Christ's Presbyterian—was deconsecrated in 1995 because of dwindling membership. Many locals feared that the building would be torn down, as it lacked official landmark status. It was finally rescued in 2001 by Beard's friend and neighbor Frank Faulkner, who purchased the church and later sold it to him. (Faulkner lives in the church's lyceum next door.)

The sanctuary boasts a massive pipe organ built in 1897, as well as original exterior columns, fir flooring, and solid mahogany doors at both ends.

The church is ringed with stained-glass windows, installed in about 1910. The Beaux Arts designs, abstractions of classical architectural themes, gleam in the light with opalescent green and brown tones.

"The light is darker than it would be with clear glass," Beard notes. "It gives a slightly warmer light, and it is quite beautiful when the sun comes out. The light moves throughout the church, and you can always tell what the weather is outside."

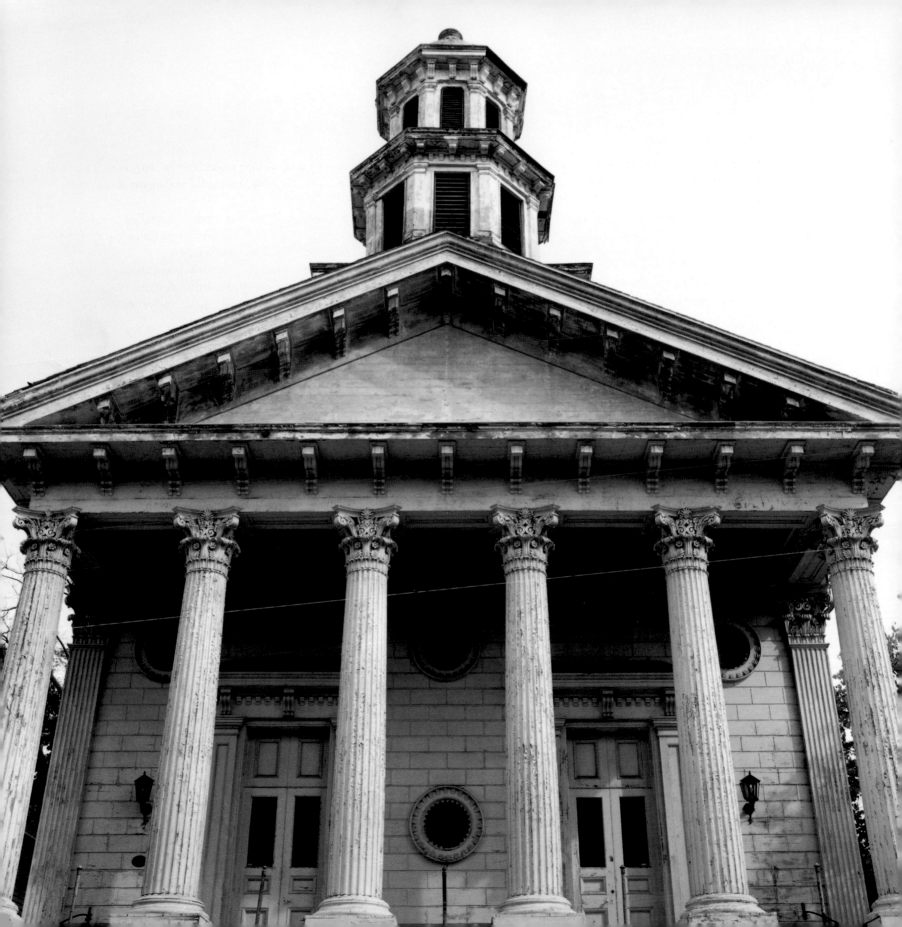

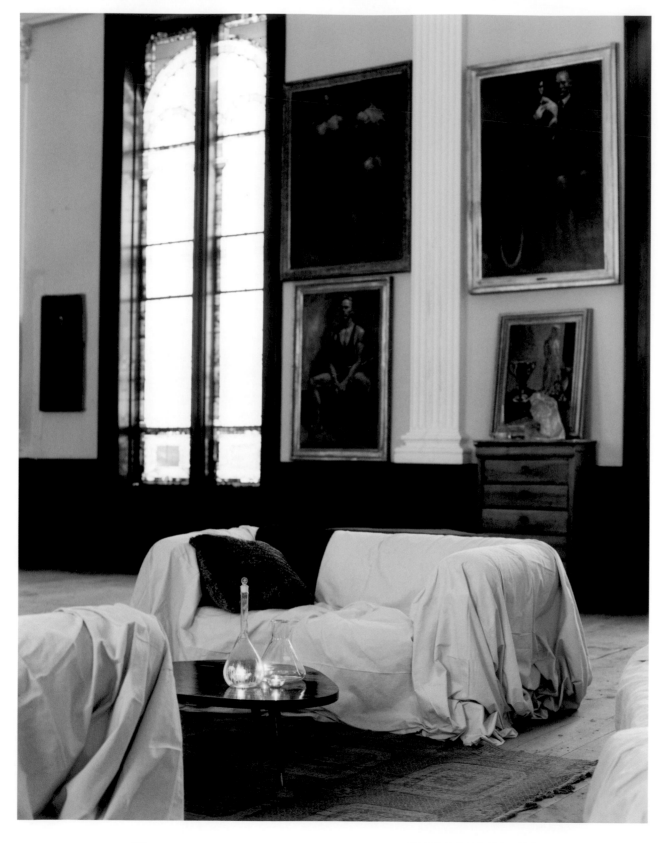

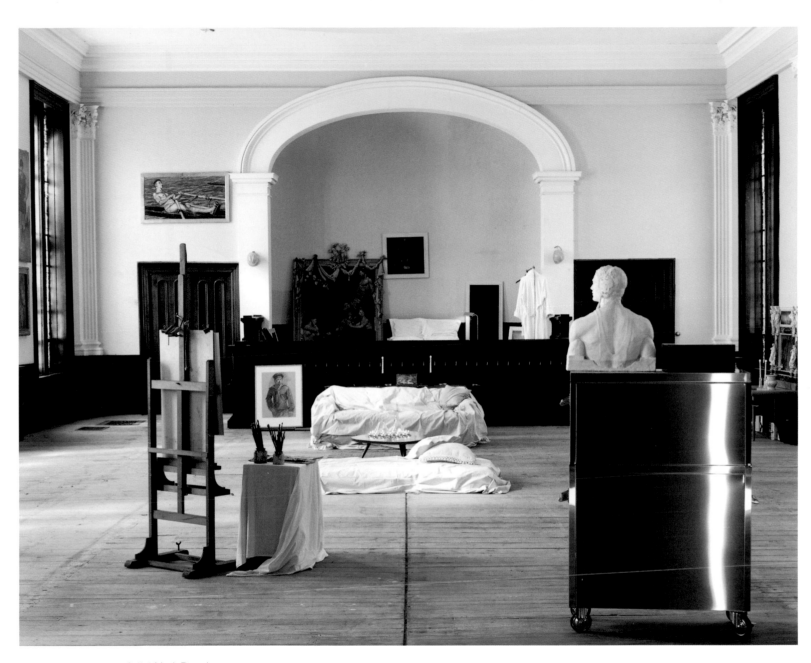

OPPOSITE AND ABOVE: Artist Mark Beard uses
the main space of his 1840 church for painting and
gathering. At the back of the room, a former choir loft
has been fashioned into a bedroom. Paintings by Bruce
Sargeant grace the wall by a stained-glass window.

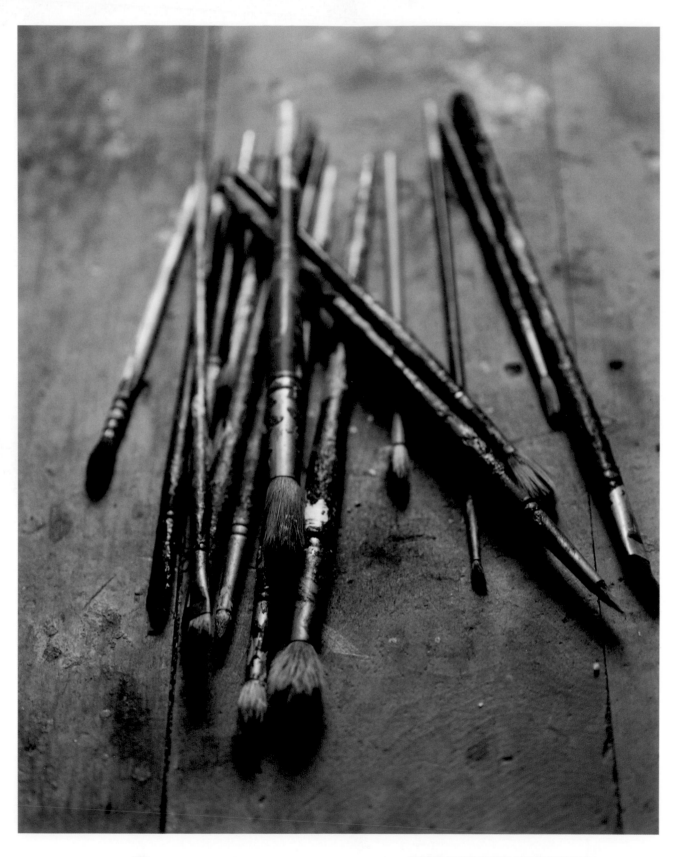

AT HOME IN THE HUDSON VALLEY BEARD HOUSE

THIS PAGE: Original neoclassical columns create
a stately façade in front of the 1840s church. Inside,
ceiling lights mimic the molding.

OPPOSITE: The artist's well-worn brushes make a
still life of their own.

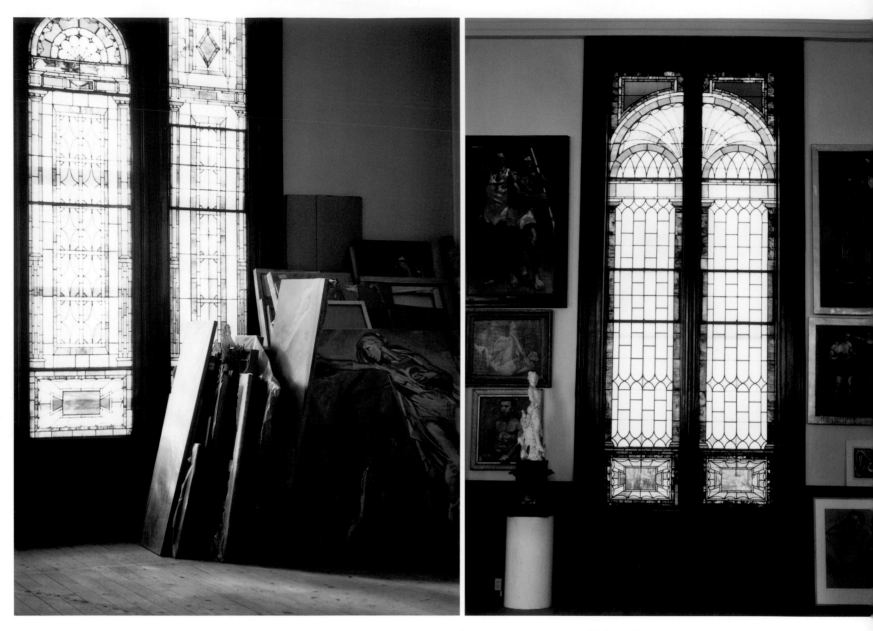

THIS PAGE AND OPPOSITE: Stained-glass windows, installed about 1910, feature Beaux Arts designs and abstractions of classical architectural themes. Their opalescent green-brown glow reflects light onto the rough fir flooring. The owner hangs paintings by various artists on the walls.

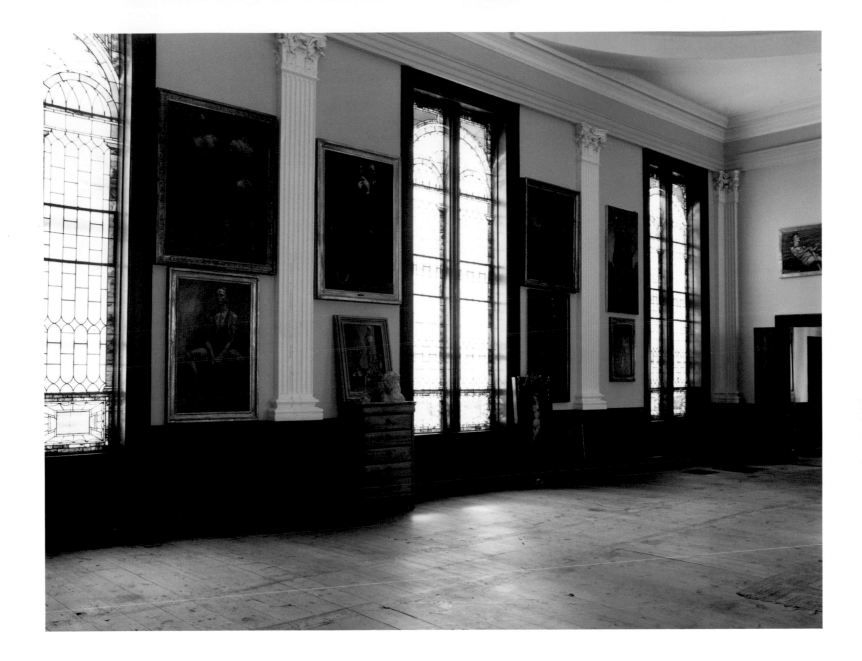

THIS PAGE AND OPPOSITE: Classical sculptures
punctuate the studio, where many works in progress
are on display.

TOWN HOUSE MEETS BAUHAUS

WILSON KIDDE

In the preservation-minded town of Hudson, New York, modernizing an 1830s town house is bound to raise a few eyebrows. But when it came to saving a derelict building from decay, owner Wilson Kidde decided to do something bold.

"I took a Federal house and made it Bauhaus," says the artist and writer, who bought the place, which he uses as a weekend retreat, from a friend four years ago. In looking at the house with an architect, Kidde saw the potential for a more modern renovation, one that would retain the building's footprint but let more light inside. "I started thinking about an International Style approach," he remembers.

As a result, the entire back side of the building was redone with floor-to-ceiling windows. Beyond that, Kidde says, "There was no overall plan except to keep whatever original features we could."

Luckily, they were able to save the brick facade of the narrow, fifteen-foot-wide building which is wedged between two other houses from the same period. In addition, Kidde kept the original staircases and the American cherry banister.

Kidde also kept the living room's original exposed brick wall and some of the original flooring. He furnished the space with a few midcentury modern pieces as well as other eclectic items from friends, and he installed a wood stove for a homey appeal.

To modernize the home, Kidde put in a completely new kitchen. He installed a gorgeous industrial sink of forest green limestone that had been refinished and outfitted with new faucets. The rubber-tile floor is both stylish and practical, as are the birch cabinets and Formica countertops. The room's updated look is warmed by wood furnishings.

The third floor was in major disrepair, so Kidde gutted the entire space, added a back deck, and put in new maple floors. Since he uses the open, loftlike space for his bedroom, he installed a Pullman bath with a bluestone surround and slate floors. The result here, as in the rest of the house, is a whimsical interplay between old and new.

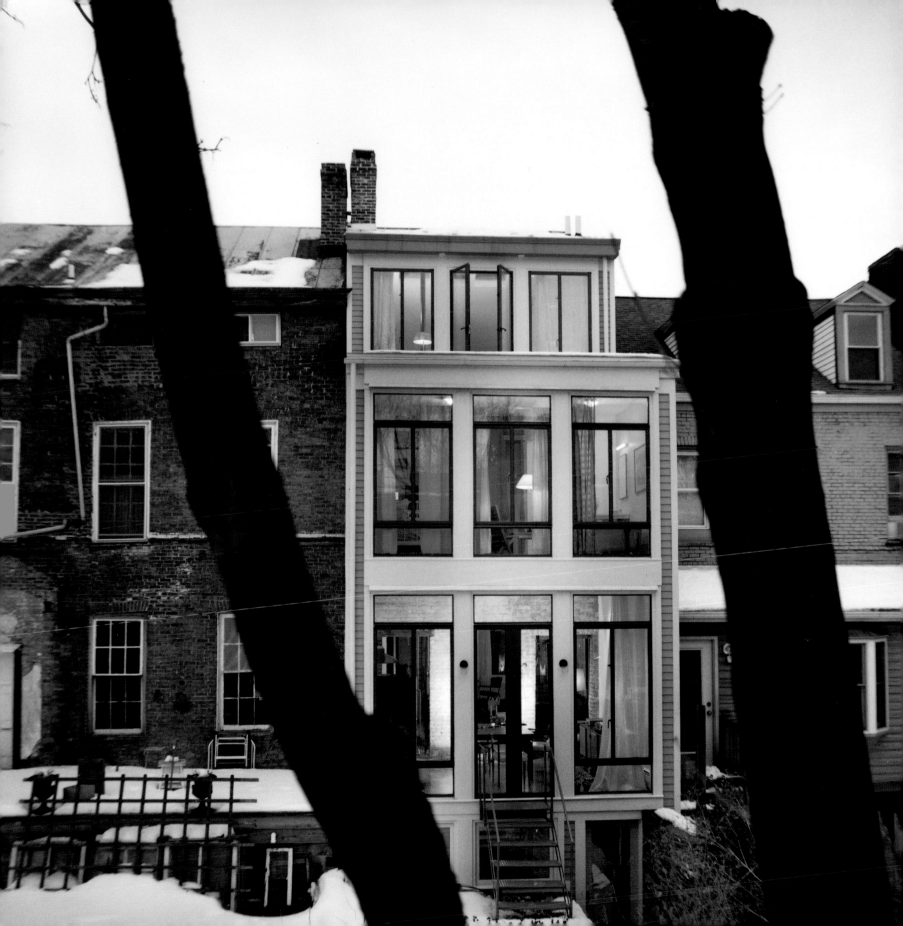

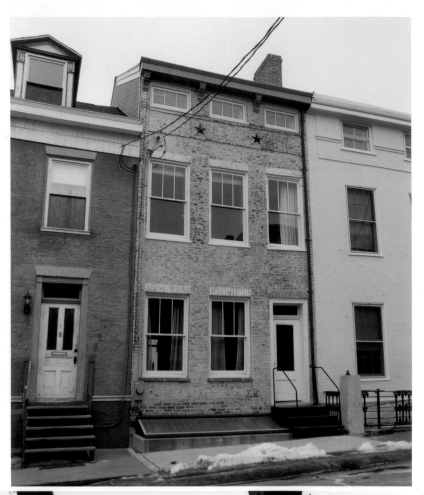

THIS PAGE: At the front, the 1830s town house is typical of buildings found in Hudson, New York. A view of the back shows the modern renovation with copious windows creating a nearly all-glass exterior.

OPPOSITE: The living room highlights the original front windows and American cherry-wood banister.

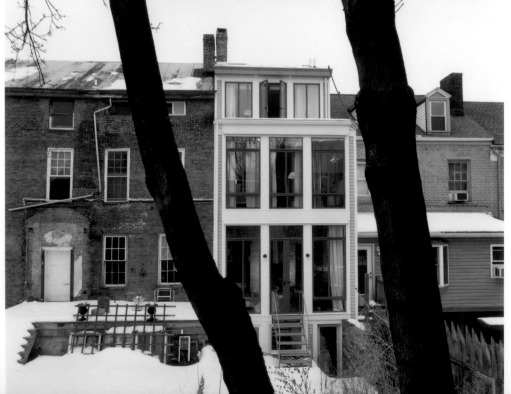

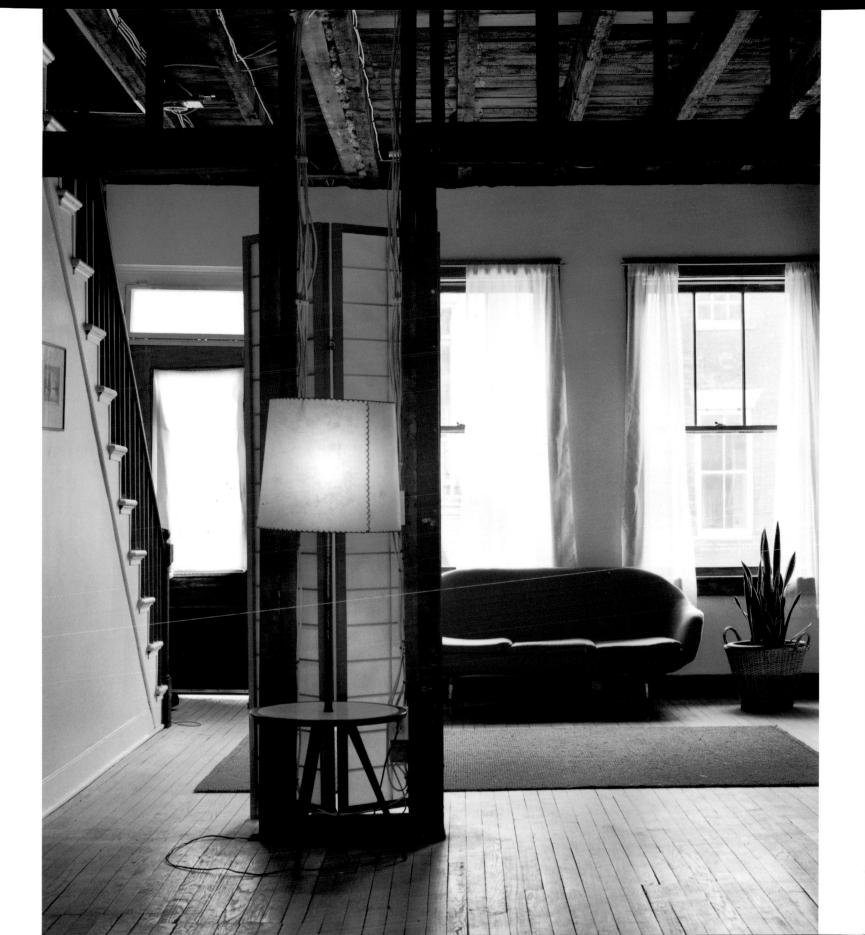

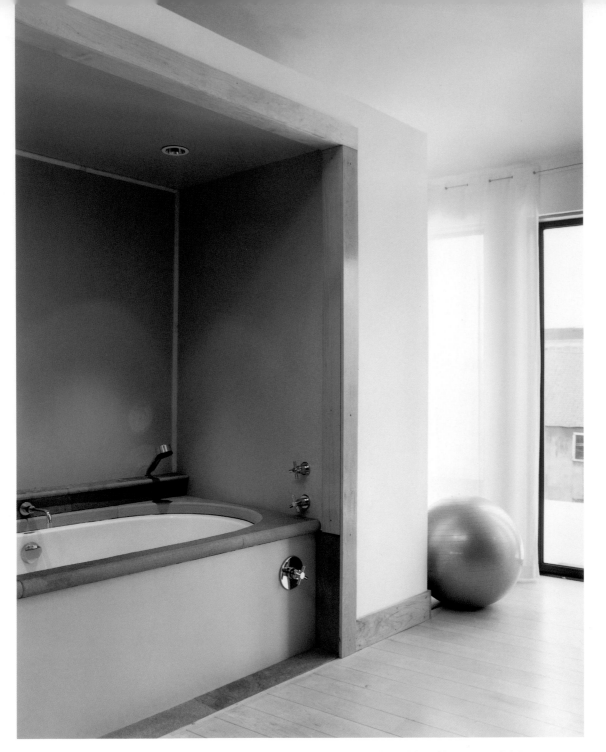

A Pullman bath fashioned from bluestone and slate creates an open bathing area in the master bedroom.

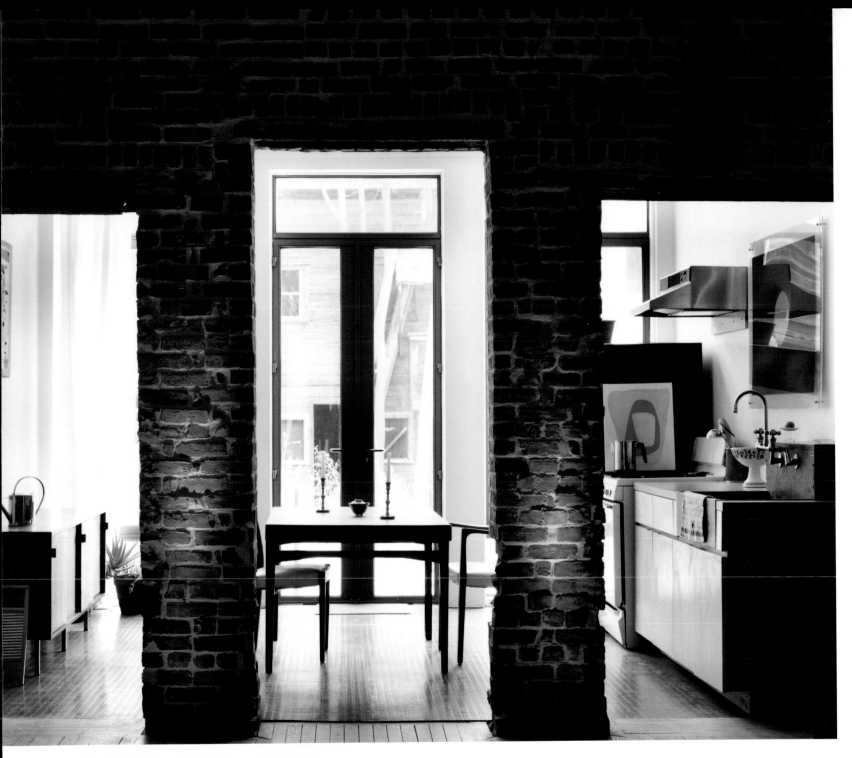

An original brick wall leads to the updated kitchen, where an industrial limestone sink is offset by warm wood furnishings.

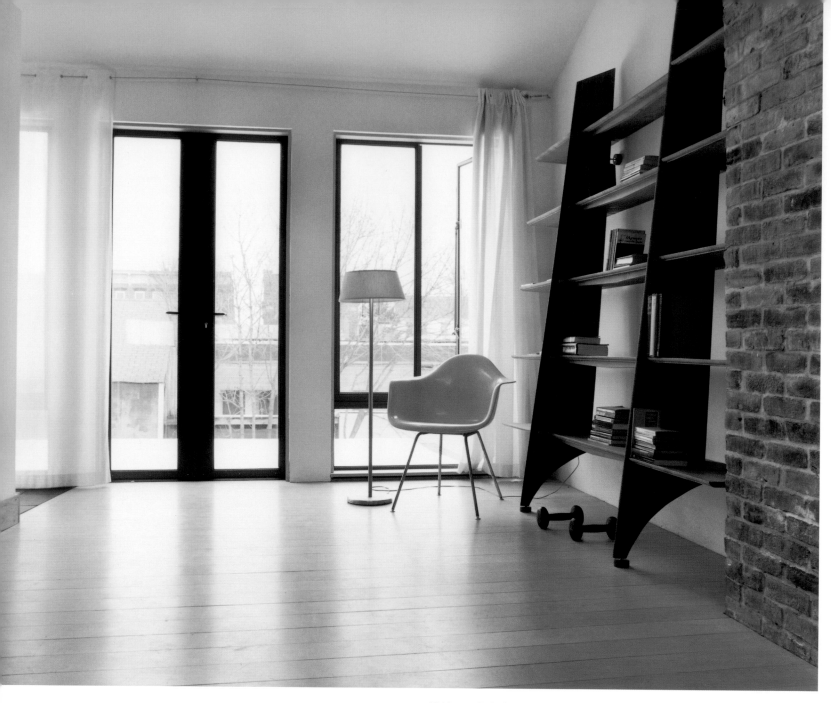

Kidde created a large open space with new maple floors for his bedroom. French doors lead to the large deck; handmade shelving and exposed brick give the room warmth and texture.

171

FABULOUS PREFAB

KARIM RASHID

Product designer Karim Rashid, known for his colorful, organically shaped furnishings and accessories, had only one requirement when he began looking for a weekend escape a few years ago: it had to be less than one hour from New York by train.

"I travel for work all the time, so I never want to get on a plane for a vacation. Planes are awful, and the time change is a killer," he says. So when he happened upon a Techbuilt house in Croton-on-Hudson, within easy access to the train station and Bear Mountain State Park, Rashid knew he was on the right track.

"I never thought I would buy a house in the country, because I have so many allergies to grass and trees," says the diehard urbanite. But when he made the decision to close his design studio for part of August every year, he yearned for a quiet escape outside the city.

Designed in 1956 by Carl Koch, a vanguard German architect who pioneered Techbuilt prefabricated houses, Rashid's retreat was built in three days using a flexible panel system and post-and-beam construction, easily positioned for optimal sun, light, and ventilation.

The house is sited on 1.5 acres of woods, and faces west toward the Hudson River; generous windows bring plenty of light to the interior. Rashid has retained the original colors inside and out: bright yellow and cobalt blue adorn the streamlined, peaked-roof exterior; the same blue is repeated on one living room wall. He has also filled the house with colorful furnishings—many of his own design—and large-scale canvases. Within the light-filled space, pomegranate-colored dining room chairs and citrus-hued chaises pop like candy.

Upstairs is a serene loftlike space with two bedrooms and an office. The walls are white and the furnishings minimal to emphasize the airiness of the space, which is warmed by original hardwood floors and gauzy, floor-to-ceiling white curtains.

Rashid and his wife, Megan, retreat to the house about once a month. Together they draw and look for inspirations for designs. "Mostly we relax, reflect, and rebound," the designer says. In addition, the couple often throws casual dinner parties here for friends up from New York, a welcome respite from the busy pace during the week. "In the city, no one seems to get around to having people over," Rashid laments.

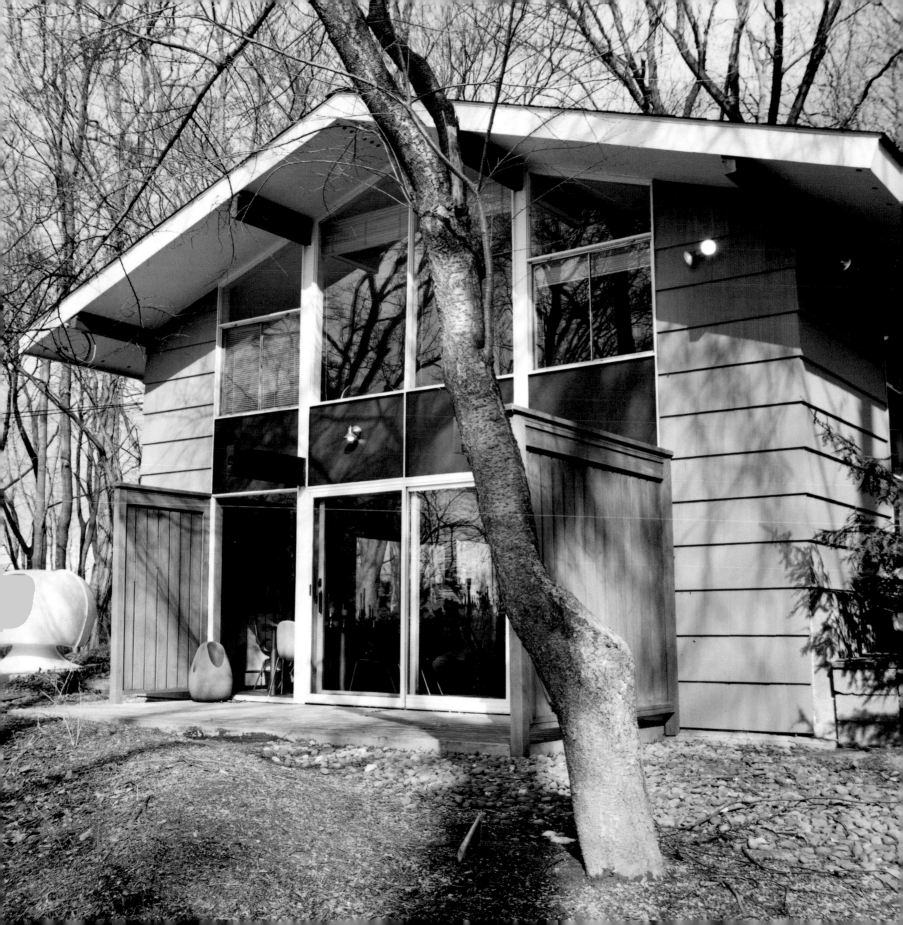

Pop goes the living room: Rashid retained the original
blue-and-yellow color scheme of the house and filled
the space with playful modern furnishings with organic
shapes and bold colors. A painting by Rashid's wife,
Megan Lang, hangs above the couch.

y

174 **AT HOME IN THE HUDSON VALLEY** RASHID HOUSE

THIS PAGE: A guestroom in the loftlike upstairs emphasizes warm wood and plenty of natural sunlight. Curvy shapes and vibrant colors characterize much of the furnishings and accessories in Rashid's home.

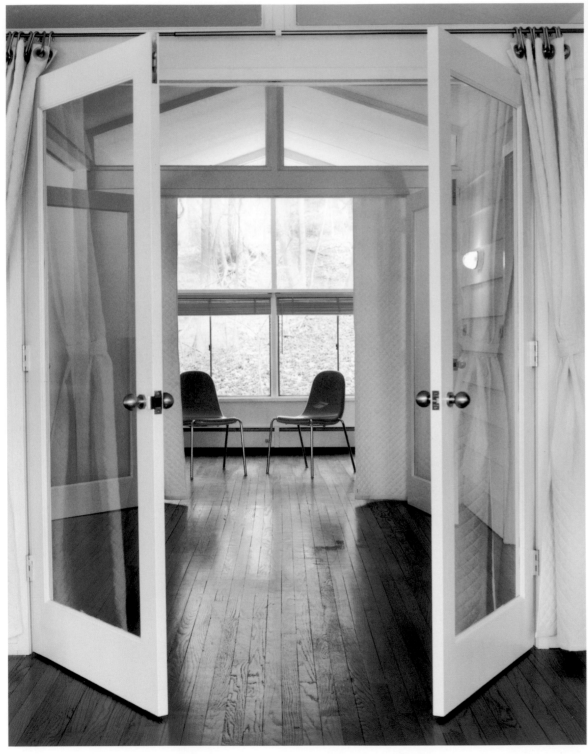

AT HOME IN THE HUDSON VALLEY RASHID HOUSE

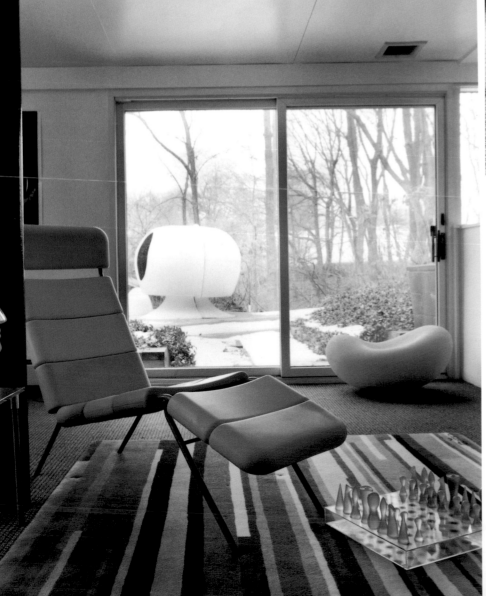

177

INTO THE WOODS
ADAM YARINSKY AND AMY WEISSER

The interplay between the man-made world and the natural one necessitates a tricky balance, one architect Adam Yarinsky has expertly pulled off with his weekend retreat in Garrison, New York. Built for his wife, Amy Weisser, and the couple's two young children, Yarinsky's modernist, light-filled dwelling provides the ultimate family retreat while responding sensitively to its surroundings.

The house consists of two, sixty-by-twenty-foot rectangular blocks joined together and terraced in relation to the sloping hillside property. With an open public space at ground level and more discreet rooms for sleeping below, the house takes on a modified loft plan for maximum flexibility. The family wanted an open kitchen, living, and dining space to accommodate different degrees of entertaining. Yarinsky explains, "There is always something going on in the kitchen, so it shouldn't be cut off." At the same time, the open space means that his children can run freely through the main living area.

To join the house with the outdoors, Yarinksy placed a premium on windows, with 40 percent of the perimeter made of glass, which envelopes the dramatic landscape beyond; in winter, the living room incorporates a stark vision of trees and a rocky hillside. A clever system of mesh shades and casement windows on both sides allows for adjustable sun penetration and cooling cross breezes. To further emphasize the natural picture, Yarinsky used a supporting framework of Parallam, a composite lumber cut from huge stands of trees. The material mimics wood's natural grain and is consistent in pattern and direction. The verticality expressed throughout the space—accentuated by the eleven-foot ceilings—echoes the quiet drama of the trees outside in a way that is both subtle and arresting.

Outside, the striking building hugs the land, with an emphasis on horizontality that keeps the low-slung structure connected to the ground. The architect used horizontally corrugated aluminum siding that also highlights the breadth of the five-acre site.

Straightforward materials define the house's construction. The floor is poured concrete with radiant heat. For visual warmth, Yarinsky and Weisser chose wood furnishings. A friend fashioned the family's coffee and dining tables out of walnut planks; Yarinsky built a series of open shelving sets out of medium-density fiberboard stained to look like wood.

In the summer, the family takes to the outdoor patio at the back of the house, where Yarinsky created a discreet living area that makes good use of the distinctly warmer microclimate. (The area is sheltered from the wind.) Large pavers help define the area, and an all-purpose stainless-steel table serves as dining space.

In Garrison, life takes on a slower pace that what the family is used to during the week in Manhattan. "It's refreshing to get away, and I don't do any office work here," the architect points out. "We mostly hang out and cook; the kids do art projects. And we all do a lot of yard work." Sometimes, in the evenings, the family gathers around the telescope to admire the stars in the clear night sky.

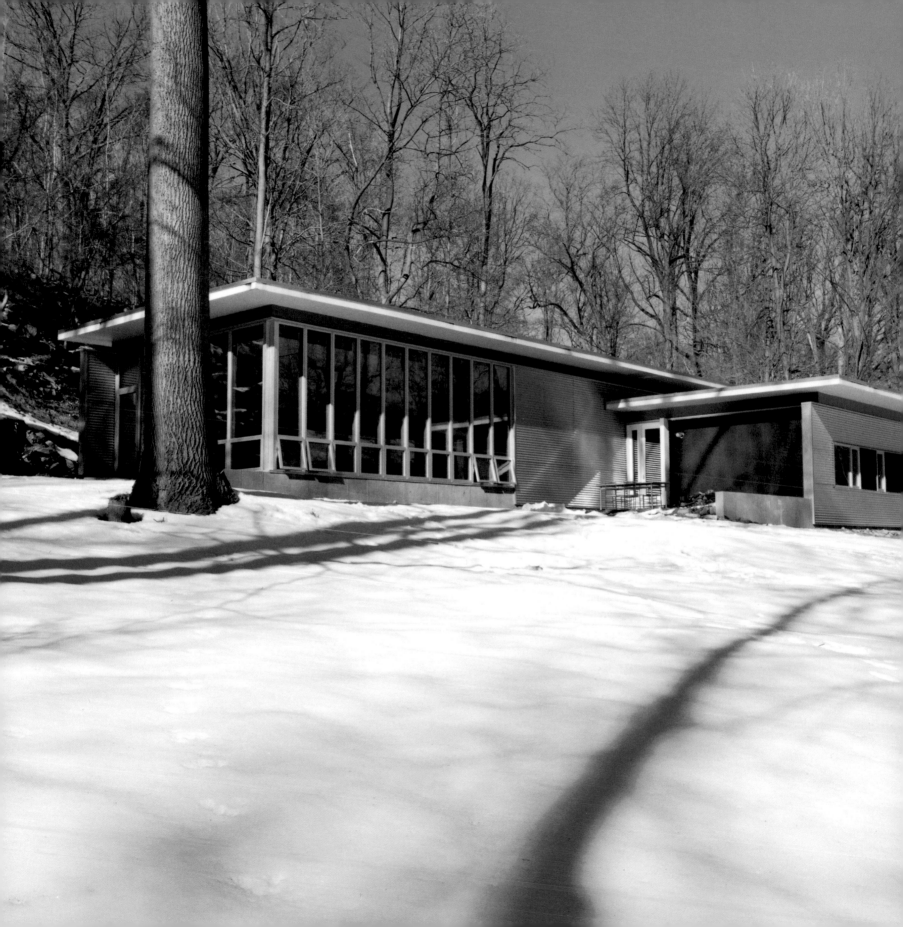

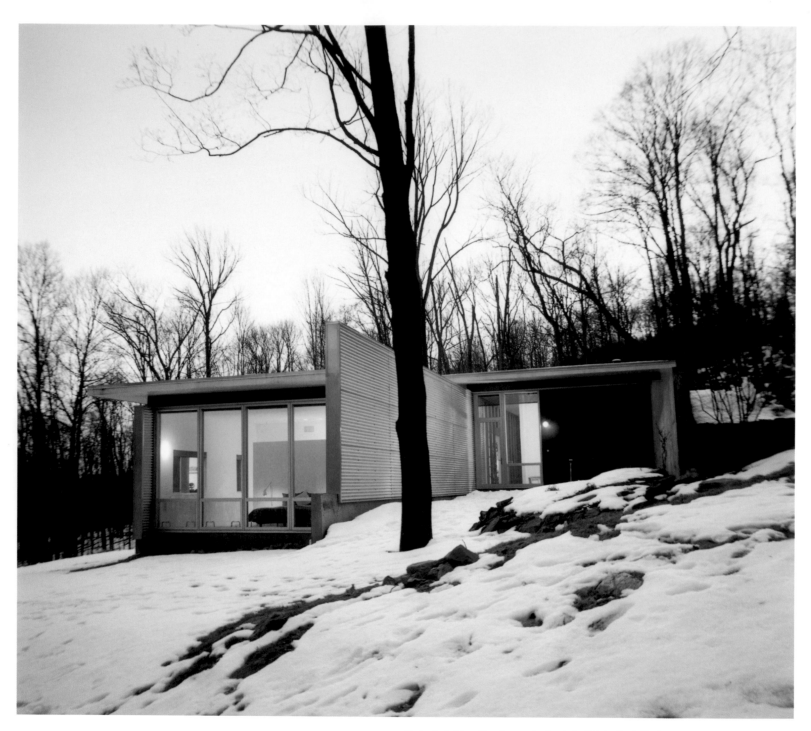

Yarinsky's bisecting-boxes design is built into the hillside; 40 percent of the perimeter is made of glass to envelop the landscape beyond.

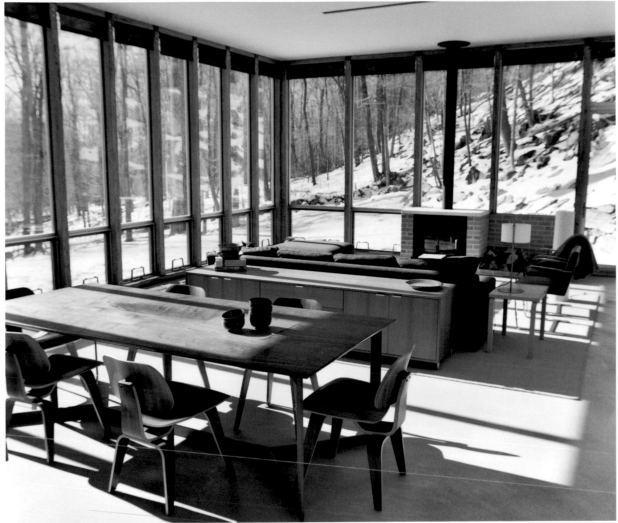

ABOVE: The main living space is wrapped in glass for a seamless integration with the woods beyond.

LEFT: Horizontal, corrugated-metal siding emphasizes the low-slung nature of the house's design.

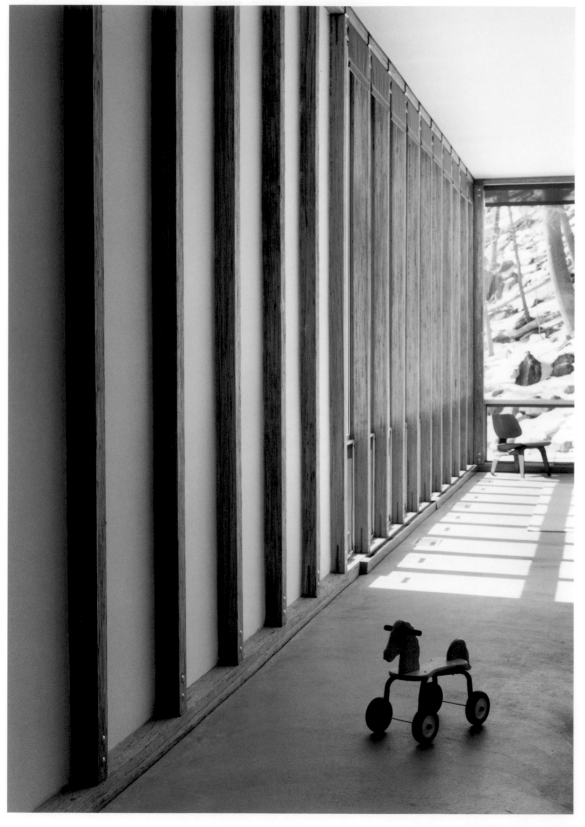

Yarinsky used Parallam, a composite lumber cut from huge stands of trees, for the house's supporting framework.

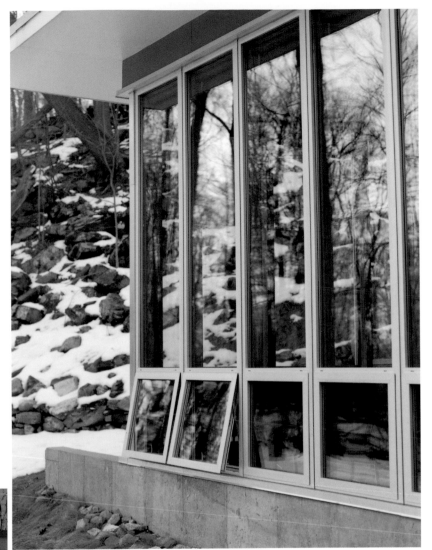

ABOVE: Casement windows around the main living space provide cooling cross breezes to regulate the sun's heat.

LEFT: A patio behind the house serves as a family gathering spot.

183

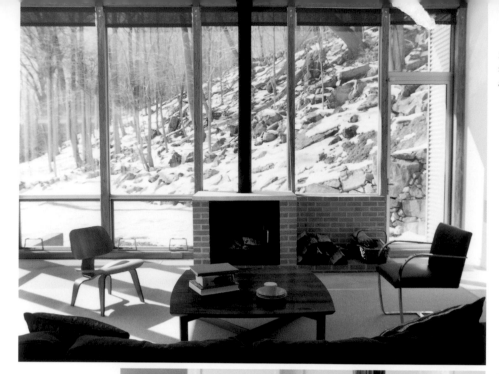

LEFT: The living room looks out onto a snow-covered rocky hillside, which makes for a dramatic scene in winter.

LEFT AND OPPOSITE: Yarinsky designed open shelving made of medium-density fiberboard stained to look like wood in both the bedroom and hallway.

RESOURCE GUIDE

Steeped in history, rich in natural beauty, and boasting a burgeoning art scene, the Hudson Valley has much to offer visitors. From its dramatic scenery to its picturesque towns, from the mansions and historic sites along the river to the many impressive museums and performance spaces, the Hudson Valley has something for everyone, including opportunities to eat and drink well and charming places to stay.

Easily accessible by train or car from New York City, New England, and Pennsylvania, the Hudson Valley is a four-season destination. Fall is ideal for foliage viewing, wintertime brings cozy cold-weather pursuits, springtime in the valley is lush and green, and summer is perfect for hiking, boating, and other outdoor adventures.

The following recommendations are not a comprehensive travel guide. The suggestions listed here represent many of the area's best-loved establishments; many of the ideas for shopping, dining, and lodging reflect the interests and experience of the home owners in this book.

SHOPPING

ALAIN PIOTON/HUDSON ANTIQUES CENTER
536 Warren Street
Hudson, NY 12534
518-828-9220

Fine selection of old-world antiques

CLOUDS
1 Mill Hill Road
Woodstock, NY 12488
845-679-8155

One-of-a-kind glassware and jewelry

FACE STOCKHOLM
401 Warren Street
Hudson, NY 12534
518-822-9474

Cosmetics and gifts for the home from the Swedish retailer

MARK McDONALD
555 Warren Street
Hudson, NY 12534
518-828-6320

Twentieth-century American and Scandinavian furnishings, ceramics, and design books

OLDE HUDSON
434 Warren Street
Hudson, NY 12534
518-828-6923

Gourmet provisions and country-inspired items for the home

PATERAE
136 Main Street
Saugerties, NY 12477
845-246-9106

Upscale antiques

ROSENDALE WARES
416 Main Street
Rosendale, NY 12472
845-658-7673

Hip selection of retro housewares and clothing

RURAL RESIDENCE
316 Warren Street
Hudson, NY 12534
518-822-1061

Country-inspired home furnishings

SERVICE STATION
2440 Route 28
Glenford, NY 12433
845-657-9788

Coffeehouse and purveyor of furniture, sculpture, gifts, and magazines

SHOP NAKED
608 Warren Street
Hudson, NY 12534
518-671-6336

Modern country gifts for the home

TIVOLI TILEWORKS
54 A Broadway
Tivoli, NY 12583
845-757-5023

Handmade tiles and ceramics

VARIEGATED TEXTILES
www.variegatedinc.com
518-671-6667
By appointment only

Chic pillows, throws, and other home furnishings

THE VELVET EGG
528 Warren Street
Hudson, NY 12534
518-822-9556

Inspired gifts for the home

VINCENT MULFORD ANTIQUES
417-19 Warren Street
Hudson, NY 12534
518-828-5489

Eclectic selection of antiques

LEFT: A self-service farm stand offers a bounty of local fruits and vegetables.

RIGHT: Shop Naked is just one of the many stylish boutiques along Warren Street in Hudson, New York.

RESTAURANTS

BEAR CAFÉ
Route 222
Woodstock, NY 12409
845-679-5555

Fresh and imaginative new American fare; a mecca for food lovers

BLUE HILL AT STONE BARNS
630 Bedford Road
Pocantico Hills, NY 10591
914-366-9600

Restaurant and agricultural center in a former Rockefeller estate

BREAD ALONE
45 East Market Street
Rhinebeck, NY 12572
845-876-3108

Best bakery in town, excellent sandwiches

CAFÉ TAMAYO
89 Partition Street
Saugerties, NY 12477
845-246-9371

Seasonal American cuisine based on fresh local ingredients

CULINARY INSTITUTE OF AMERICA
Route 9
Hyde Park, NY 12538
845-452-9600

America's preeminent cooking school; there are several excellent restaurants on site.

DEPUY CANAL HOUSE
Route 213
High Falls, NY 12440
845-687-7700

Fine dining using seasonal Hudson Valley ingredients

EARTH FOODS
523 Warren Street
Hudson, NY 12534
518-822-1396

Delicious fresh sandwiches, salads, and soups

MAX'S MEMPHIS BBQ
136 South Broadway
Red Hook, NY 12571
854-758-6297

Southern regional cooking using fresh local ingredients

MISS LUCY'S
91 Partition Street
Saugerties, NY 12477
845-246-9240

Shabby-chic home-style restaurant

RED DOT
321 Warren Street
Hudson, NY 12534
518-828-3657

Sophisticated comfort food and lively bar scene

SANTA FE TIVOLI
52 Broadway
Tivoli, NY 12583
845-757-4100

Innovative Mexican and Southwestern fare

LODGING

EMERSON INN AND SPA
146 Mount Pleasant Road
Mount Tremper, NY 12457
845-688-7900

Small luxury inn and spa

KATE'S LAZY MEADOW MOTEL
5191 Route 28
Mount Tremper, NY 12457
845-688-7200

Retro-chic lodging owned by B-52's singer
Kate Pierson

HUDSON GUEST HOUSE
536 Warren Street
Hudson, NY 12534
518-822-9148

Two apartments furnished with lovely antiques
in historic downtown Hudson

MOHONK MOUNTAIN HOUSE
Route 44-55
New Paltz, NY 12561
800-678-8946

Family-style lakeside resort

UNION STREET GUEST HOUSE
349 Union Street
Hudson, NY 12534
518-828-0958

Two beautifully appointed suites in a historic
building in downtown Hudson

VILLA AT SAUGERTIES
159 Fawn Road
Saugerties, NY 12477
845-246-0682

Country-chic bed-and-breakfast

HISTORIC HOUSES

BOSCOBEL
Route 9D
Garrison, NY 10524
914-265-3638

One of the America's best examples of neoclassical
Federalist architecture and furnishings

CLERMONT
One Clermont Avenue
Germantown, NY 12526
518-537-4240

Established in 1728, Clermont was the Hudson
River seat of the politically and socially
prominent Livingston family of New York for
more than 230 years

**FRANKLIN DELANO ROOSEVELT HOME,
LIBRARY, AND MUSEUM**
Route 9 G
Hyde Park, NY 12538
845-229-9115

Former FDR estate

KYKUIT
Route 9
Tarrytown, NY 10591
914-631-9491

Former home to four generations of Rockefellers;
one of the best preserved Beaux Arts houses in
the nation

LYNDHURST
Route 9
Tarrytown, NY 10591
914-631-4481

One of the best examples of Gothic Revival
architecture in the country

**MANITOGA/RUSSEL WRIGHT
DESIGN CENTER**
Route 9D
Garrison, NY 10524
845-424-3812

Former home of modernist designer
Russel Wright

OLANA
Route 2
Hudson NY 12534
518-828-0135

Built in the late ninetheenth century in a
distinctive Moorish/Persian style, Olana is the
former home of Frederick Church, a major figure in
the Hudson River School of landscape painting

SUNNYSIDE HOUSE
Route 9
Tarrytown, NY 10591
914-631-8200

Former home of Washington Irving, America's
first internationally known author

VAN CORTLAND MANOR
Route 9
Croton-on-Hudson, NY 10591
914-271-8981

Eighteenth-century stone manor house
featuring collections of Georgian and Federal
period furnishings

VANDERBUILT MANSION
Route 9
Hyde Park, NY 12538
845-229-9115

An imposing Beaux Arts mansion built by
McKim, Mead, and White for Frederick and
Louise Vanderbilt

MUSEUMS AND CULTURE

ART OMI
59 Letter S Road
Ghent, NY 12075
518-392-7656

Ninety-acre art park dedicated to contemporary sculpture by internationally recognized artists

DIA: BEACON
3 Beekman Street
Beacon, NY 12508
845-440-0100

The largest contemporary art museum in the world featuring major works of art from the 1960s to the present

RICHARD B. FISHER CENTER FOR THE PERFORMING ARTS
Bard College
Annandale-on Hudson, NY 12504
845-758-7950

Performing arts center designed by Frank Gehry; offers a variety of music, theater, and dance programs

HUDSON OPERA HOUSE
327 Warren Street
Hudson, NY 12534
518-822-1438

Restored nineteenth-century opera house with ongoing arts and performance programs

OLD DUTCH CHURCH AND SLEEPY HOLLOW CEMETERY
Rte 9 at Pierson Street
Tarrytown, NY 10591
914-631-1123

An historic church erected in 1697; the adjacent cemetery dates to the pre-Revolutionary Dutch tenant farmers and contains the graves of luminaries Frederick Law Olmsted, Washington Irving, Walter Chrysler, and William Rockefeller

SHAKER MUSEUM AND LIBRARY
88 Shaker Museum Road
Old Chatham, NY 12136
518-794-9011

Museum features one the largest collections of shaker artifacts in the world, including boxes and baskets, farm tools, machinery, and furniture

STORM KING ARTS CENTER
Old Pleasant Hill Road
Mountainville, NY 10953
845-534-3115

The largest sculpture park in the United States, with over 500 acres devoted to such artists as Alexander Calder, Louise Nevelson, Isamo Noguchi, and Richard Serra

FARMERS' MARKETS AND FOOD PURVEYORS

CHATHAM SHEEPHERDING COMPANY
155 Shaker Museum Road
Chatham, NY 12136
888-743-3760

Exceptional hand-crafted cheeses

HANSEN CAVIAR COMPANY
881 Route 28
Kingston, NY 12401
800-735-0441
845-331-5622

Fine caviar and smoked salmon

HUDSON RIVER FARM MARKET
17 North Fourth Street
Hudson, NY 12534
518-828-0935

Year-round indoor market, specializing in local and regional products, including meats, produce, cheeses, and more

HUDSON VALLEY FOIE GRAS
80 Brooks Road
Ferndale, NY 12734
845-292-2500

Purveyors of the country's finest foie gras

LOVE'S APPLE ORCHARD
1421 Route 9 H
Ghent, New York 12075
518-828-5048

Offers exceptional seasonal fruit, gourmet items, and pick-your-own facilities

MILLBROOK VINEYARDS
Shunpike Road
Millbrook, NY 12545
845-677-8383

Renowned winery celebrated for its Chardonnay

OPPOSITE: In autumn, apples are ripe for picking throughout the valley.

LEFT: The frigid waters of the Hudson make for a typically wintery scene.

INDEX

FOLLOWING PAGE, CLOCKWISE: Country decor in a hip setting defines Wunderbar & Bistro in Hudson, New York; Farmland in the valley gives the region a bucolic feel; Warren Street in Hudson, New York, is filled with antique stores and other appealing shops; Autumn brings vivid, fiery colors to the valley.